ART
of Northern
California

PAINTING SCULPTURE PHOTOGRAPHY

DRAWING PRINTMAKING MIXED MEDIA

ACKNOWLEDGEMENTS

Special thanks to California College of Arts and Crafts instructors Howard Eige and Clay Jenson for helping review the hundreds of submissions received for this book.

ALCOVE BOOKS

Art & Design by Region • Museum & Artist Catalogs
652 65th Street, Oakland, CA 94609 USA
www.alcovebooks.net

Library of Congress Cataloging-in-Publication Data
Yu, Chingchi, 1961- Art of Northern California: painting, drawing, sculpture, photography, printmaking, mixed media / by Chingchi Yu;
edited by Michelle Kellman, Cheryl Koehler and Aileen Kim. p. cm. Includes index.
ISBN 0-9721890-1-7
1. Art, American--California, Northern--20th century. 2. Artists--California, Northern--Directories. I. Kellman, Michelle, 1972- II. Title.
N6530.C22 N679 2003 709'.794'20904--dc21 2002151682

ALSO AVAILABLE - CRAFT OF NORTHERN CALIFORNIA

Order via:
Phone 510-428-0930
Fax 510-428-0955
Internet orders@alcovebooks.net
Mail 652 65th Street, Oakland, CA 94609 USA

Art of Northern California	$16.95
Craft of Northern California	$16.95
Design Source San Francisco	$16.95

Check, Visa or MasterCard. Shipping is $1 each, in California add $1.40 sales tax.

ART OF NORTHERN CALIFORNIA explores one of California's great resources—its contemporary artists. Many of those profiled here have work in public and private collections around the world; others are just beginning promising careers. Together, they represent both a rich source for original art and a cultural archive of creativity in California at the turn of the new century.

Artist's gallery & show affiliations are represented by abbreviations shown in the lower-left page of their profile.

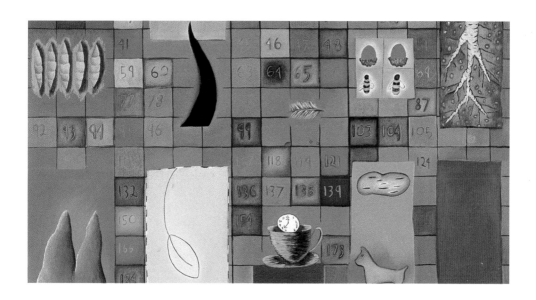

Above: L. Piels - pg. 216
Front cover, clockwise from top: J. Long - pg. 144, K. Carr - pg. 38, J. Liston - pg. 143
Back cover, from top: M. Ulriksen - pg. 269, W. Robinson - pg. 230, D. Eddy - pg. 64

INTRODUCTION

ARTISTS WORKING IN THE PAST HALF-CENTURY have participated in an era of great democratization of the arts. Vastly expanded leisure time has provided the time and space, both intellectually and economically, to support art and artists on an unprecedented scale. The critical climate within the art establishment in America has further extended boundaries of permission. Generations of artists have searched for new and unique ways of defining the individual's voice, creating movements, concepts and forms that have forever changed our visual lives.

California occupies an unusually independent and varied position in modern art history. Its geographic position faces an Asian theater of very different aesthetics than Europe, which for so many centuries governed the definition of art. If our Wild West heritage and distance from the New York art world were not enough to prepare us for freedom, the presence of great poets such as Robinson Jeffers, Gary Snyder, and Allen Ginsberg and radical thinkers like Alan Watts, Buckminster Fuller and Linus Pauling all contributed immeasurably to this fertile edge of continent. How can we imagine our world without the creative contributions of Bay Area mavericks like Hewlett and Packard, Wozniak and Jobs—innovators as much a part of our creative lives as our artistic icons? Richard Diebenkorn, Elmer Bischoff, Joan Brown, Manuel Neri, William Wiley and Roy deForest form a part of a mother lode of genius, which informs the sensibility of every student of art to follow.

Surveying the current art of our region we find imagination and vision that know no boundaries; restlessness and joy are our heritage. From *plein air* landscapes rich in the subtle colors of seasonal hills, to studies of the human form in oil paint, encaustic, stone and metal, the artist's materials take a shape given by gifted sensibilities.

Technological innovation, rather than limiting the need for traditional art forms, has redefined the purpose and meaning of craftsmanship present in beautifully made paintings and sculpture that draw us to their materiality with an almost metaphysical reverence. New technologies thus expand the artist's consciousness, toolbox of materials and practices to unprecedented variety.

Scanning these pages, one finds work that inspires fascination and deep interest. In the world of artistic pluralism we inhabit, art's importance is less a matter of pronouncements from "on high" than the appreciation of individual probity and passion by peers eager to engage in the challenges and pleasures available in the art of our own time and place. Culture is created by the connections between minds—and the richest culture is that which is most tolerant and varied, capable of inclusion and imaginative transformation.

Whatever challenges individuals and societies face in this confusing age, we may all find evidence here of the fruits of freedom, for the artistic legacy of a culture is indeed its finest harvest. This collection celebrates that richness and diversity, and points to the outward and inward looking that is so essential to our collective health.

Chester Arnold, Sonoma County, CA

Benny Alba

Originally from Columbus, Ohio, Benny Alba has worked in art since 1981 and maintains a studio for teaching workshops. "I create art to communicate with viewers of the future as well as viewers of today. I am descended from several generations of artists. I'm not formally trained, although one might say there was art school every day at home. I hew my own path. I am told that my work is deceptively simple, which is understandable because it takes some time to see art that is very different from the typical. Another term

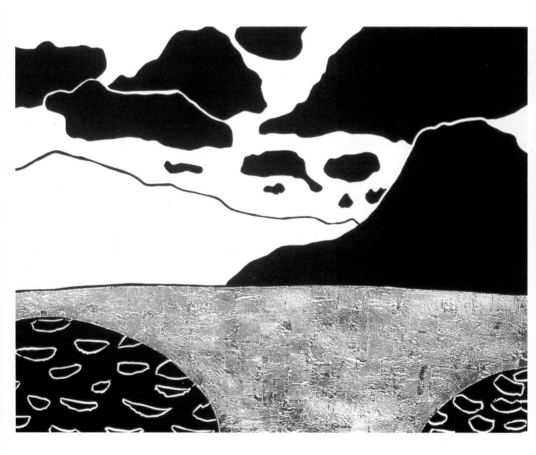

Waves. Linocut with aluminum leaf. 18" x 24"

used is tranquil. This I found confusing, as wild landscape is a magnificent, powerful aspect of our existence. Upon reflection, I realize that my ease and delight in the exuberance and beauty of wilderness comes through as a calm mood that gives viewers respite from the frenetic whirlwind of today's life—a view through a different window."

4219 MLK Jr. Way, Oakland, CA 94609
510-547-4512 www.bennyalba.com

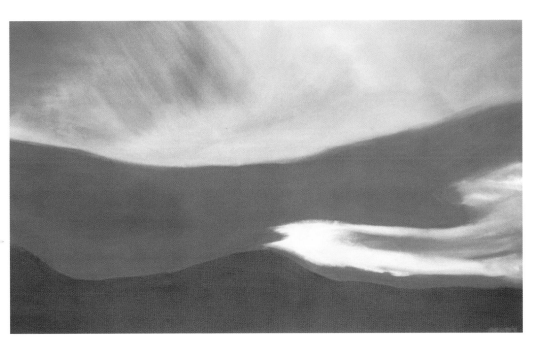

Windy Cloud Day. Oil. 30" x 54"

Alba

Kent Alexander

Kent Alexander received an MFA in painting from the California College of Arts and Crafts in Oakland and has taught painting and drawing at several San Francisco Bay Area colleges. "These works are acts of faith. They are, certainly, meditations on the miracle of us existing at all, and on our human struggle to become fully ourselves. In the end there is the figure emerging from the stuff of life. I hope these paintings bring some clarity of faith to our lives. The figure is first painted and then gradually painted over with a series of glazes.

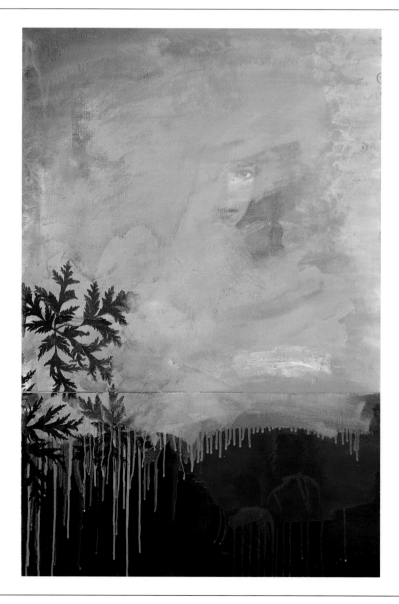

Reflection. Oil on linen. 36" x 24"

When I begin a painting I don't know how far I'll need to go, or what will be involved in its layers. These paintings examine the emergence of personality from the chaos and patterns of our lives. There are overt and covert aspects to our lives, outer and inner, and aspects both under and outside our conscious control. We discover things gradually in these paintings as we do in life."

7833 Sterling Dr., Oakland, CA 94605
510-568-3183 www.kentalexander.com

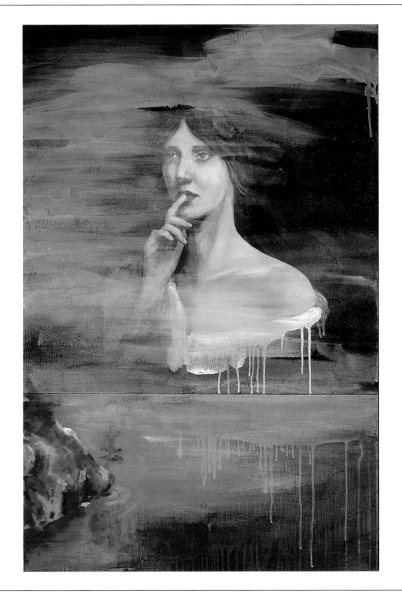

Lady of the Lake. Oil on linen. 36" x 24"

Alexander

Douglas Andelin

A native of the San Francisco Bay Area, Doug Andelin received a BFA from the Art Center College of Design in Pasadena. "Painting is a place where I go to be small—to be an observer of forces much greater than myself and to be humbled by the experience of nature, my greatest teacher. The process of my painting is simple and pure. I paint outside, directly from life. This is where the life of the painting begins. I ask questions about perception, time, space and myself as an artist. Standing there I strive to look outside my own

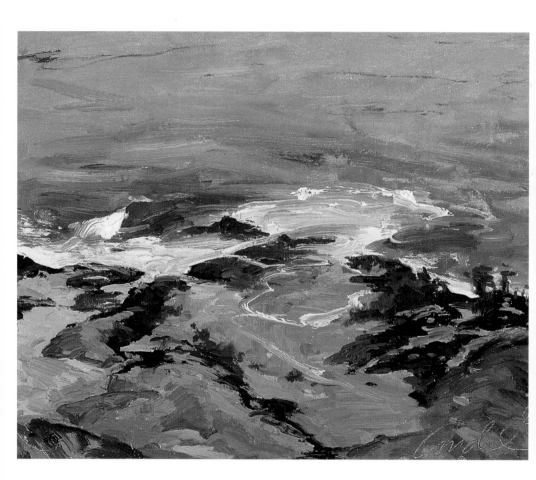

Churn. Oil on canvas. 11" x 14"

answers and listen. I want to shed what I know and reach into the paint to grasp a new honesty. I am in a constant balancing act between searching and forgetting, asking and listening, consciousness and unconsciousness. Painting has a long history within my family, but I am more deeply rooted in the history of painting itself. The voices I hear are Turner, Rembrandt, Michelangelo, Monet and Wyeth."

19 Bayview Ave., Larkspur, CA 94939
415-927-1945 dougandelin@aol.com

Shadow. Oil on canvas. 11" x 14"

Andelin

John Arbuckle

John Arbuckle studied at the New York School of Visual Arts and received a BFA in painting and printmaking from Pratt Institute in Brooklyn. He has been exhibiting since 1977. "Everyday objects elevated to a magical level just beyond the real world—this is my art.

A shell, a flower, some gourds, a quince on a leafy branch all become luminous globes, painted with many layers of glazes, some in oil on canvas and some in watercolor on paper. I am passionate about light and shadow and the sensuous nature of objects

Dancing Gourds. Oil on canvas. 30" x 42"

and their relationships to each other. I also explore the idea of abstraction within reality when in the process of painting. It has been said that my work is very Zen, which I strive for in my art. The goal of my work is to slow the viewer down and take them to a quiet place away from the madness of day-to-day life." Collections include the Brooklyn Museum of Art and Lloyd's of London.

P.O. Box 883573, San Francisco, CA 94188
415-822-7866 www.home.earthlink.net~jaart

New Quince. Watercolor. 11.5" x 18" **Arbuckle**

Kathryn Arnold

Originally from Kansas City, Kathryn Arnold received an MFA from the University of Kansas at Lawrence and has lived and painted in San Francisco since 1999. "These paintings are a result of intuitive nonobjective processes and contain my search for visual magic. The sense of touch and chaotic energy of color and marks play an important role in building up layers that function to create an encompassing, enveloping field and bewildering space. The grid becomes a reference point. The intrinsic relating of parts form poetry, an interplay

Rivulets. Oil on canvas. 7' x 7'

between subjective and objective realities. A current *100!* series explores an actual physical grid created through small canvas pieces. The viewer can interact and recreate this arrangement by rearranging them. My inspiration is life, noting the concepts that direct and give order. There is no limit to the recreations in *100!* yet this conceptual grid holds it all together."

301 8th St. #245, San Francisco, CA 94103
415-863-8531 www.kathrynarnold.com

100! Oil on canvas. 100" x 100"

Arnold

Paula Bailey

Paula Bailey received a BS in design from the University of California at Davis and is managing director of Art Works Downtown in San Rafael. "When the clouds escape to the next ridge I paint as quickly as I can so I can show you the intense, lusty colors that I saw in just that moment, the shadows and the wind trails pulling me in…. It is my challenge to set the image down loosely enough to invite the viewer to participate in the discovery. I do not wish to paint exactly what I see but what I'm feeling about what I see. I am absorbed in

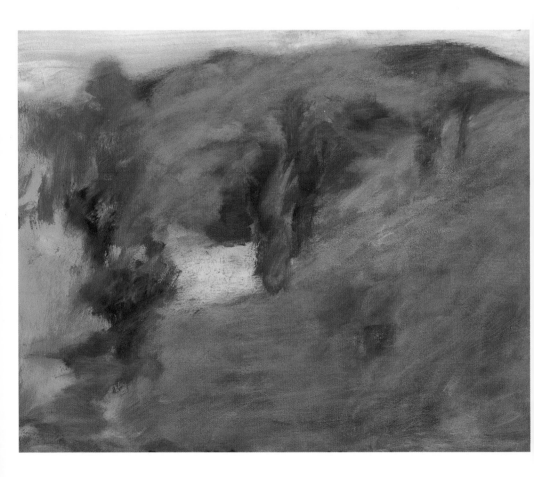

Wild Mustard. Oil on paper. 22" x 30"

painting the scene and when I leave feel as though I have stolen something, that if I turn around too fast I might see a white space where I have erased what was there. The location is somehow influenced by my having been there. I rush home to see what I have.

Am I any closer to recording essence? This elusive process, the search for the spirit of place continues with the viewer."

Novato, CA
415-382-9068

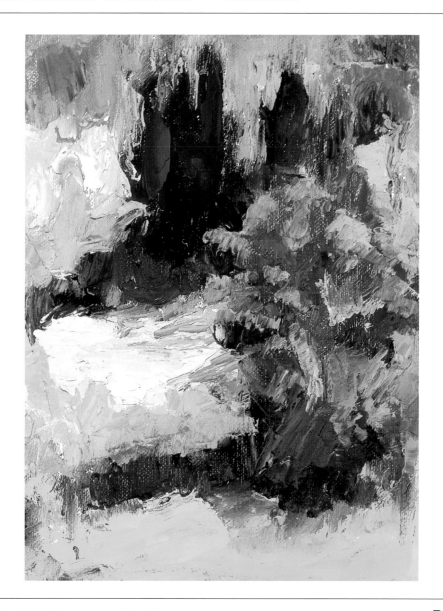

King Mountain. Oil on canvas. 8" x 6"

Bailey

Angela Baker

Originally from Philadelphia, Angela Baker received a BFA from the Columbus College of Art and Design in Columbus, Ohio. "My paintings combine gestural figures with fields of layered color inspired by various landscapes. The idea of adapting elements from nature began during an artist's residency in Hungary. The countryside contained endless fields of sunflower and wheat, creating a high horizon line. Many buildings were painted in warm ochre and oranges, colors that seemed particular to the region and made a striking

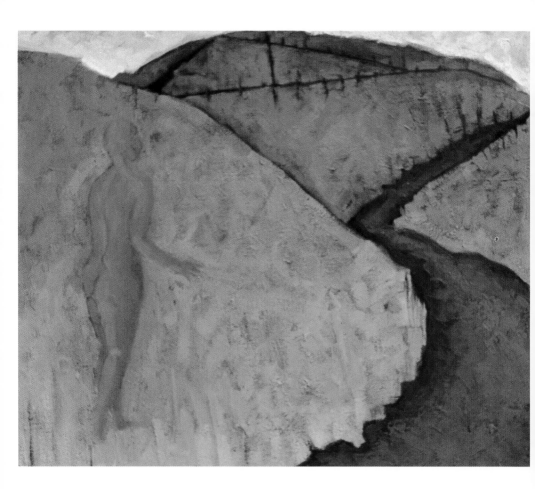

Imagination and Reality Meet. Oil on linen. 30" x 36"

impression. Working with the figure as more of a suggestion had an ephemeral quality that matched my temporary stay. Color, land, telephone wires and even billboards, continue to serve as sources of inspiration. I often combine pieces of my environment with the figure to create paintings that examine the attraction to places, and how location has potential to influence our thoughts and lives."

3759 Folsom St.
San Francisco, CA 94110 www.bakerart.com

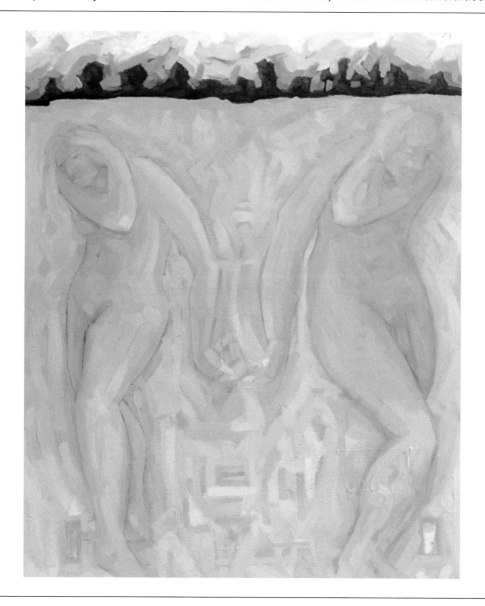

Collection of Days. Oil and collage on canvas. 50" x 40" **Baker**

Jennifer Beckman

Jennifer Beckman studied painting and drawing at The School of the Museum of Fine Arts in Boston, and printmaking at the College of Marin. She first worked in ceramics, and later in gouache while living in Bali. "A love of jazz influences my work. While painting I try to express the lyricism and freedom of a jazz musician exploring the relationship between improvisation and structure. Neither purely abstract nor totally realistic, my landscape work explores the poetry between the two. It is this relationship between light and dark,

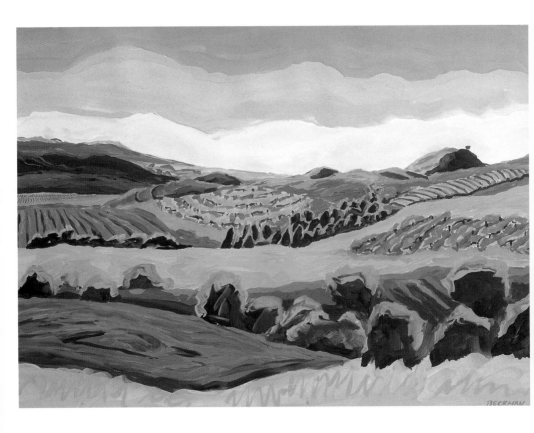

Wild Cat Mountain III. Acrylic gouache on paper. 26" x 41"

order and disorder, harmony and dissonance that interests me. It is as if my paintings are emblems of places we have all seen and loved, images of places we keep deep in our memories, but can't quite find again. My paintings, like music, are about a felt but not ultimately tangible reality. They are an exploration of the difference between what is and what could be."

Sausalito, CA
415-332-7018 www.jenniferbeckman.com

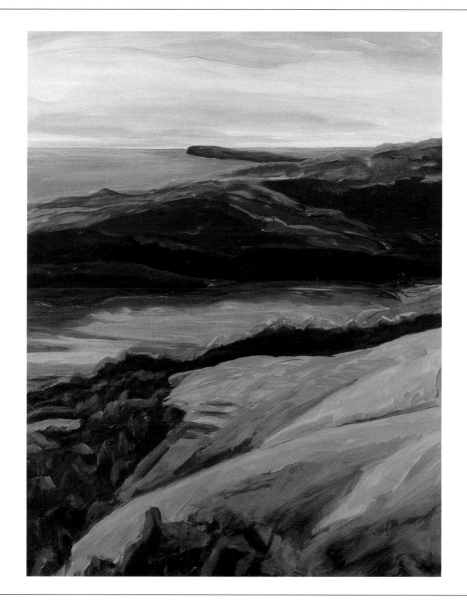

Leaving Bolinas. Acrylic gouache on canvas. 48" x 36"

Beckman

Jan Bernard

San Francisco native Jan Bernard received a BFA from the University of California at Berkeley, where she studied Japanese watercolor with Chiura Obata. "My inspiration comes from dreams and a vivid imagination. Abstract artist and teacher Hans Hofmann said that the artist must paint what is real. From the smallest particle in the atom to the largest of heavenly bodies, attraction, energy and motion are everywhere. In an almost infinite universe, it is hard to paint anything that is not real somewhere. With this in mind, I start with an

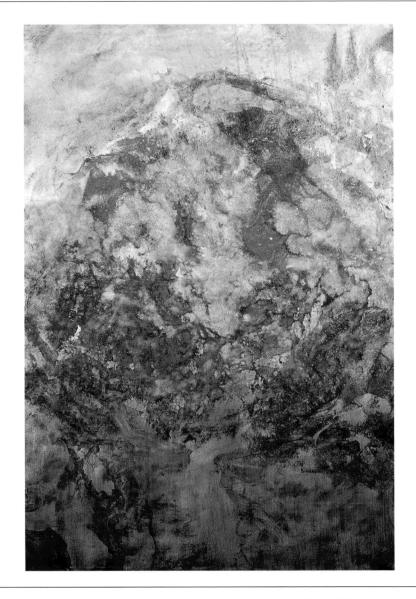

Gaea. Oil on canvas. 56" x 37"

abstract and study it and create the pictures I see in the paint. Using this technique, I try to stretch my ability to view things from many different perspectives. We artists are lucky. We can travel and visit many places while never leaving our easels. In my paintings I try to leave enough undefined so that the viewer can discover and become a co-creator."

21 Mercedes Way, San Francisco, CA 94127
415-334-1484 janhber@pacbell.net

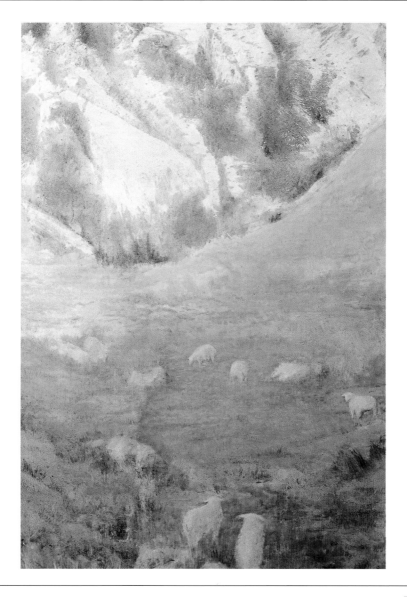

Sheep/Rocks. Oil on canvas. 56" x 39" **Bernard**

Deborah Bertola

Originally from New Jersey, Deborah Bertola received a Ph.D in philosophy from the University of California at Berkeley, and in 1990 left a corporate career to become a painter. She has studied painting in private lessons with Chester Arnold, Paul Bridenbaugh and Randall Sexton. "I began as a *plein air* painter and gradually concentrated on less traditional images. I am drawn to subjects that evoke a certain history, and an ambiguity of time and place. I find this focus appealing intellectually, emotionally and artistically. The paintings

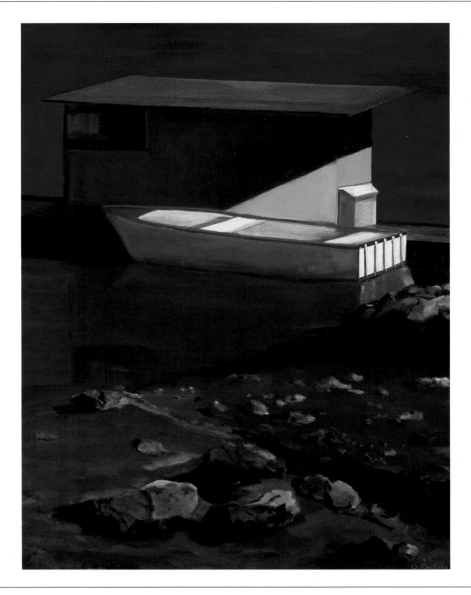

Beach Bungalow Redux. Oil on canvas. 30" x 24"

reveal my interest in the quality of light, and in the beauty and, often, mystery found in unusual places. Working with these subjects I eliminate extraneous detail to capture the thing itself. Viewers reactions to these paintings vary; some see them as austere and lonely; others find them peaceful and beautiful. I think my muse is looking to organize the world in a way I can relate to more positively."

440 Gate 5 Rd. #282, Sausalito, CA 94965
415-381-5103 deborah@dbertola.com

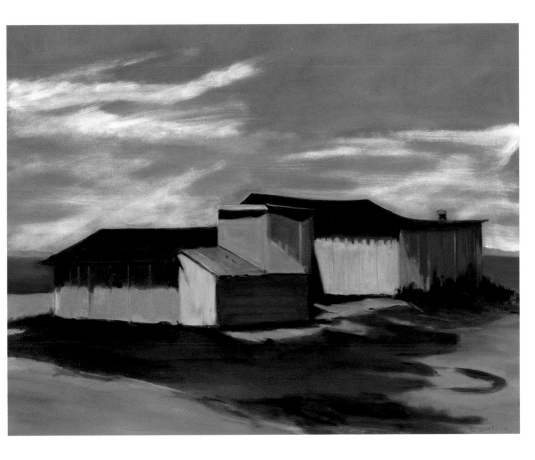

Gas Dock. Oil on canvas. 24" x 30"

Bertola

Mary Black

Mary Black received an MFA from the San Francisco Art Institute and gives workshops in encaustic painting. "Encaustic paint contains wax, pigment and dammar resin and must be heated and fused. These dual properties of liquid and solid feel alchemical and ritual-like, reminiscent of the Catholic Church, shrouded in mystery and ceremony. My work reflects aspects of Jungian psychology, duality and the unconscious mind. The division of space, use of grids and multiple panels represent our psyches divided into many parts as we struggle

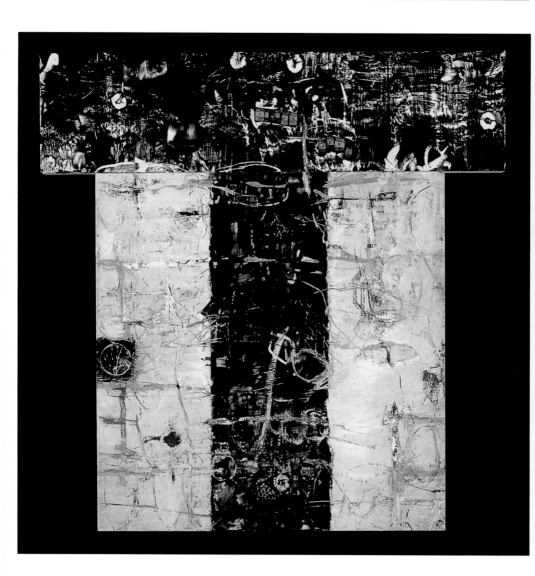

Between the Flesh and the Bones. Encaustic mixed media. 48" x 48"

in our search for wholeness. My paintings comprise bits and pieces of my life that surface as I work. As I layer on materials, then scrape away, images or a history are revealed to me. Digging into the surface, seeking what's within the paint and wax is as important as any image I might impose. The paint and wax hold qualities of time, memory and chance, which lend themselves to my style of working."

Sebastopol, CA
707-823-5261 www.maryblack.net

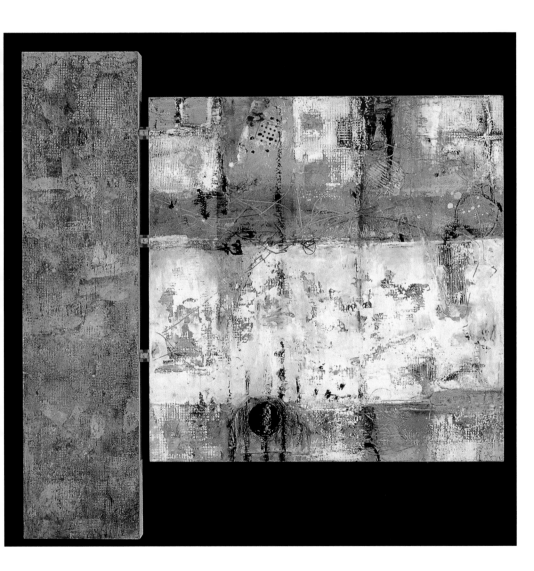

Halfway Between the Seeing and the Doing. Encaustic panels. 48" x 12", 36" x 36" **Black**

Tesia Blackburn

Tesia Blackburn received a BFA from the Academy of Art in San Francisco and an MA from John F. Kennedy University in Orinda. She has taught art at the Mendocino Art Center, Palo Alto Art Center and San Francisco City College. "Standing in the red and purple deserts of New Mexico or on a California beach, I feel the land, I hear it, I smell it. Back in the studio, I filter the experience through my brain and heart and out into my hands, and it explodes onto the canvas in a riot of color. I start with a bold underpainting, quickly putting

Naos. Acrylic on panel. 36" x 48"

down an initial thought or feeling. Then I respond to what I see, putting down, taking away, looking, listening, as the work unfolds before me. It's a dance I perform with the painting, sometimes leading, sometimes following, sometimes right on the precipice, but always exciting, and always, color is the key. That elation with the colors of the landscape is what I hope to transmit to the viewer."

601 Van Ness #E524, San Francisco, CA 94102
415-822-5939 www.blackburnfineart.com

Cardinal Axes. Acrylic on canvas. 36" x 48" **B**lackburn

Richard Bolingbroke

Originally from Southsea, England, Richard Bolingbroke received a degree in geography from London University and traveled widely, including five years in India, before reaching San Francisco in 1986. "My work has embraced many phases and styles. At art school, sculpture and photography were my focus, but later explorations led to a greater interest in painting, especially conceptual and philosophical explorations of the nature of reality. While traveling I began working in watercolor due to its ease of use on the road.

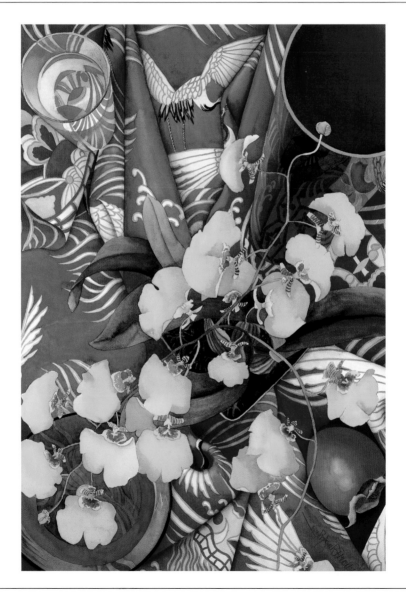

Studio Still Life #1. Watercolor on paper. 41" x 29"

Landscapes became the main theme as I worked my way across Asia. Watercolors of flowers and still life have remained my principal inspiration since 1986, but I have recently been painting the California landscape and exploring printmaking in monotype and intaglio. An investigation of pattern and color has resulted in complex images using Japanese kimonos, bold striped fabrics and other fabrics."

2356 15th St., San Francisco, CA 94114
415-863-5654 www.rbolingbroke.com

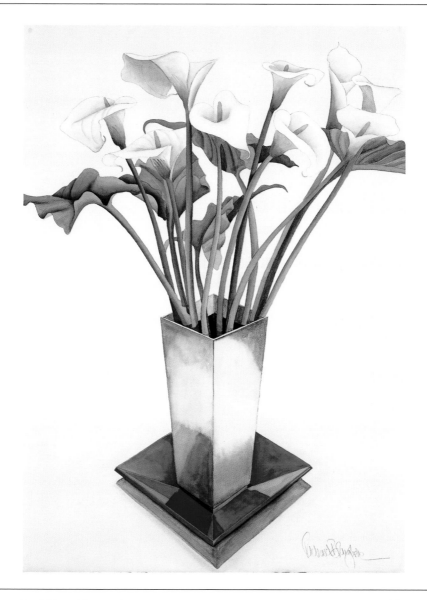

Callas on a Red Plate. Watercolor on paper. 41" x 29"

Bolingbroke

Doug Burch

Doug Burch received a BFA in painting from the California College of Arts and Crafts in Oakland and studied architecture at the University of Cincinnati. "Incorporating oil paint, glass, paper and thread to create a dissolving image, my work represents the clouded, elusive and fleeting nature of the memories which objects evoke. I develop ideas triggered by memories of objects I encounter in the urban landscape. My creativity is fueled by the absurd conditions of discovery and a curiosity for the history of an object and its owner.

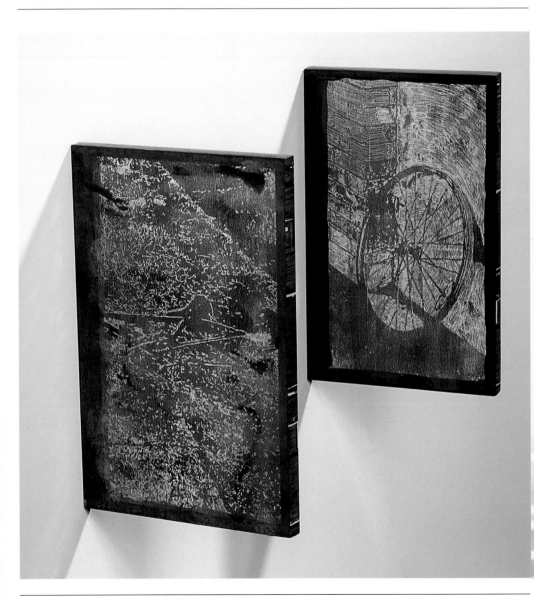

Spoken Ride. Mixed media. 8.5" x 5.5" each

Objects become artifacts when pulled from their explicit context. Each piece communicates a visual narrative that reflects both the conditions of the artifact's discovery and the possibility of a more intimate and meaningful context for it. My work, like a good painting or poem, at first appears simple, only to become surprisingly more complex and interesting upon closer inspection."

1145 Pine St. #44, San Francisco, CA 94109
415-864-1786 burchd@mindspring.com

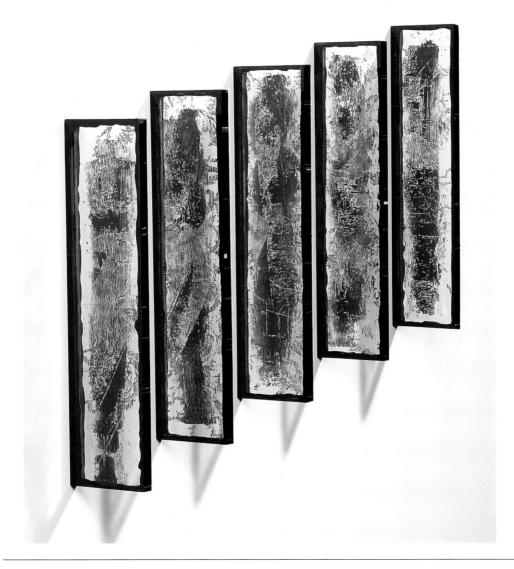

Slumber 1-5. Mixed media. 12" x 3" each

Burch

Jane Calender

Jane Calender was born in Oakland, and attended the College of Arts and Crafts in Oakland and Stanford University. "My art has evolved into a passion for creating *plein air* impressionistic oil paintings of Northern California, and my life has driven me to seek peace, quiet space and renewal. Nature provides me with healing inspiration. My wish is to share the beauty I experience. There is excitement about what each step will be for a painting. After I find a place that inspires me and I set up my easel, I do

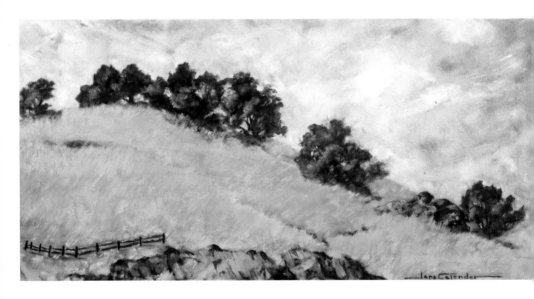

Oaks from Across the Ridge, Mt. Tam. Oil on canvas. 15" x 30"

several small sketches to work out the composition. With thin paint I draw my subject with a brush on a toned canvas. Then I begin, slowly building up the paint, working in layers. The process is often difficult, sometimes a struggle, yet there is definitely a thrill in the challenge, and ultimately joy in the finished painting."

305 E. Strawberry Dr., Mill Valley, CA 94941
415-381-8281 janecalart@aol.com

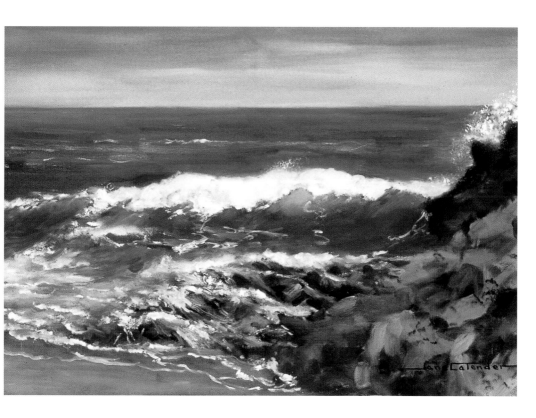

Breakers at Rodeo Beach. Oil on canvas. 18" x 36"

Rusty Cantor

A self-taught artist, Rusty Cantor remains active at seventy-five. "I have been an artist ever since I can remember. My work is about hope. It's about praying in a spiritual but secular way. It's about bringing a balance of male/female energy and intelligence back into the world. I believe we need this kind of balanced power in order to save the planet and ourselves. Much of my work is based on the findings of Harvard archeologist Marija Gimbutas. I use my vocabulary of symbols in the hope of touching emotions beyond the

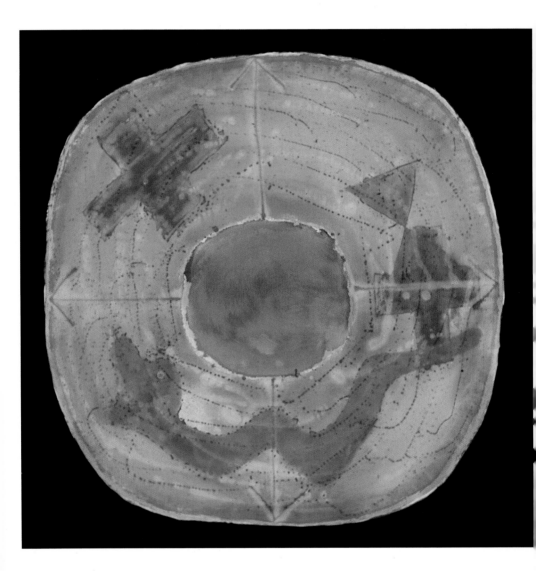

Prayer Shield. Acrylic on canvas. 5.5" square

reach of words. I love making art. I have produced art in various media: paint, glass, wood, fiber, bronze, marble, found objects and other materials and processes. It's wonderful to play with a new idea, to work in series, choose the colors, materials, sizes and whatever else goes into it. Making art is intuitive, intellectual, physical and emotional. All my abilities are used in the process."

2512 Ninth St. #14, Berkeley, CA 94710
510-845-6258 rustycan@lmi.net

Invocation '98 #1. Acrylic on canvas and fabric. 56" x 68" **Cantor**

Kathleen T. Carr

Kathleen T. Carr received a BFA in photography from Ohio University and is the author of *To Honor the Earth*, *Polaroid Transfers* and *Polaroid Manipulations*. "For years I have photographed nature, people and the landscape in my travels. I was fortunate to have studied with Minor White, whose approach encouraged a reverence and connection with the subject before exposing the image. I then began to see photography as a vehicle for spiritual growth—a mirror of my inner and outer awareness of life. I want my

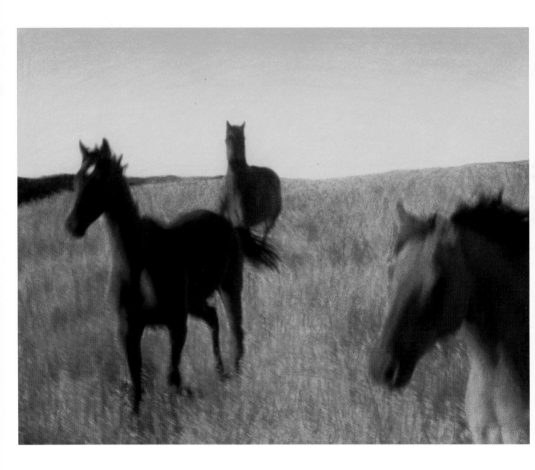

Horses. Hand-colored Polaroid image transfer. 8" x 10"

photography to inspire people to honor the earth and all who live upon it. I work with Polaroid image and emulsion transfers, and SX-70 manipulations, then hand-color the images, expressing a more subjective and less literal vision. I often enhance an image in Photoshop, and then print on watercolor paper or canvas with archival pigment inks to create limited edition prints up to fifty inches wide."

Sebastopol, CA
707-829-5649 www.kathleencarr.com

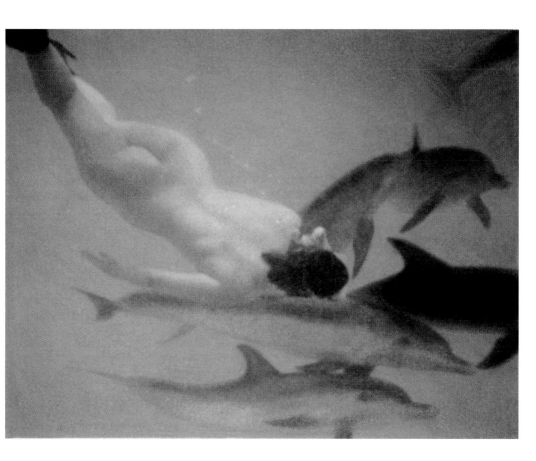

Nude & Dolphins. Hand-colored Polaroid image transfer. 8" x 10" **Carr**

Michelle Casciolo

Michelle Casciolo seeks to reveal the aesthetic beauty of practical structures stripped of their utilitarian functions. "This series focuses on the essential elements of a space: color and form. While most of the images reflect ordinarily busy places, people are conspicuously absent. The images are documents of urban spaces rather than snapshots of urban life; inherent qualities are allowed to emerge once removed from the context of time and scale. Lobbies and entryways are the most democratic and public space of any building, one's first impression of

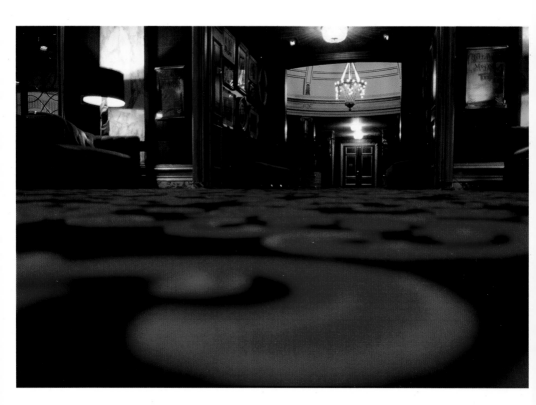

Fairmont Hotel. Photograph. 16" x 20"

a place and a likely indicator of what one might find in the rest of the structure. Color and lighting largely determine the mood. Hallways and train aisles can seem endless and lost in time as fluorescent lighting mixes with colors that exist in the space. These design elements can achieve similar effects, whether the space is a subway entrance or the elaborately designed lobby of the Fairmont Hotel."

52 Page St. #6, San Francisco, CA 94102
415-864-2392 www.shadylanes.org

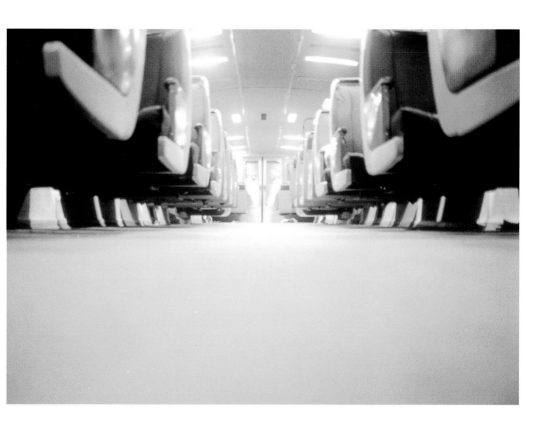

BART. Photograph. 16" x 20"

Casciolo

Belinda Chlouber

Belinda Chlouber studied painting at the Kansas City Art Institute and Parsons School of Design in New York City. "I use the theme of human relationships with other animals and nature, which is rich with imagery and imagination. We are an integral part of the animal kingdom but are often alienated and distanced from it. My paintings try to connect the two, and realize the symbiotic relationship they have. Patterns fascinate me—their reliability, their predictability and their necessity to nature. They are everywhere, yet disguised

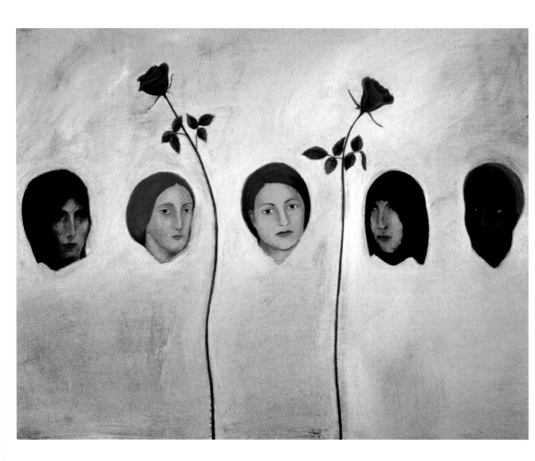

Flowers and Thorns. Oil on canvas. 36" x 44"

and seemingly random. Patterns comfort us. They make us feel safe in an unpredictable world. I often embed them hidden behind transparent layers of paint. Often the paintings are at first glance simple, yet on closer inspection a complex world reveals itself.

I see my paintings as silent conversations that intrigue and motivate the viewer to examine his or her own ideas and beliefs."

San Mateo, CA
650-578-9261 www.tenfingers.com

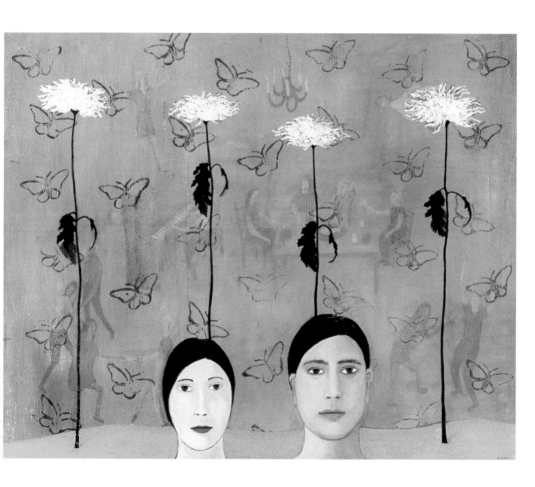

Memories Intertwined. Oil on canvas. 32" x 40"

Chlouber

Paula J. Clark

Originally from Ann Arbor, Paula Clark received a BFA from Eastern Michigan University and has worked as an illustrator, toy designer, goldsmith and ceramics instructor. Watercolor has been her primary medium since 1993. "Painting is a relationship between myself and the pigment. I experience this process like a waking dream. There is the reality of the paint and its sensual nature—this becomes integrated in my immediate response to what is either within me or before me. I simplify my response (composition) to focus on the

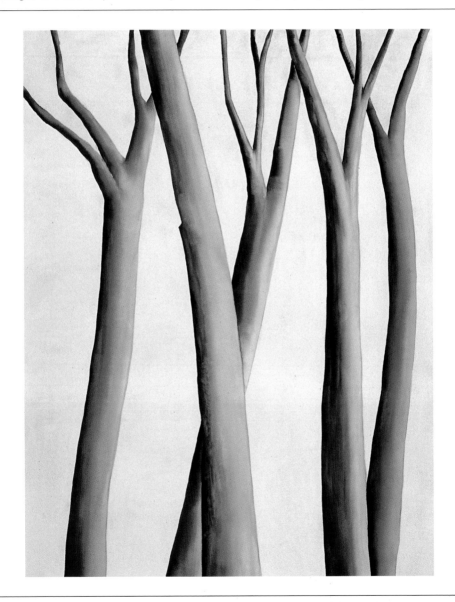

When Trees Were King. Watercolor. 60" x 40"

application of color. I find the unpredictability of watercolor and my preference for sedimentary and somewhat opaque pigments to enhance my exploration of color and form. I rely heavily on the depth and variation of these pigments to both mix together and separate out from one another in the process of application and drying. My desire is to reveal a reverence for color and subject matter."

827 34th Ave., San Francisco, CA 94121
415-752-0632 www.paulaclark.com

Metamorphosis. Watercolor. 22" x 30"

Clark

Lee K. Cline

Lee Cline received an MFA in creative writing from Mills College in Oakland and is largely self-taught in visual arts. "Artmaking, for me, is a process of coming to terms with the overtly conscious and deliberate—allowing for the play of spontaneity, mystery and surprise. This means tapping into something of a subconscious, focused dream state when I work. It also means relinquishing a bit of control and surrendering to the materials—embracing, for example, the unpredictability of watercolor, oil or raw pigment. With a live

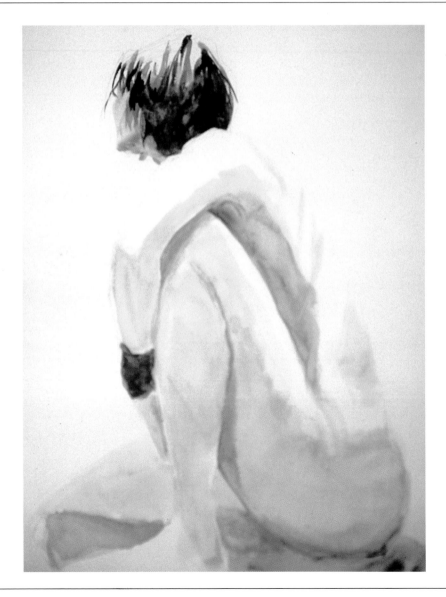

Djinni. Watercolor. 12" x 9"

model I have to work quickly, and that helps to keep the marks honest. I like to work in the gray area between realism and abstraction, or in the realm of the unfamiliar, or the slightly strange, where the imagination can most richly engage. To suggest a potential for story and let the viewer complete it however he or she does—that, too, is part of the letting go."

2425 17th St., San Francisco, CA 94110
415-626-6948 mizlee@mindspring.com

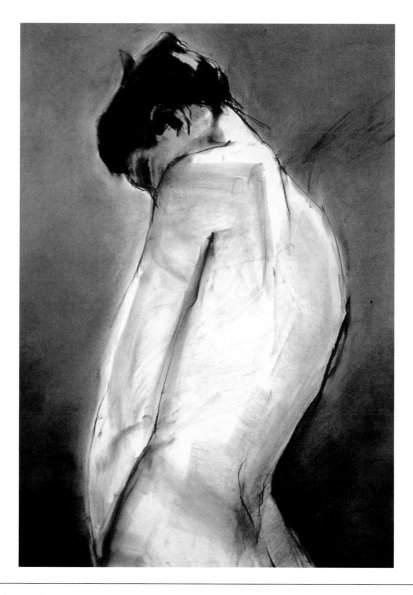

For Paul. Charcoal and pastel. 24" x 18"

Cline

Linda Sanders Colnett

Linda Sanders Colnett's work is inspired by the general human condition, including issues related to gender, race, ecology and geopolitical power struggles. "In the 1990s I worked with recycled cardboard boxes, lovingly painting them to represent trees in the four seasons, to pay homage to trees felled by humans to produce mundane items. Working with boxes I was reminded of how we humans also come in various sizes and shapes but share some of the same limitations. I thought of the ways we box ourselves in—of creating

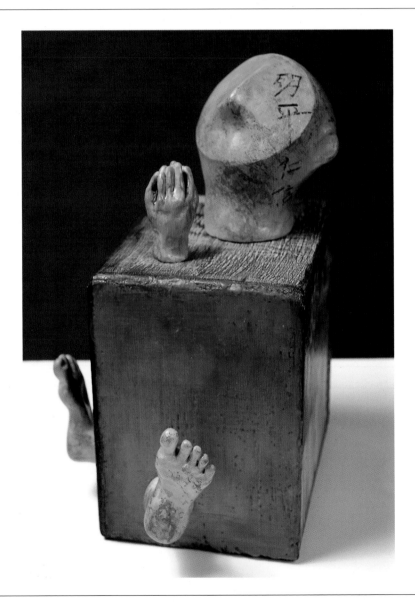

Contemplative #2, Lao Tzu. Mixed media. 9" x 8.5" x 5"

boundaries from which we cannot escape. However, from time to time, there are those who break out of the box—who think great thoughts and contribute to the betterment of mankind, who challenge us to think and gain some understanding of the human condition.

My series entitled *Contemplatives* is dedicated to those unique individuals and to those of us who aspire to break out of the box."

2965 Pacific Ave., San Francisco, CA 94115
415-567-5434 lscol@att.net

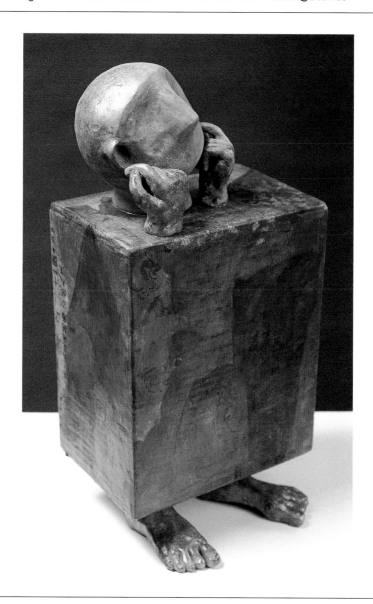

Contemplative #1, Atisha. Mixed media. 21" x 9" x 10"

Colnett

Deborah Colotti

Deborah Colotti received a BA in sculpture and has studied such diverse subjects as comparative philosophy, tea ceremony, mask carving and landscape design in England, Austria, India and Japan. "At first, the wall installation of naked dolls appears humorously confrontational, and the household textiles seem nostalgically non-threatening. Yet, both works contain vital elements of personal solace and cultural challenge. My varied art training and travel experiences come together to support my strongly ethical and free-ranging

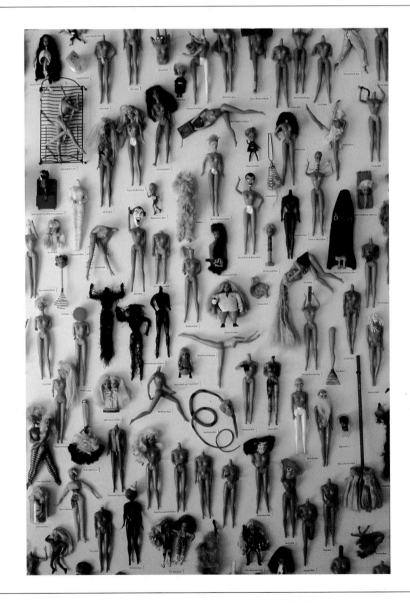

the Barbs. Installation detail. Dolls, toys, screws, glue. 9' x 8'

aesthetic adventures. Using familiar, even mundane, materials I seek to spark subversive optimism, creating questions regarding the sweet joys and deep frustrations of our contemporary psycho-socio-political world. I continue to question the dominant patterns of living, and find help and joy in posing my questions through commonplace objects found in everyday life, in everyday homes."

2750 Bloomfield Rd., Sebastopol, CA 95472
707-823-7040 dcolotti.com

to Explore. Clothesline device, linen, ink, clips, pin. 18" x 36" x 4" **Colotti**

Mitch Confer

Mitch Confer received a BFA from the Art Center College of Design in Pasadena, California, and has worked in illustration, photography and design. Since 1981 he has employed mixed media to experiment with images, color and printing techniques.

"The familiar, ordinary shapes and forms in the *On Ramp* series provide a meditative, consoling perspective of something both high and low tech, banal and extraordinary. The highway is an engineering and design monument, and from a distance these images

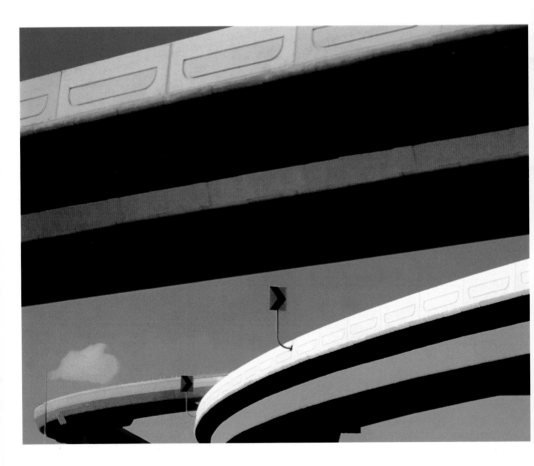

57 Reunion. Digital. 18" x 22"

are abstract. But a closer view reveals a detailed study of interpenetrating shapes and space, frozen in time, absent of movement from people, cars. Whether through pushing pigment or pixels, I want to present images that have an element of realism but drive the limit toward abstraction. I want the viewer to work a little bit, to commit and look more closely, and by doing so, get involved."

101 Horne Ave. #1111, San Francisco, CA 94118
415-822-2833 mitchellconfer@earthlink.net

Rain Lilies. Mixed media. 18" x 24"

Confer

Melinda L. Cootsona

A native of Northern California, Melinda L. Cootsona received a BFA in interior architecture from the California College of Arts and Crafts. Formerly an interior designer, she studied painting with Ted Goerschner and William Rushton. The early California impressionists influence her work. "I love oil paint. I love the gooey textures and the thick, rich colors, and, yes, the smell. Unlike watercolors, I can change any stroke at any time; the entire painting experience is dynamic. I am fascinated by time and the

Impending Storm. Oil on canvas. 36" x 36"

illusion of space. I often play with the transparency and opacity of the oil paint to achieve the feeling of layering and depth— time and space. In my work there is often a fine line between realist and abstract painting. The illusion of three-dimensional space on a two-dimensional canvas is a time honored concept that I love to explore and manipulate, creating questions in the viewer's mind."

621 Arbor Rd., Menlo Park, CA 94025
650-566-1528 www.mlcstudios.com

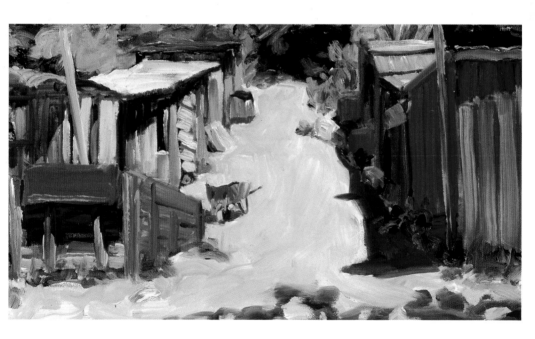

Garrod Stables. Oil on canvas. 12" x 24"

Cootsona

Claire B. Cotts

Artist and children's book illustrator Claire B. Cotts received an MFA from the University of California at Berkeley. She has lived and painted in Italy and Mexico, and in Turkey under a Fulbright Fellowship. "Places where there is an accumulation of history and stories—that inspires me. When I was young, my mother would read to me from *D'Aulaire's Book of Greek Myths.* It had a profound effect upon me and gave me a great love of pictures and stories; I think that is what led me to become an artist and a children's book

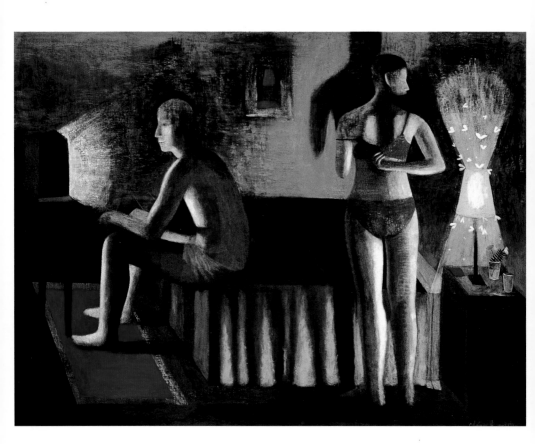

Hotel Room. Acrylic on canvas. 45" x 60"

illustrator. In those myths emotions carried such tremendous weight: envy or desire could transform into a spider, a calf, a laurel tree. It impressed me, too, that there were unseen upper and lower worlds, invisible, yet there. My own paintings are personal narratives, fragments of stories exploring ideas about relationship, vulnerability and hope."

Berkeley, CA
510-845-4174 www.clairebcotts.com

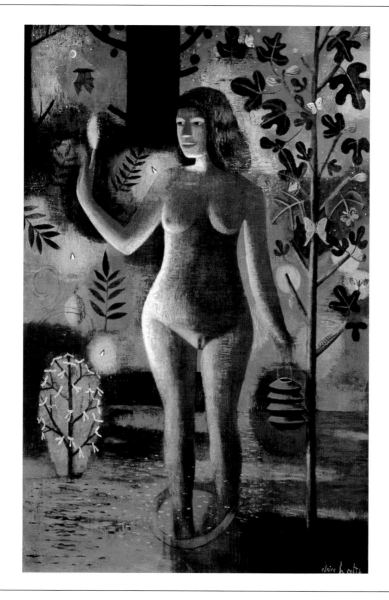

How We Find Our Way in the Dark (Intuition). Acrylic on canvas. 75" x 48"

Cotts

Maeve Croghan

Maeve Croghan received a BFA from New College of California. "My subjects are carefully chosen to convey certain emotions. The paintings are composed to lead the viewer deeply into the painting, so that they directly experience nature. As our technological society progresses we become ever more removed from the natural world, allowing people to be less caring and more destructive to the environment. I want to transcend viewers into nature through painting, heightening their awareness of our natural world. My paintings

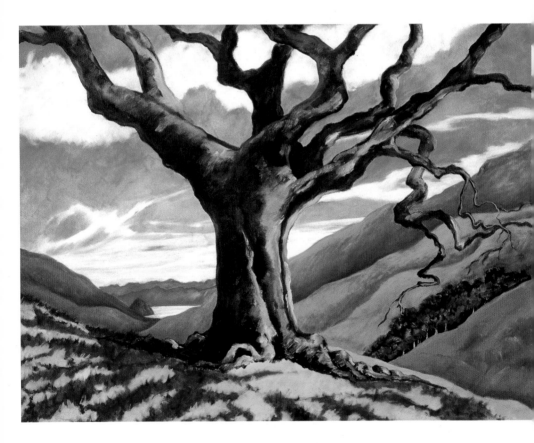

Morrow Bay Oak. Oil on canvas. 30" x 36"

are begun outside, where I find a subject to paint. I am attracted to old forms of life; aged trees, vines and rocks seem to possess knowledge beyond human understanding. Back at my studio, I work from memory and feeling. As the work evolves, it sometimes changes from the original scene, taking on its own life. The painting eventually becomes a symbol of my experience with that environment."

653 Francisco St. #2, San Francisco, CA 94133
415-775-6374 www.maevecroghan.com

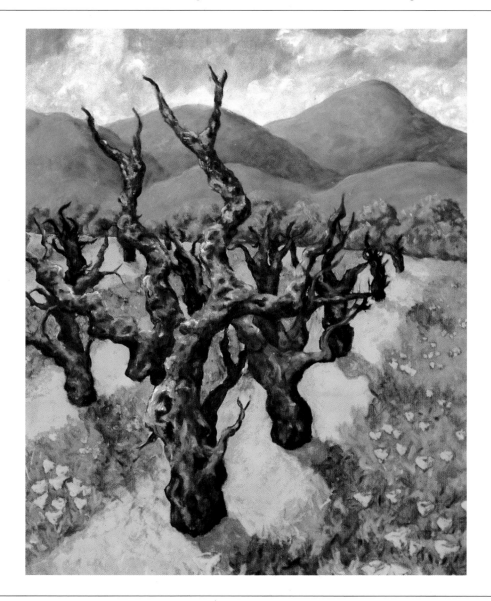

Valley of the Moon. Oil on linen. 36" x 28" **Croghan**

Sidnea D'Amico

Originally from Brazil, Sidnea D'Amico worked in photography and jewelry design before coming to the U.S. to focus on drawing and painting. "I explore the relationship between representational and abstract imagery, expanding my visual vocabulary. My process involves building a surface, then scratching away most of what was painted. As I scratch I become in touch, literally and metaphorically, with the painting. Some images survive, others are buried, and some remain large while others become more intimate in scale. Images and

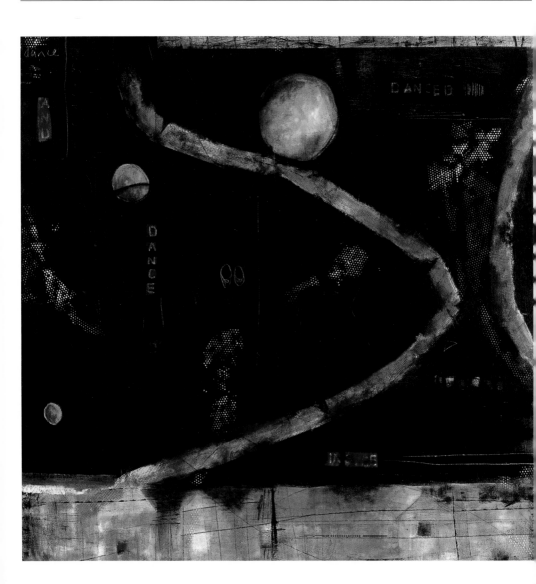

Dark Moves #2. Acrylic on canvas. 40" x 40"

ideas metamorphose unpredictably. For me painting is a matter of listening and keeping my mind receptive and truly in the present moment. I know a painting is done when I sense harmony and when I hear no sound coming from it anymore. Often, it ends in a balance of reds. Red for me is a vibrant hum, able to synthesize diametric opposites in a kind of metamorphic transformation."

1460 Golden Gate Ave. #22
San Francisco, CA 94115 415-771-8115

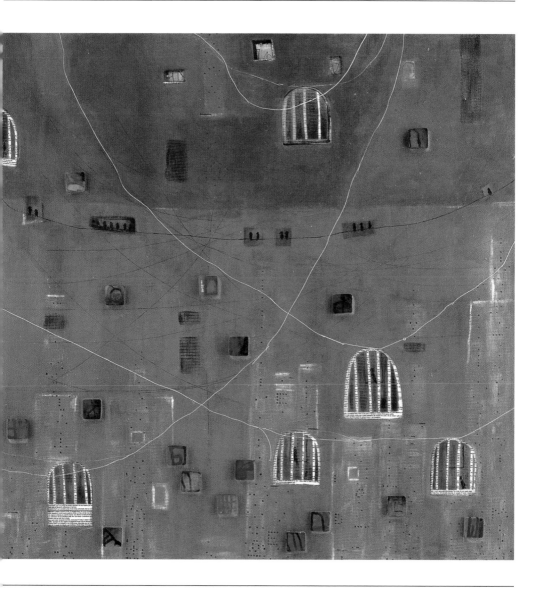

Framed Freedom #2. Acrylic on canvas. 40" x 40"

D'Amico

Karen Desjardin

Karen Desjardin received a BA in journalism from the University of Wisconsin at Madison. "Photography for me is a constantly evolving form of expression beginning with my early years as a newspaper photographer and continuing today as I explore more artistic techniques such as the use of infrared film, hand-coloring, Polaroid transfers and manipulating SX70 Polaroid prints. Whether capturing the fierce determination of a cancer victim on his way to winning the Tour de France, photographing a serene, rural Tuscan

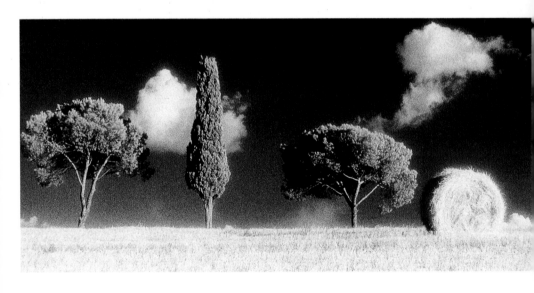

 Tuscan Trees. Sepia-toned photograph. 6.5" x 12.5"

landscape or standing in the middle of a vineyard ablaze with the color of yellow mustard, it all comes down to recording the essence of the moment or place. Much of my work in the last several years has been of European scenes, landscapes and architecture. Having moved to the Sonoma County wine country, I am also working on applying the same vision closer to home."

Santa Rosa, CA
707-537-7617 www.karendesjardin.com

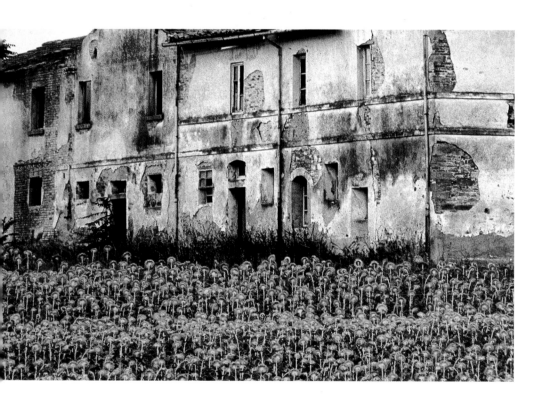

Cortona Ruins. Sepia-toned, hand-colored photograph. 8.5" x 12.6"

Desjardin

Deborah Eddy

Deborah Eddy received a BA from Pennsylvania State University. She has been drawing all her life and painting with pastels since 1987. "My art has always focused on the spirit of the land, the trees and rocks, and the sky and clouds around us. I also love the beautiful lines, forms and colors found in the natural world. My vision is to create work that awakens our ties to the earth. All of my paintings are done on location in chalk pastel and are composites of the days spent at each site. The strong elements within the pictures

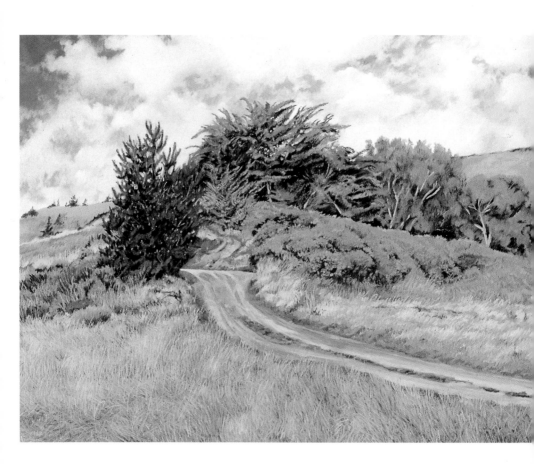

 The Road to Yellow. Pastel on paper. 19.5" x 25.5"

are revealed by the sun as it moves across the sky. Many of the scenes I choose to portray are the ordinary places around us that we sometimes take for granted or fail to see. Others are 'endangered landscapes' threatened with alteration or destruction.

I hope to cause the viewer to feel present at these places, to discover and experience them for the first time."

P.O. Box 363, Soquel, CA 95073
831-476-8341 eddyart@earthlink.net

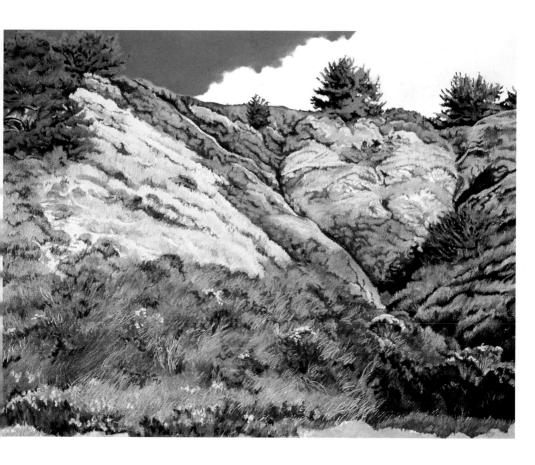

Canyon near Greyhound Rock. Pastel on paper. 19.5" x 25.5"

Eddy

Anna W. Edwards

Anna W. Edwards has studied art with Takeshi Nakayoshi since 1993. "The sights and sounds of the city weave a distinctive tapestry of color, texture and geometry throughout my work. The urban landscape is my focus, because cities have always held a special fascination for me.

Cities provoke memories and feelings from an earlier time of traveling with Grandmother Edwards up and down the East Coast. Walking city streets connects me with a timeless energy that I endeavor to impart in my paintings. I wish to give the urban landscape an energetic

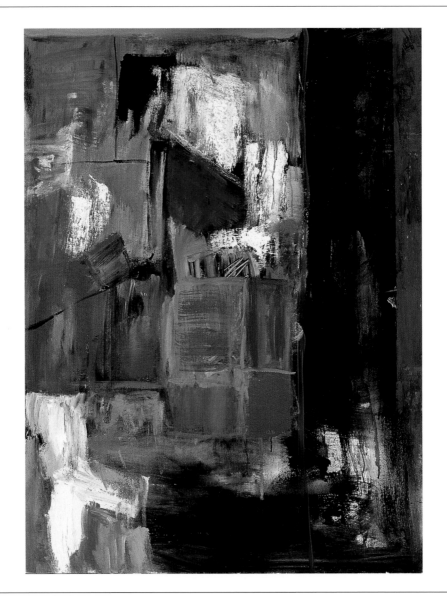

St. Nicholas Terrace. Mixed media on canvas. 48" x 36"

and personal quality. I don't give a literal rendering of known places but an ephemeral sensation of the sights and sounds I feel as I paint. I want my art to bring a dimension to the viewer of what a 'cityscape' can be. I want the viewer to spend time with the work and allow it to challenge the imagination, to feel the sights and sounds one feels visiting a city for the first, fourth or fortieth time."

P.O. Box 952, Oakland, CA 94604
510-636-1721 www.annawedwards.com

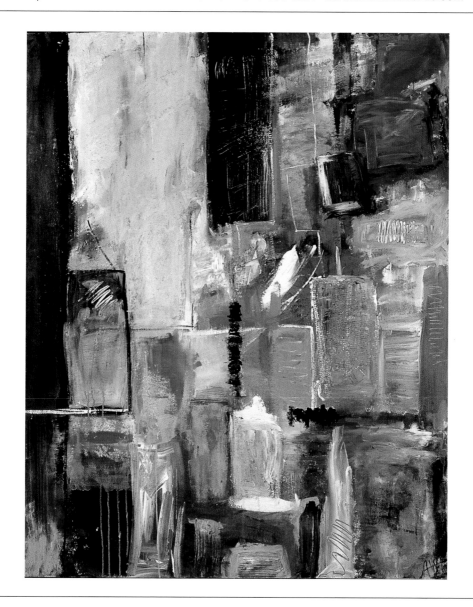

Midtown '99. Mixed media on canvas. 60" x 48"

Edwards

Karen Ruth Evenson

Karen Evenson received a BA in art history from the University of Oregon at Eugene. "Contact with medieval art convinces me of the power of symbolism in artistic imagery. I compose still lifes as iconic cruciforms that contain form and frame. Beyond these confines lie objects that symbolize other realms of existence and other dimensions of time and space. My works are layered over time with natural and found objects, paint and photographs of different generations of the pieces of the final image. Through this process

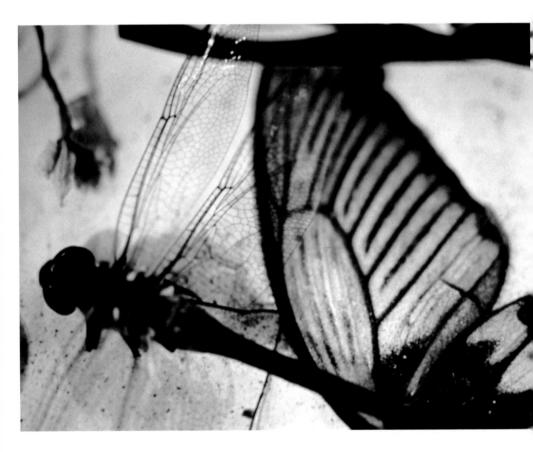

Resonance. Split-toned, silver print. 11" x 14"

of picture within picture and frame within frame I hope to begin exploring the nature of the experience of life. Time's passage through the living work and through our consciousness is envisioned in the imagery of these series. I am exploring the afterlife of beings who inhabit the skies, the seas and the land. These beings are given a mythology in human thought, and so take on power in our daily experience."

5685 Carberry Ave., Oakland, CA 94609
510-420-1572 krephoto@earthlink.net

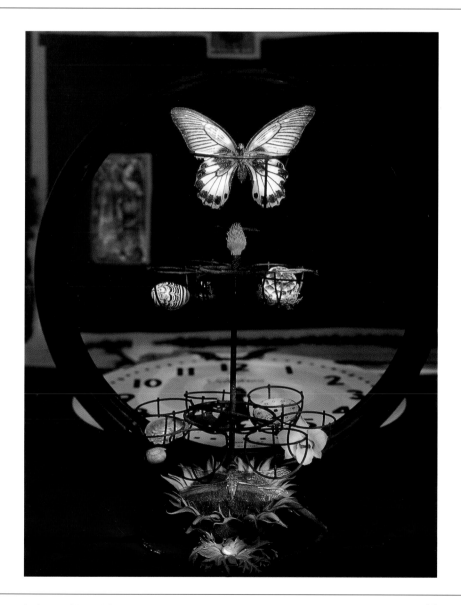

Sunflower's Inner Circle. Ilfochrome photograph. 20" x 16"

Evenson

Richard Feese

Richard Feese received an MA in art from Sacramento State University, where he is currently a faculty member. "These works represent segments of my life and are statements of my identity. They also reflect my concern about a diminishing environment.

If I choose an image of a living creature, it is to honor it. I have also made maps of my travels and self-portraits. All are part of the stream of my life; the choice of an image is connected to past works, works in process, and will connect to my work in the future. I use mostly recycled

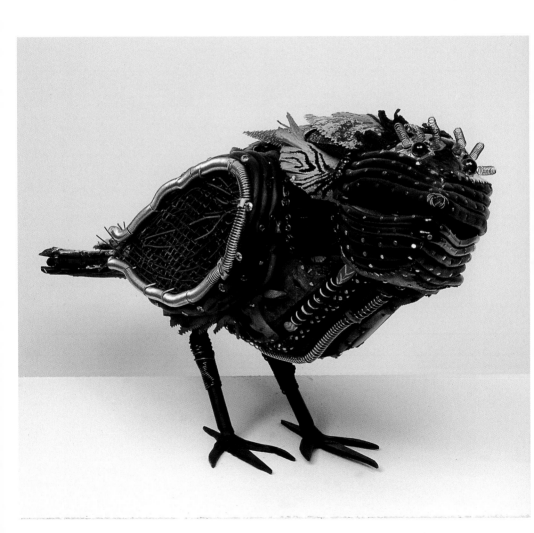

Death Valley Raven. Mixed media. 12" x 31" x 8"

materials and found objects. The contrast between subject matter and materials used can be an example to others of the importance of being conscious consumers of the materials Mother Nature produces, along with a reminder of the beauty and wonders of living creatures.

If there is a population of healthy species on the planet, we will have a healthy planet."

4905 U St., Sacramento, CA 95817
916-455-5591 fishfeese@hotmail.com

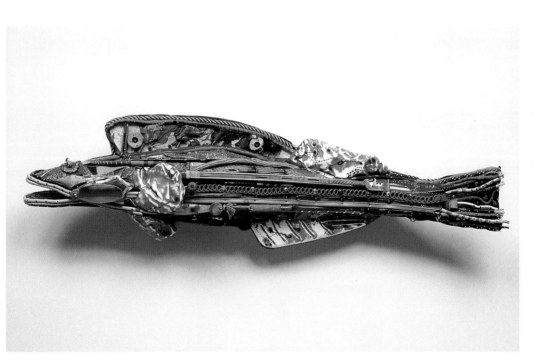

Greenling. Mixed media. 11" x 40" x 8"

Feese

Egon Fjortaj

Formerly a commercial designer, Egon Fjortaj has worked as a fine artist since 1999. "Much of my training consists of research, trial and error (and more error). Having experienced perpetual creation of superficial images as a commercial designer, I was determined to plumb the deep realm of visual art as a fine artist. Contrary to the surface water where lucid creatures are nurtured by the sun, in the darkness of the abyss the creatures of unearthly shapes must create a glow of their own to guide them. My primal urge to develop

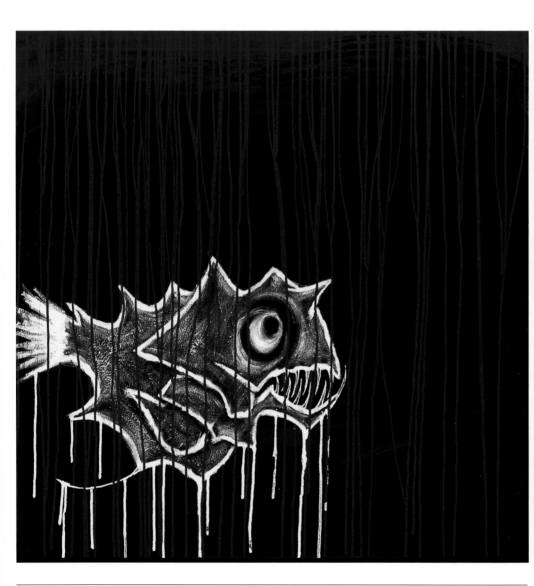

Heavy Water #2. Acrylic and dry pigment. 36" x 36"

a path-finding light from within is realized through the binding of elements with both raw and synthetic media. Elements of an infinite spectrum are all around us as a basis for art. An artist's conception as a free thinker and action as a binder create an ascending agitation from an undercurrent that enriches not only the abyssal realm, but also the static surface layer."

1375 21st Ave., San Francisco, CA 94122
415-412-5705 www.egonfjortaj.com

Rope #5. Mixed media. 48" x 48"

Fjortaj

Tom Fowler

Tom Fowler apprenticed to landscape painter Bob Gunitson and studied at the Colorado Institute of Art and the San Francisco Art Institute. He has worked as a graphic artist and as a social worker in a homeless shelter. "As an artist I search out small explosions—the aesthetics of the conversion of liquids to solids, images of nature in transition, that sublime, fleeting moment of creation and destruction. God supposedly created the universe using oxygen, hydrogen and some carbon. I attempt to tap that same primordial energy through the

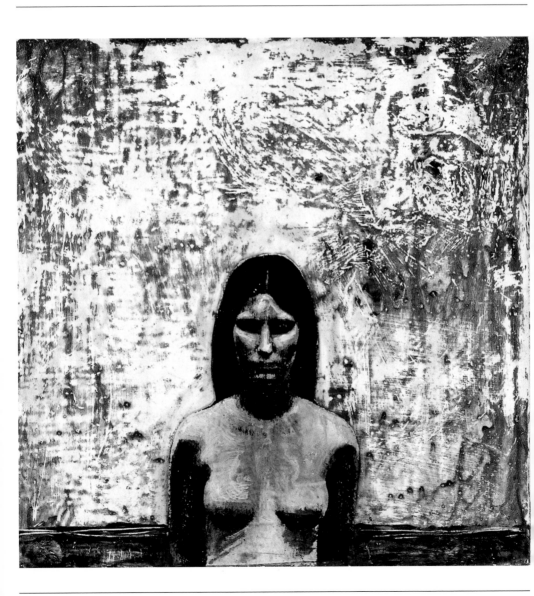

Study of Eve. Oil and wax on canvas. 12" x 12"

use of oil paint, house paint, beeswax, industrial solvents, roofing tar and collage. The alchemy of materials leads to chance encounters that reveal the inherent beauty and form of the physical world. I try to let the paintings create themselves by getting out of the way and allowing the materials, gravity and random accidents do the work. I bear witness to God's small explosions."

151 Potrero Ave. #4, San Francisco, CA 94103
415-695-0119 tomdraws@yahoo.com

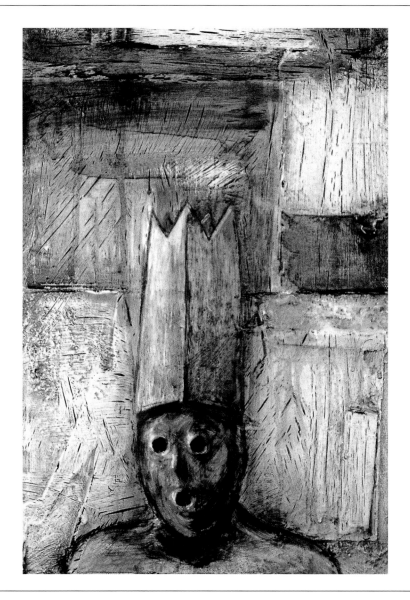

Study for Whipping Boy. Oil and collage on canvas. 11" x 8"

Fowler

Jennifer Foxley

Originally from Omaha, Nebraska, Jennifer Foxley received a BA in environmental design from the University of California at Berkeley. She cites architecture as influencing her work, which she describes as a process of building pieces in a series of layers. "I work with the materials intuitively in collage fashion. My subconscious is able to take the lead when I work this way. I use found objects and scraps left over from other endeavors in this series, as well as objects from the natural environment including hornet's nest paper, limestone rock

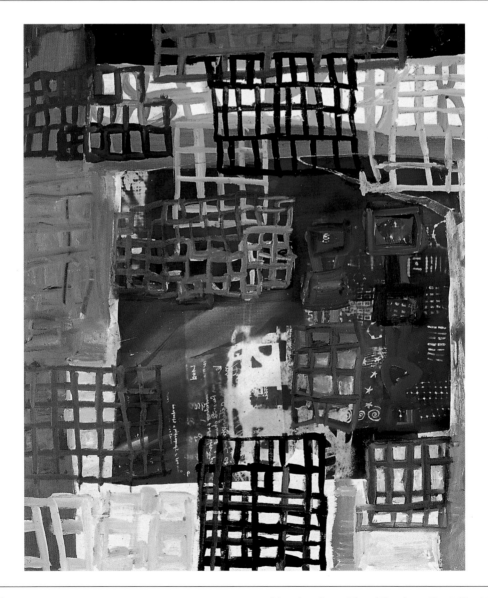

Hopskotch on Blue. Mixed media. 24" x 20"

and rust particles, which I mix with acrylic gel. I also incorporate patterns, which are shapes and forms culled from my subconscious, on the pieces. Serendipity, stream-of-consciousness and intuition are the vehicles I use to access the space and place of creating. It is through the process of making art that I find free reign for my curiosity and explorative tendencies."

3206 Boise St., Berkeley, CA 94702
www.foxleystudio.com

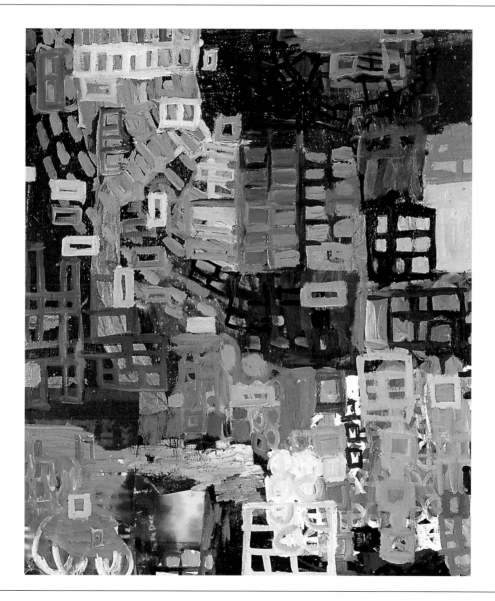

Jasper Charm. Mixed media. 24" x 20"

Foxley

Michael Fram

Michael Fram received a BA in art from California State University at Northridge, and has worked as a graphic artist and candle maker. "The San Francisco Bay Area is my home and sometimes the inspiration for my paintings. I often carry a sketchbook and draw from nature, but am most interested to work freely from memory and impulse, in order to create a fresh vision in the studio. My paintings are generally about human activities; at times I indulge in fantasy and humor. In the most recent work human presence is suggested

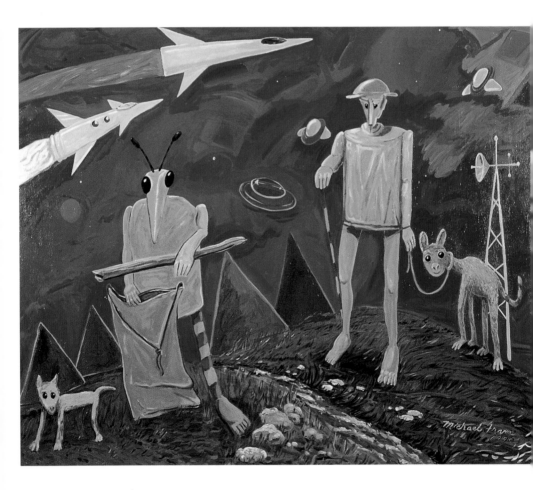

Early Spring. Acrylic on canvas. 51" x 62"

ather than directly revealed. The pictorial realm, separate from the everyday world, is a place we can go beyond our immediate experience. It is refreshing in its ability to lead us to see things differently. I'm confident that, in spite of the apparent excitement and bustle of technological society, the hand-painted image continues to have enduring value in conveying the spirit of mankind."

5212 Shattuck Ave., Oakland, CA 94609
510-655-0871 mfram@earthlink.net

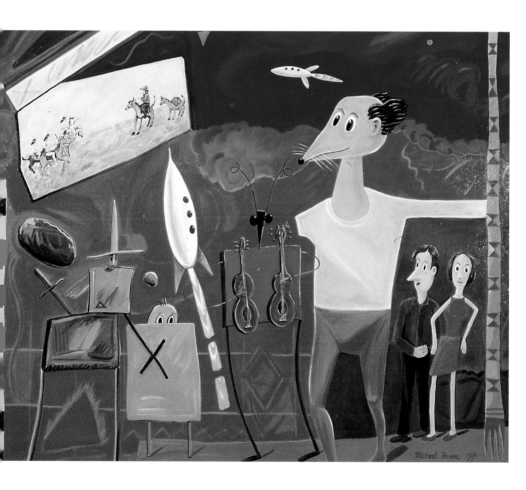

Pancho Villa Meets the Mouse Man. Acrylic on canvas. 51" x 62"

Fram

Elaine Frenett

Landscape painter Elaine Frenett received a BS in graphic design from San Jose State University, and offers handcrafted bookmaking, illustration and watercolor presentations. "My intrinsic attraction to nature has channeled both my choice of media—watercolor—and subject matter—landscapes. The earthiness and spontaneity of media and subject mirror one another. I relish working loosely with rich, deep values, yet enjoy the precision of detail. Always, what stirs my need to paint an image is the intense response I feel, and from there,

Sedona Drama. Panel 1 of Diptych. Watercolor on paper. 16.5" x 39

must capture and share it with my audience. For me the relationships evident in the ecosystem or just in the architectural design of a flower reveal a fragility and strength much like the human spirit. That is why I find such a recharging element in spending time in or painting the natural spaces around us. I believe my unconscious motivation is to reconnect our human spirit to that of nature."

San Jose, CA 95125
408-450-1630 www.elainefrenett.com

Columbines. Watercolor on paper. 40" x 25"

Frenett

Todd Friedlander

Originally from Great Falls, Virginia, Todd Friedlander received an MS in architecture from the University of California at Berkeley. He now practices architecture in San Francisco. "I can remember every photograph I have taken in its own context. I remember what I was doing when I decided to frame and snap the photograph. Photography has the power to suspend time, a fact we all know and use. What I ponder is how my subjects may change in the time following the photograph. A tree dies, a building is razed,

Lake Wenatchee. Chelan Lake, Washington. Photograph. 8.5" x 11

a hilltop is flattened for houses. Landscape photography is a reflection of whatever landscape you find yourself in. I am just as comfortable taking a photo in a national park as taking a photograph in a condemned building. My goals are the same—to photograph these places standing in silent austerity before being changed forever."

136 Duncan St., San Francisco, CA 94110
415-244-4259 www.toddfriedlander.com

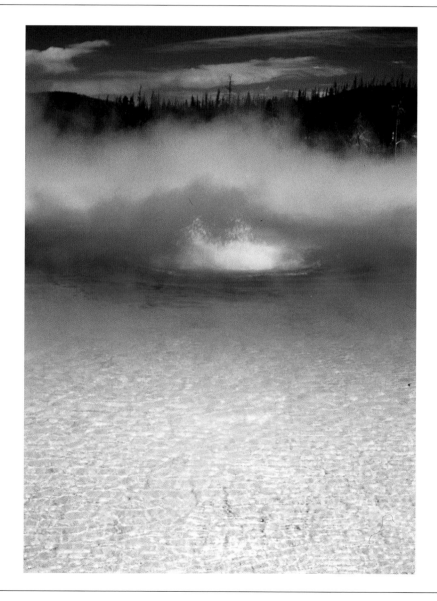

Geyser. Yellowstone, Wyoming. Photograph. 11" x 8.5"

Friedlander

Alice Gibbons

San Francisco native Alice Gibbons has been a visual artist since 1963, and studied printmaking at the San Francisco Art Institute and drawing at the Academie de la Grande Chaumiere in Paris. She is a member of San Francisco Women Artists, the Graphic Arts Workshop and the California Society of Printmakers. "My works are representations of urban and rural landscapes in California, particularly San Francisco. I am fascinated by the things people use, and places where they live. These scenes of country and city are, to

Opening. Etching. 4" x 5"

me, portraits. Instead of portraying people I portray their environment. People influence their environment, while at the same time their environment influences them. My prints are mostly black or sepia etchings. I choose this media to focus on mood, tone and detail, with the intention of depicting a world that the viewer and I can experience."

1420 Turk St. #309
San Francisco, CA 94115 415-929-2278

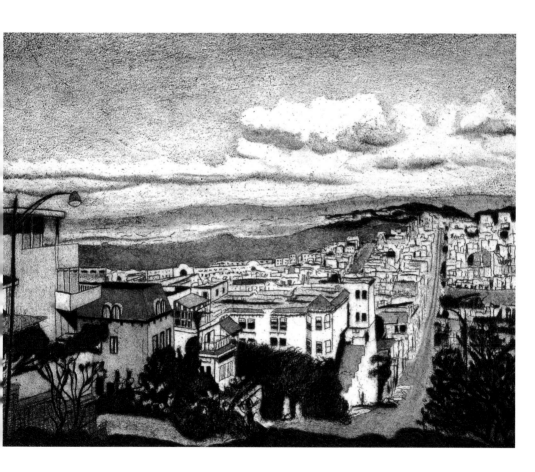

Down Lombard Street. Etching. 4" x 5"

Gibbons

Katie Gilmartin

Katie Gilmartin received a Ph.D in American Studies from Yale University. She teaches printmaking at SOMARTS in San Francisco and is co-owner of City Art Cooperative Gallery, a gallery devoted to emerging artists. "I valiantly attempted to embody the anguished, suffering artist, but chronic backsliding forced me to resign myself to a life of delight and abundance. My work honors the redemptive power of pleasure with images that celebrate mirth, ease and lust. These are our birthright and, in a just and therefore peaceful world,

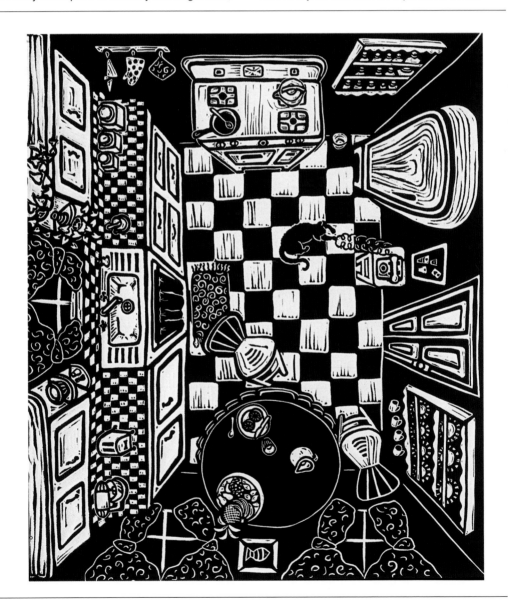

Sunday Morning. Linocut. 13.5" x 12"

would be available to every one of us in abundance. It was the search for bliss in my day-to-day life that led me to become a printmaker, and I believe my art reflects the fact that it is conceived in pleasure and meant to provoke the same. My next major project is the Fun Institute, a research establishment devoted to the serious study of the causes, nature and rampant propagation of fun."

828 Valencia St., San Francisco 94110
415-970-9900 www.katiegilmartin.com

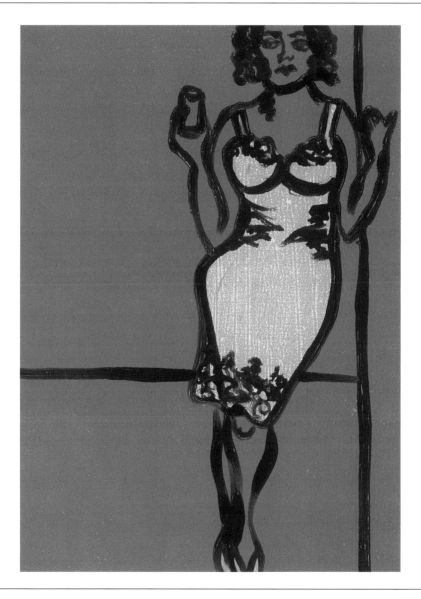

Bourbon, 2 AM. Monotype. 12" x 9"

Gilmartin

Wendy Goldberg

Wendy Goldberg received a BFA from Cornell University and an Individual Artist Grant from the Marin Arts Council. "Mystery, secret corners, unfoldings and the how and why intrigue me. The natural world entices, draws me in. My work ranges from small intimate pastels to larger drawings, monotypes and paintings. Most are portraits of a particular place or time of day where and when the shadows are deep and the light is intense, peculiar or limited. Because I attempt to describe or portray a sense of place, a

Studio View: Winter. Chalk pastel. 4" x 8"

moment in time, rather than draw the smaller details that often comprise a scene, the forms tend to be semi-abstract or impressionistic. If I am able to translate some of the spirit of place that I feel as I look and draw, to recreate even a taste of the scents that drift through and the feelings of moisture and light, the mystery or uniqueness of a place, then I feel I have succeeded."

Fairfax, CA
415-454-9397 bluelights@earthlink.net

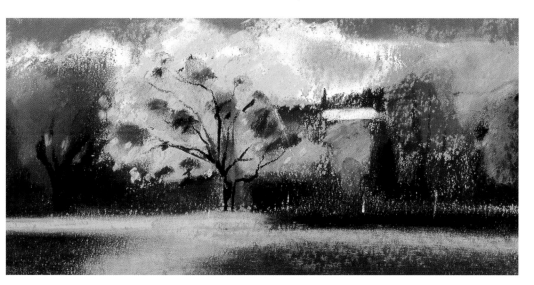

Ignacio Valley. Chalk pastel. 4" x 8"

Goldberg

Nemo Gould

Nemo Gould received an MFA from the University of California at Berkeley. He focuses on kinetic metal and wood sculpture. "Pairing obsolete common goods with a unique sense of form, I discover new-found life in the daily detritus of our consumer culture. As I look to my creative values, I find them as ambiguous as American culture. Biblical stories and cartoons are the same kind of fiction to me. Through the kaleidoscope of popular culture, these icons lose their distinctions of high and low. The moral current of an epic tale is lost in

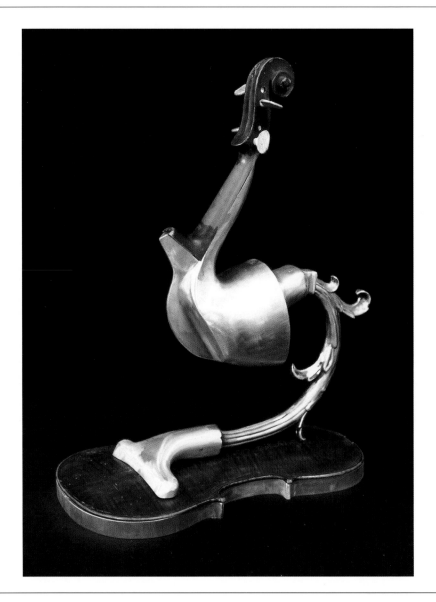

Solution for Violin. Mixed media. 18" x 14" x 8"

an advertising scheme, celebrities return from the grave to sell vacuum cleaners. In this country we often confuse our spiritual hunger with simple boredom. We eat when we are not hungry, we work to buy things we do not need. The result is overflowing landfills and lost souls. Through the archaeological study of our own age, the beauty and humor of our fractured culture is unearthed."

2525 LeConte St. #5, Berkeley, CA 94709
510-845-4724 www.nemomatic.com

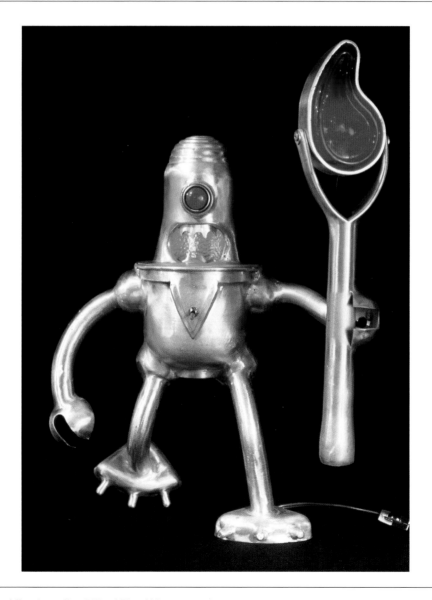

Cyclops. Mixed media. 16" x 15" x 11"

Gould

Ralph S. Greco

Originally from the Bronx, Ralph Greco is a professor and chief of general surgery at Stanford University. He is also a scientific writer and a surgical research scientist holding six patents. Dr. Greco studied sculpture with Lilli Gettinger at the Princeton Art Association, and has produced representational, figurative and abstract works in stone and wood. "The intersection of sculpture and surgery is a place where tension reigns—one is beautiful, the other beneficial. Each requires a skill that can be learned, the one requiring imagination, the

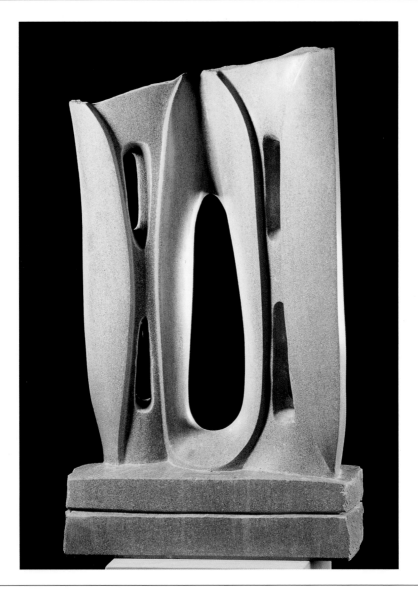

Cezanne's Landscape. Limestone. 38" x 18" x 8"

other, judgment. Sculpture is about creation; surgery is about destruction and re-creation. Flesh is warm and tolerant, stone cold and unyielding. The two consume my days, my nights, my reveries and my dreams—but sculpture is more soothing, more lasting, more the stuff of contentedness. But sculpture is alone, surgery connected to others. The contradictions are unavoidable and inevitable."

Palo Alto, CA
grecors@stanford.edu

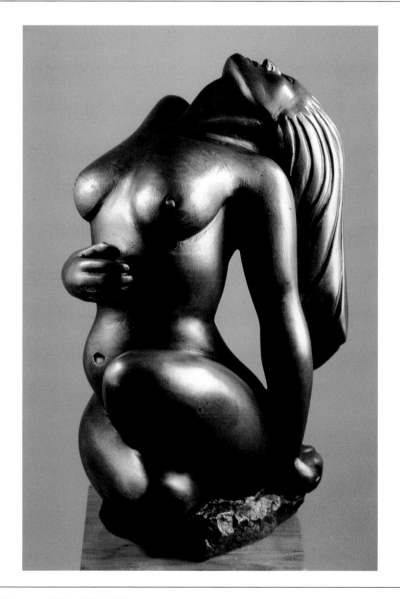

Expectancy. Bronze. 25" x 14" x 12"

Greco

Jane Grimm

Jane Grimm received an MFA from the California College of Arts and Crafts in Oakland. "I want to influence the viewer's preconception of what ceramic sculptures are, so they understand that clay is not necessarily synonymous with function or kitsch. I use the seductive qualities of the ceramic medium of color and surface to attract the viewer's attention. 'What is happening here? What are the objects made of?' In the *Evolution* series, I focus on the effects of internal and external forces on objects. Through freeze frame

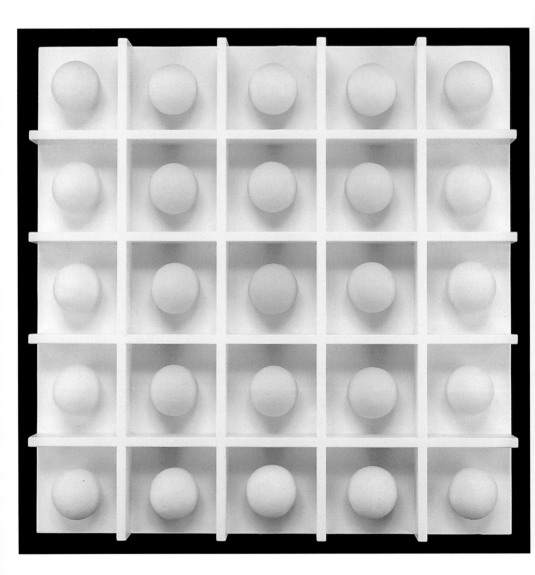

Vortex VI. Ceramic and wood. 27" x 27" x 3"

sequence, the evolution of objects in a storyboard format is explored. Some pieces come alive through apparent animation. The work appears organic and therefore lends itself to being presented in display cases reminiscent of those used for scientific specimens. The boxes, aside from serving a useful function of protecting the fragile ceramic objects, are used to give importance to the sequences."

San Francisco, CA
415-922-2823 jbgrimm@pacbell.net

Jacob's Ladder II. Ceramic and wood. 37" x 3" x 3"

Grimm

Marc Ellen Hamel

Marc Ellen Hamel studied at the University of Washington and the University of California at Berkeley. "My paintings are mental landscapes or visual stories. Intense color, compositions of space and suggestive shapes manifest places or moments in time on the surface of a canvas.

A painting is a visual story and messy, malleable, colorful oil paint is the medium that works for me in finding and telling this story. I start with simply a desire to use a particular color or see space broken up in a certain way and the painting grows from there.

Paean. Oil on canvas. 36" x 24"

While working I recall places I have been, geographically or emotionally, but this time I am in charge of how things look. Actually, it's a collaboration; the paint is often in charge, but I have the final say. At the end of the process a 'place' becomes manifest in the painting and represents me; it's proof that I exist. The point is to create an image only you can make and it becomes the representative of your world."

3723 24th St., San Francisco, CA 94114
415-643-7814 hamel-klimek@sbcglobal.net

Elysian Fields. Oil on panel. 46" x 40"

Hamel

Cynthia Hamilton

Cynthia Hamilton received a BFA in illustration from the Academy of Art College in San Francisco and was a computer graphics animator and art director, working on PC and video games in the early days of game development. She studied painting in workshops with Craig Nelson, Ralph Oberg and Matt Smith, and is a member of the California Art Club and the Pastel Society of the West Coast. "After ten years in the computer game industry, I returned to the more traditional genre of pastels, and more recently,

China Camp. Oil on canvas. 9" x 12"

oil painting. An outdoor enthusiast awed by the incredible beauty of the California landscape, I found that *plein air* painting combined my passions for being outdoors and painting. I strive to capture the emotional response and mood of a landscape, rather than rendering every detail. My finished pieces are loose, painterly impressions of the beauty of nature."

216 Yarborough Ln., Redwood City, CA 94061
650-366-6650 cynthia_hamilton@yahoo.com

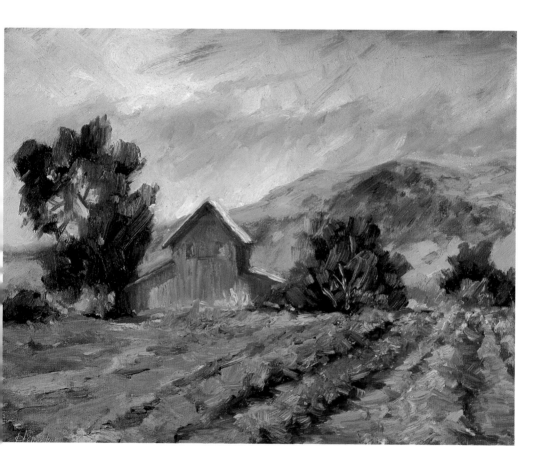

Gilroy Ranch. Oil on canvas. 11" x 14"

Hamilton

Ed Hamilton

Ed Hamilton received a BA in fine arts from Seattle University, and in 1997 left a career in the computer industry to make photographs full time. "I developed my feeling for the desert landscape from motorcycle touring. Through workshops at Joshua Tree, Death Valley and Mono Lake I discovered night photography as a means of expressing some of those feelings in my imagery. I look for my subject matter in the desert, mountains, water or on city streets. But for me, finding photographs is largely a state of mind. Many of my photographs are

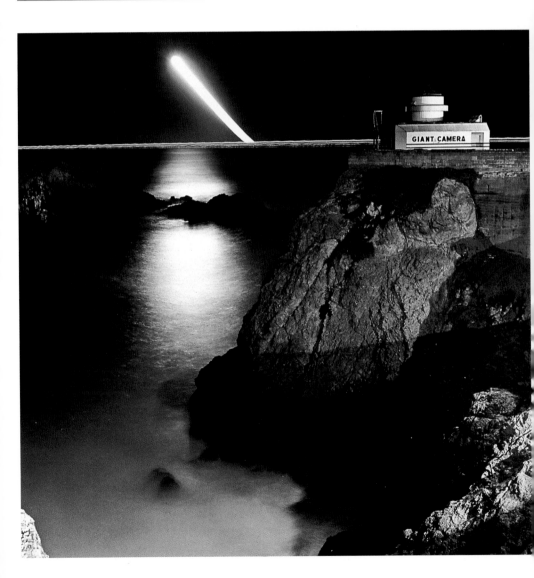

Giant Camera, San Francisco. Silver gelatin print. 9.5" x 9.5"

taken at night or in the low-light hours of morning and dusk. The night photo is not so much a record of time and place, as about what happens over a period of time. In this setting, the amazing and unexpected can happen, and often does. I want the final image to convey a sense of the fun and mystery that I experienced."

San Francisco, CA
415-647-3111 edwham@attbi.com

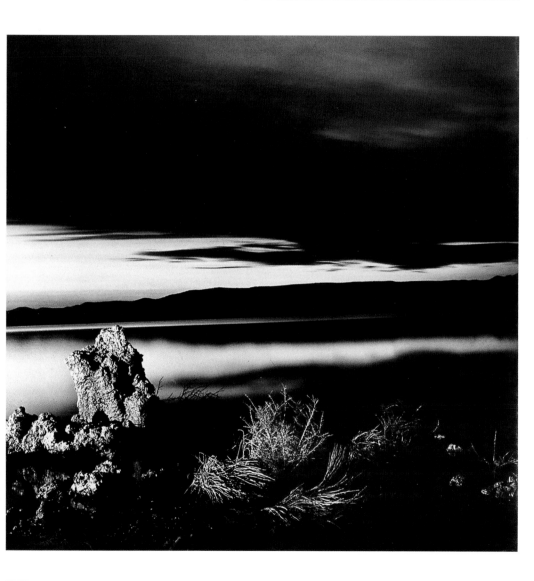

First Light, Mono Lake. Silver gelatin print. 10" x 10"

Hamilton

Nils Volkmar Hammerbeck

Born in South Africa, Nils Hammerbeck divides his time between residential architecture and artistic photography. "The images and ideas of Extractionism have evolved from hobby to passion over the past eleven years. The work has two branches: the art of Extractionism is based on the tenet that the camera allows for the abstraction of reality, simply through the extraction of an area from its context. The images bridge the gap between abstraction and reality. The products of Abstract Extractionism, on the other hand, are seen as

The Art of Extractionism, Image #40. Crimped sheet metal. 30" x 20"

paintings created out of serendipity and chaos, rather than consciousness. A single image of Extractionism is simply mirrored on itself once, twice, or more, or rotated. The results are fascinating patterns that are equally real and imagined. I feel that nature and its forces in our world cannot be improved upon; whether we can see that as fact is one of the important questions of our time."

311 Durham Ct., Danville, CA 94526
nils@extractionism.com

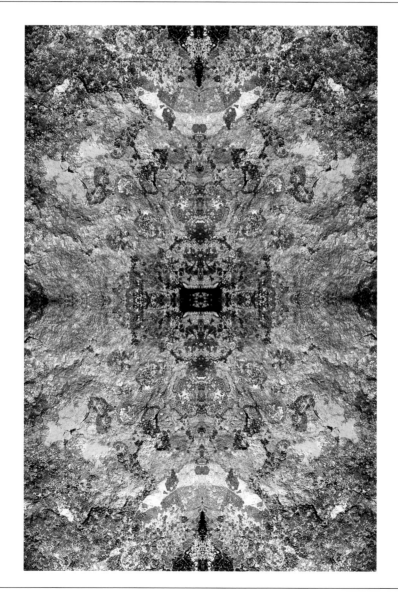

Abstract Extractionism. Black lichen on volcanic rock, mirrored. 20" x 13"

Hammerbeck

Fain Hancock

Fain Hancock received a BFA and MFA from the California College of Arts and Crafts in Oakland. "What is learned about the experience of being female and what is innate? Where in our consciousness and our body is this information stored? And is it wrong to want things to look beautiful? My pieces explore these topics. Growing up in Texas, I was often told to be ladylike yet strong and independent. These pieces examine some of the possibilities that being ladylike might offer: beauty, femininity, ripeness and especially the aspect

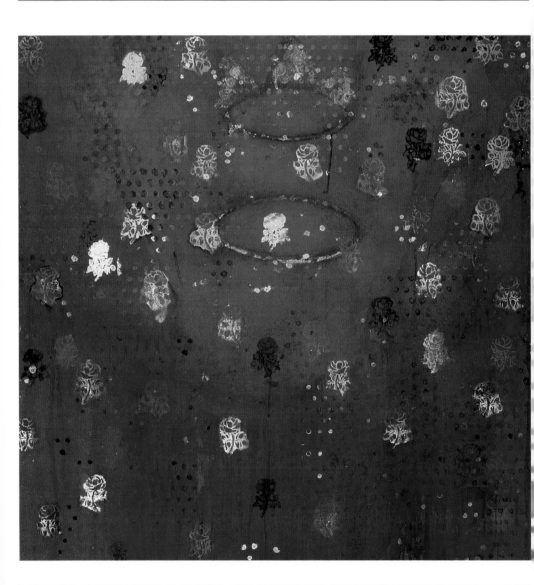

First Runner-up. Oil, gold leaf on canvas. 36" x 36"

of visual appeal. My complex, layered surfaces indicate a sense of patience and of precious time passing waiting for something to occur. These paintings function both as emotional landscapes and a record of thoughts forming. Often the titles are quotes from my mother and other women relatives who, above all else, encouraged me to be ladylike."

Napa, CA
707-257-6082 fainh@earthlink.net

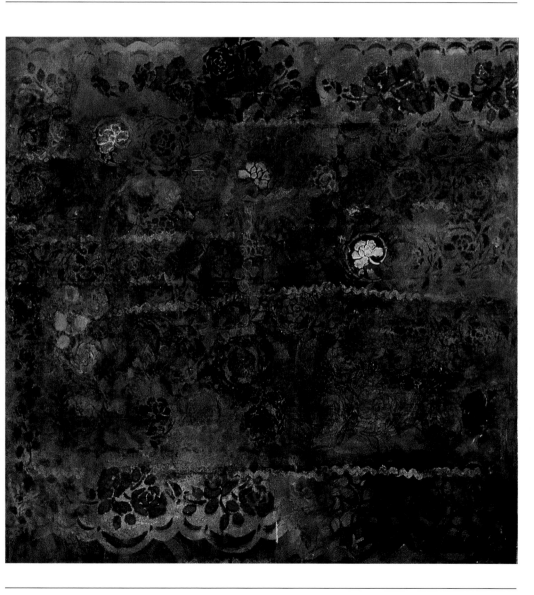

In Grandma's Sewing Room: Notions, Rickrack and the Secret Storm. 36" x 36" **Hancock**

William Harsh

William Harsh studied painting with Philip Guston and James Weeks at Boston University. "From imagination and memory, I draw in thick oil paint, constructing forms to expose the emotive power of physical, tactile imagery. Through many reconfigurations of what first emerges on canvas, intensities of color and movement arise. Jerry-rigged assemblies, sometimes fortress-like in appearance, get built up and 'set' in ambiguous spaces. Mix-ups in 'representation' occur. If all goes well, space becomes alive in its

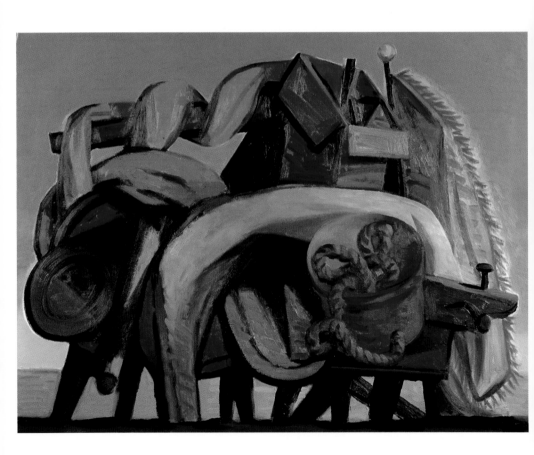

Thirst. Oil on canvas. 32" x 42"

compression, ordinary objects become mutable, and unnamable forms adopt the authority of 'thingness.' Estrangement compels the surprise necessary to finish a picture. The whole ensemble becomes a curiosity, the way driftwood piled high on a beach or junk piled up in a studio corner can suggest a drama. A finished picture must feel at least as real as an unexpected or dismantled monument."

701 East H St., Benicia, CA 94510
707-745-8501 www.williamharsh.com

Assortment with Clothes and Tree Stump. Oil on canvas. 34" x 45"

Harsh

Wynne Hayakawa

Born in Chicago, Wynne Hayakawa received a BA from the University of California at Santa Cruz and an MFA from the University of Massachusetts at Amherst. "I paint spaces that don't exist in the real world. I am hoping for a vibration of color that will resonate within us. I am hoping to make a space that we can enter and stay in for a while. I try to create a space where we, the viewers, can exist for a while, apart from the chaos of daily life. In my paintings, colors and shapes create abstract spaces. Some pieces are recognizable

Ridge. Oil on canvas. 44" x 36"

landscapes. Other pieces are stripes of multi-layered color—the stronger the color, the more dense the space. I paint in oil because I find oil paint beautiful. The other technique I use is monotype, a hybrid of painting and printmaking. I paint on a smooth surface, and transfer the pigment to a piece of paper with pressure."

San Francisco
wynne@netwiz.net

Pond. Oil on canvas. 36" x 44"

Jonn Herschend

Originally from Branson, Missouri, Jonn Herschend began painting and drawing in childhood and received a BA from Boston University. He taught high school English in San Francisco for many years and in 2002 was artist-in-residence at the Fine Arts Museums of San Francisco. "I was raised in a midwestern amusement park, and have always been interested in how the real and the unreal interact. I believe that we seek entertainment and art as a way to escape and to acknowledge our reality, and that even in

Russian Novel. Oil on canvas. 48" x 66"

this escape there is a tension because we know what is real and what is not. Through narratives, I try to explore this tension in my paintings. I want things to be pleasing but also a little off-kilter. The tension should exist in the interaction between the viewer and the painting as well as within the painting: the characters, objects, scenery, mood and even the paint itself. Nothing should be completely static."

San Francisco, CA
415-861-8416 www.jonnherschend.com

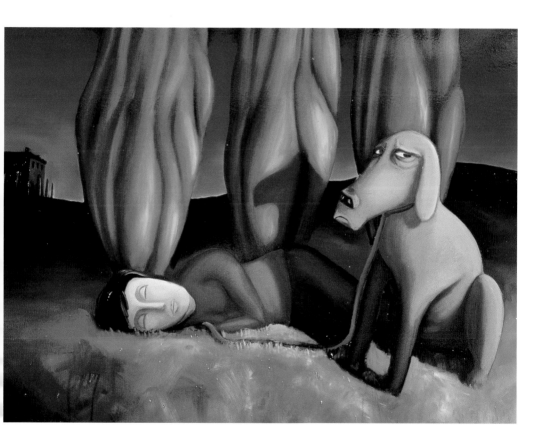

The Last Night at the Villa. Oil on canvas. 48" x 66"

Herschend

Anthony Holdsworth

Anthony Holdsworth studied at the San Francisco Art Institute, Stanford University and the Bournemouth College of Art in England. "The urban landscape is an accurate and disquieting testament to our common human condition. I encounter it first-hand working in the neighborhoods, industrial areas and downtown. Though sometimes devoid of people these cityscapes emerge from my interaction with passersby and inhabitants at each site. My paintings are oil on canvas and vary in size from one-foot to twelve-foot

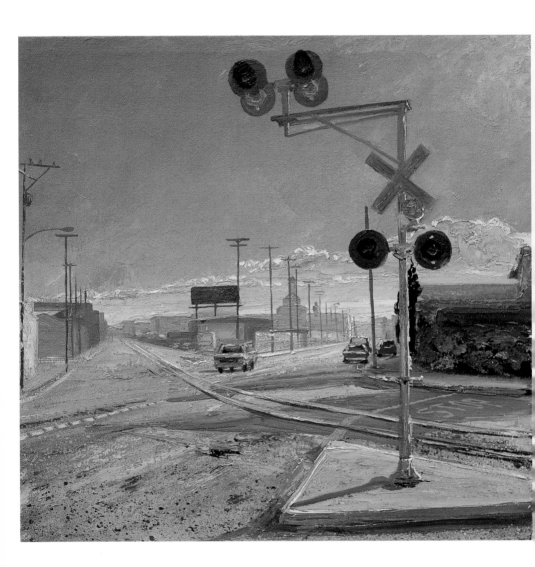

At the Crossing #2. Oil on canvas. 18" x 17"

square. The largest works are painted in my studio derived from studies created on location. Color theory, particularly the three-dimensional nature of color as presented by theorist Faber Birren, provides a foundation for my work. I combine lighting and details from different times of day to subliminally convey the passage of time."

Oakland, CA 510-836-1681
www.anthonyholdsworth.com

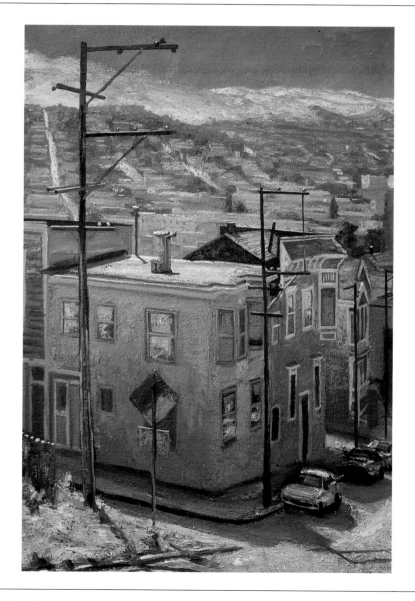

Bernal Heights Series #16. Oil on canvas. 25" x 18"

Holdsworth

Timothy Horn

Originally from Yellow Springs, Ohio, Tim Horn received a BFA from the Cooper Union School of Art in New York City, and worked in New York for graphic design firms. He later studied furniture making at City College of San Francisco, and for years made clocks and medicine cabinets from salvaged materials. Since 1998 Horn has focused on *plein air* painting. "Once, while I was painting the backs of some old, run-down buildings in an alleyway, a woman walking by said, 'I wish I had your eyes. You see beauty in things that are

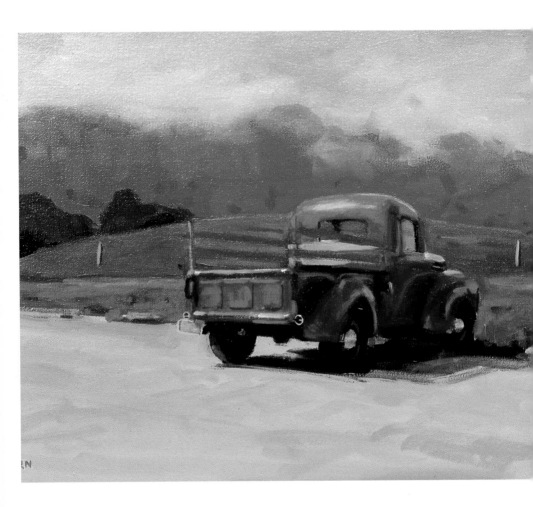

Red Truck, Route 1. Oil on canvas. 11" x 14"

normally considered ordinary or unattractive.' I had been watching that scene for about a year, and by that time couldn't imagine painting anything else. I'm forever drawn to the landscape as subject matter, but find it most interesting with an old structure or vehicle in context. It helps create a sense of history or narrative, something that people are more able to relate to with their life experience."

34 Spruce Rd., Fairfax, CA 94930
415-454-4780 www.horndesign.com

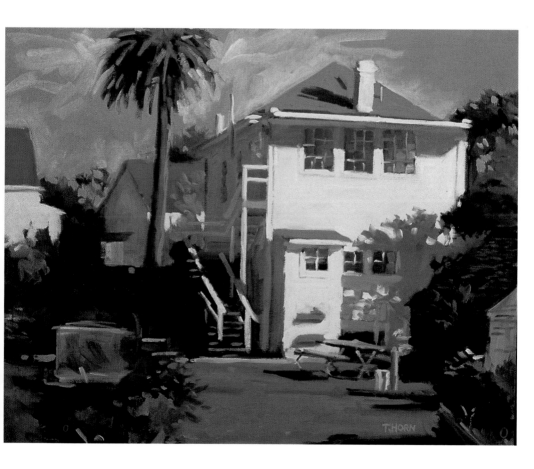

The Garden House. Oil on canvas. 16" x 20"

Horn

Anne Howson

Anne Howson was born in Detroit and has lived in California since 1968. She studied photography with Ruth Bernhard, Judy Dater and Richard Goldwach. "My work explores the nature of the image as perceived. It seeks to trigger the desire to order visual experience and engage the viewer in a quest for relevance. The viewer's life experience combined with that quest elevates the presented clues to the role of the totemic for the viewer. This memorialized remembrance engenders meaning, transcending the need for

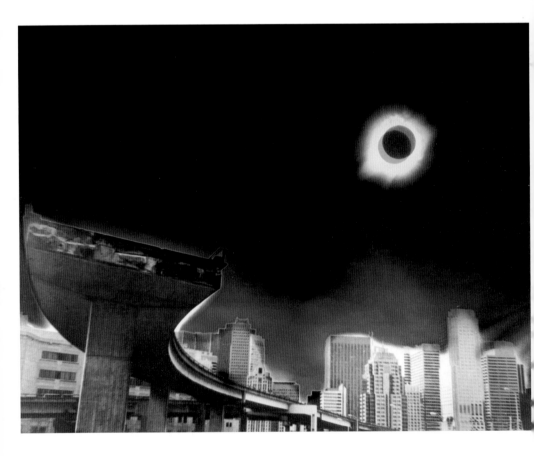

Freeway with Lunar Eclipse. Print. 10" x 13"

the structure of a vocabulary. Exploring the interplay of technique and the aesthetic in the presentation of the usual in an unusual context gives permanence to the transient. It transcends change. Focus, design, perspective, light and color are critical participants in this voyage of exploration by the viewer. If viewers connect with the work, they grasp the adventure of my artistic voyage."

150 Funston Ave., San Francisco, CA 94118
415-752-6253 funston@aol.com

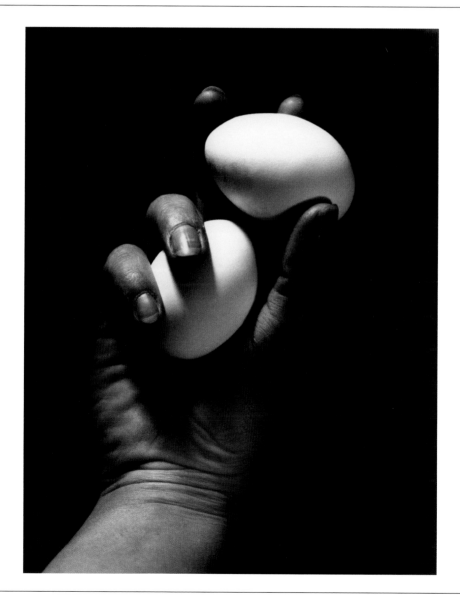

Hand and Eggs. Print. 8.5" x 7"

Howson

Kimberly Iaconetti

Kimberly E. Iaconetti received a BFA from San Jose State University. She focuses on drawing portraits, sometimes adding watercolor. "Whether creating art or just observing those around me, I have drawn portraits all my life. We are all unique and individual. Our faces are special to us alone, and yet every mood can alter our expressions and what we convey to others. I try to capture the essence of an individual while embracing the concept that less is more. What I leave out of my composition is just as significant as what I

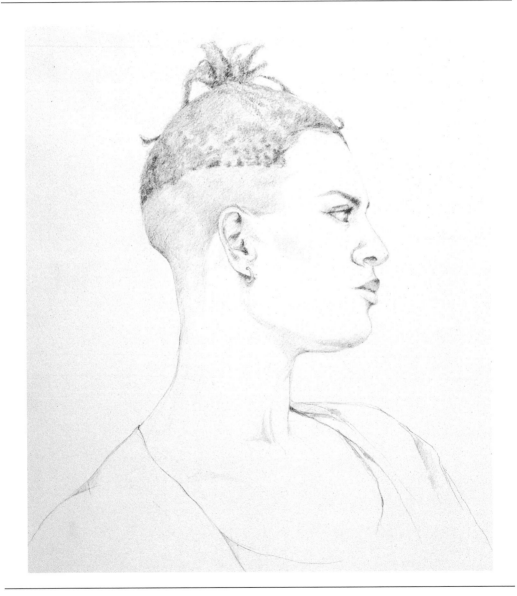

Naomi. Graphite drawing. 20" x 16"

include. My education in graphic design strongly influences my compositions. For me, pencil can truly achieve the sensitivity I wish to express, whether it is in detailed renderings or simple elegant lines. Each person and every face, whether demure or bold in character, brings new inspiration and the opportunity to once again tell a story with a lasting impression."

Marin County, CA
keistudios@aol.com

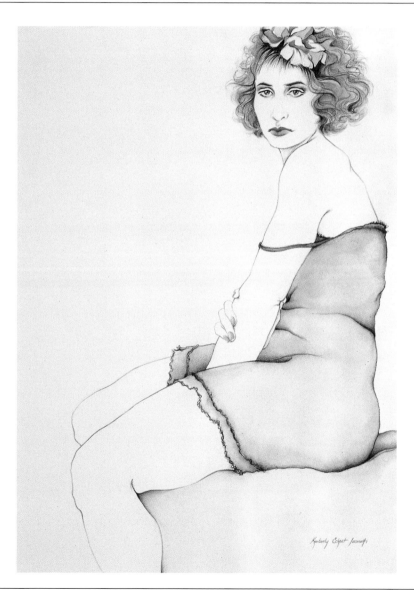

Merav with Terracotta. Drawing with watercolor. 30" x 22"

laconetti

Saori Ide

Born in Osaka, Japan, Saori Ide received a BFA from the University of New Mexico at Albuquerque. "My work is environment-inspired and dependent, inspired by the atmosphere and feel of Hiroshige and the fractured abstraction of Braque. The idea and the image take shape within the harmony of a particular place and its surroundings. I endeavor to create a dialogue between the viewer, the objects or forms that I create and the setting. My visual aesthetic is strongly influenced by my Japanese roots. The simplicity of

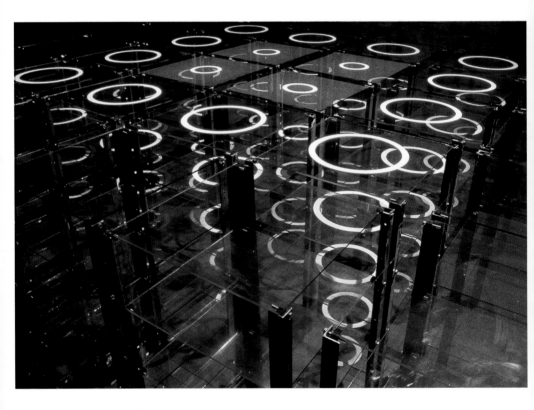

Dimensions. Installation. Glass, steel, paint. 10' x 10'

composition, the harmony within a space, and the relationship between the piece and the viewer, inherent in Japanese Zen gardens and traditional *Sumi* paintings, are the elements that I try to incorporate into my work. My fundamental idea of installation is to redefine and transform ordinary space into 'unordinary' space. I invite the viewer to have a personal, intimate and direct relationship with my work."

1777 Yosemite #150, San Francisco, CA 94124
415-671-0120 www.saoriide.com

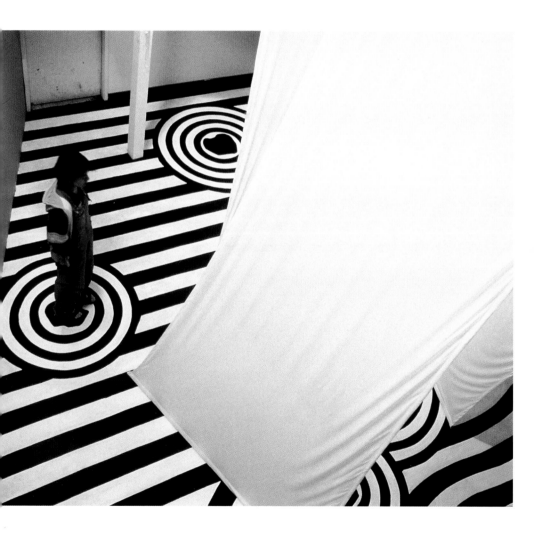

Space, Time, Place. Installation. Cloth, steel, paint. 24' x 20' x 20'

Martine Jardel

Paris-born Martine Jardel received a BFA from the San Francisco Art Institute and an MFA from San Francisco State University. She lived and worked in Yemen, Columbia, Burma and Canada before settling in California. "I believe the experience of different climates, landscapes, people and cultures are a nutrient source of my art. My work starts with gestures and no preset ideas in mind. The *Space* series paintings show a process of sedimentation. Thin layers of paint let the light seep out from within the painting. The effect of color

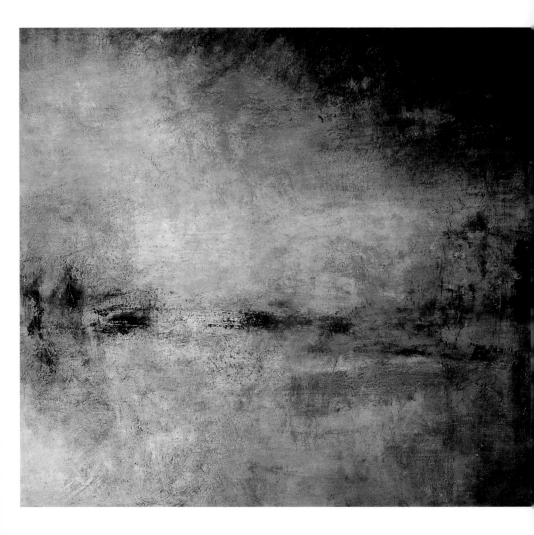

Space 46 - Meditation. Oil on canvas. 53" x 58"

ransparencies, light and dark, helps create a mood or an atmospheric quality which enhances the reading of marks, lines and shapes as loose depictions of elements in nature. But ultimately they are traces, emnants of images with no fixed identity. I like to see my paintings as spaces of ambiguity inviting the viewer to a patient contemplation."

689 Bryant St., San Francisco, CA 94107
415-921-4823 www.martinejardel.com

Space #56. Oil on canvas. 58" x 53"

Jardel

Eric Joyner

Eric Joyner received a BFA from The Academy of Art in San Francisco and divides his time between fine art and a career in illustration, working for tech companies, card companies, magazine publishers and advertising agencies. "Having a studio in downtown San Francisco, I find it impossible to ignore my surroundings like so many artists do. Indeed, with all the different cultures, old buildings, streetcars, bridges and countless other things with hills and water all around, I am compelled to paint as much of it as possible. My inspiration for these cityscapes

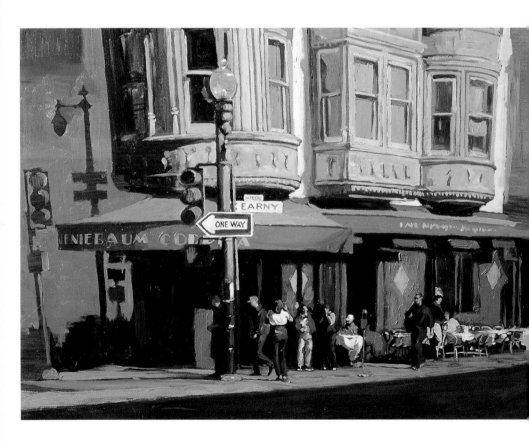

Columbus Cafe. Oil on canvas. 18" x 24

has been mainly the American impressionists and illustrators from the early 1900s such as Hopper, Wyeth, Sargent, Higgins, Bischoff, Sloan and Cornwell.... I've also arranged and painted vintage tin toys playing with size relationships; sometimes these toys are of a typical size, other times hundreds of feet tall, and placed in unlikely environments."

111 New Montgomery St. #402
San Francisco, CA 94105 www.ericjoyner.com

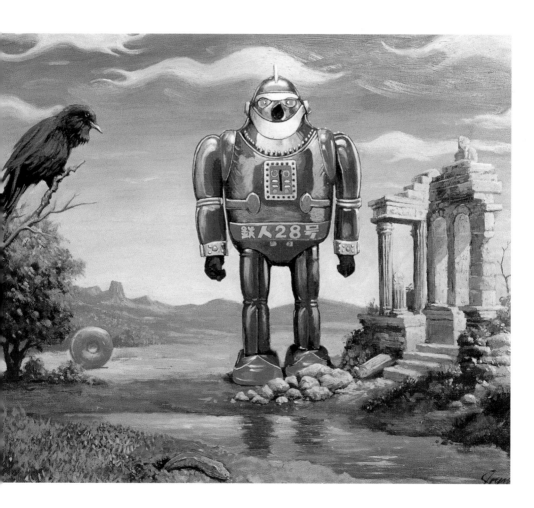

Metalman. Oil on board. 16" x 20"

Joyner

Stephanie Jucker

Born and raised near London, Stephanie Jucker received an MFA from Syracuse University in New York State, and then spent five years painting and exhibiting in England. "Since moving to the Bay Area in 1991 water has become a recurring theme in my work. Its visual qualities of reflection, transparency and color are echoed by the paint itself, a fluid medium. Most pieces start with an image in my mind's eye, inspired by something I've seen or experienced. The image has some metaphoric quality not fully formed and the act of painting

Clouds in the River. Encaustic on canvas. 48" x 48"

helps me realize it. I usually start by drawing directly with color onto the canvas and build a richly textured surface using encaustic and sand. The layering and scraping of oil paint, wax and sand are part of the trial and error involved in searching for the picture. Personal symbols and hints of myths and fairy tales are often woven into the imagery, imbuing my paintings with an allegorical quality."

1337 Fourth St., San Rafael, CA 94901
415-460-6795 sjucker@aol.com

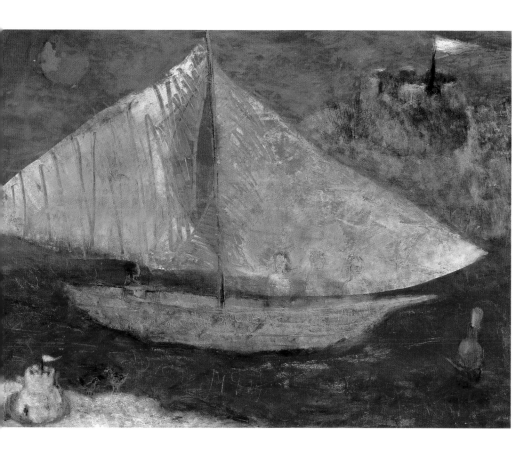

Red Sky, Cornwall. Encaustic on canvas. 36" x 48"

Jucker

Walter Kennedy

Walter Kennedy received a BFA from the San Francisco Art Institute and an MA from California State University at Sacramento. He teaches photography at American River College in Sacramento. "Observation is the beginning point for seeing or imagining photographs that try to show a bit more than the ordinary. Every picture is a metaphor that hints at another side of things. There has to be an excitement for the eye and stimulation for thought for a photograph to work. A piece can fall flat pretty easily. Somehow there has to be

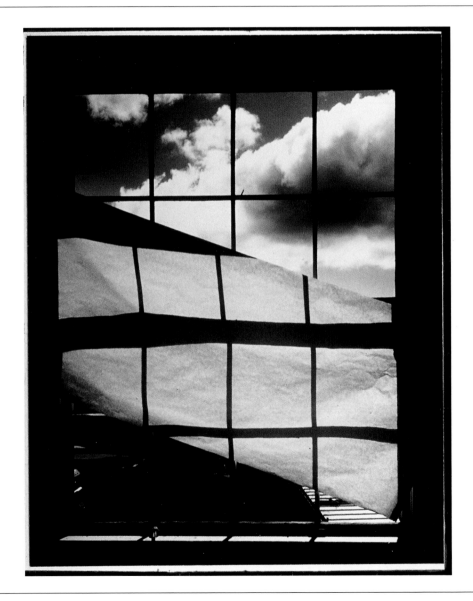

Window at Sutter Creek. Silver gelatin print. 7.5" x 5.5

more in the photograph than the natural beauty of the subject. There also has to be something to make me think. Lightness and humor sometimes help. Sometimes it can be a single image or in other cases a series of images that convey the feeling or idea. When the layers of silver on the page really glow and there's a bit of mystery, I feel I'm close to achieving what I am after."

322 Richland Ave., San Francisco, CA 94110
415-647-9065 www.wckennedy.com

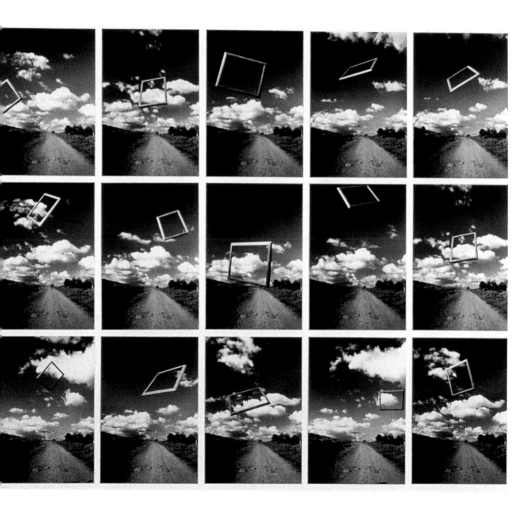

5 Views at Monitor Pass. Silver gelatin print. 20" x 24"

Kennedy

Bohdanna Kesala

Born in Pamplona, Spain to American parents, Bohdanna Kesala is pursuing an MFA in painting at San Francisco State University. "I make the process part of my work and, by using a wax medium, I slowly build up the surface of the canvas while at the same time subtracting from it, enhancing the initial marks made while adding new ones. This visual history, like time-worn architectural facades, is a part of each painting's complexion. Every stroke, even when covered or taken away, leaves a history of its existence both on the

Ocher Origin. Oil and wax on canvas. 12" x 12"

canvas and in my own mind. I do not, however, see a finished painting as a static object. I feel that its life does not end with the last stroke of the artist, but instead, its life begins with the viewer's gaze. I hope, with the use of familiar patterns, architectural elements and weathered surfaces, my paintings hold a familiar feeling for the viewer, and become spaces for self-reflection."

San Francisco, CA
415-244-9608 www.bohdanna.com

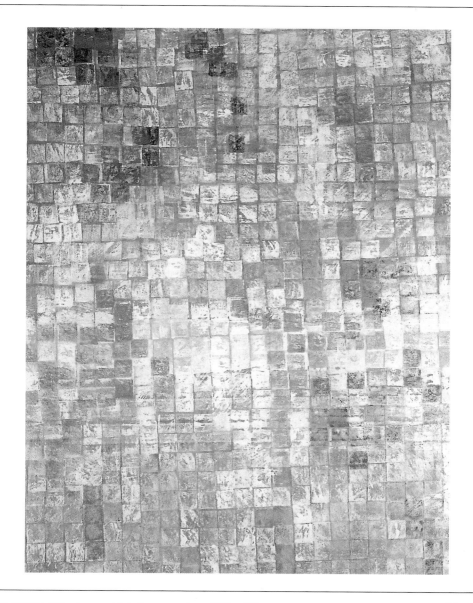

Phenomena. Oil, wax and fabric on canvas. 60" x 48" **Kesala**

Kathleen Lack

Kathleen Lack studied portraiture with Kent Rupp, Chester Arnold, Bob Gerbracht and Daniel Green. "All of my interests come together with my current subject matter—dancers. I try to capture the essence of the subject and feeling of the moment. The body language and environment I prefer is informal, relaxed and fluid: kids playing at the beach, climbing trees, observing nature—people being themselves. When I observe people I am seeing a soft golden hue against the face, the strength and beauty of a

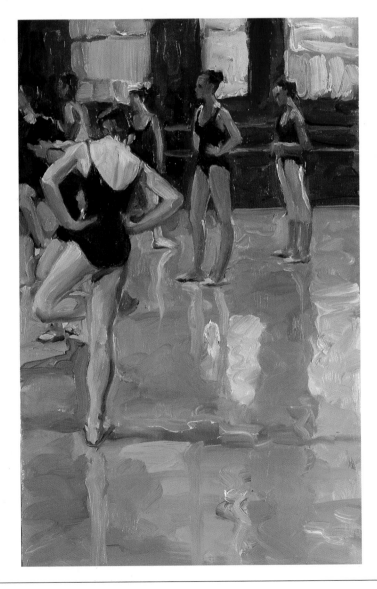

Dancers in the Pink. Oil on panel. 10" x 6"

dancer's body, an expression of emotional involvement when playing the cello, the strong morning sunlight creating magical contours over a child's face, and I am compelled to capture that on canvas. To me, it is the intensity of that moment, the graceful body positions, the light, shadows and colors that need to be rendered."

17 Terry Circle, Novato, CA 94947
415-883-5363 www.kathleenlack.com

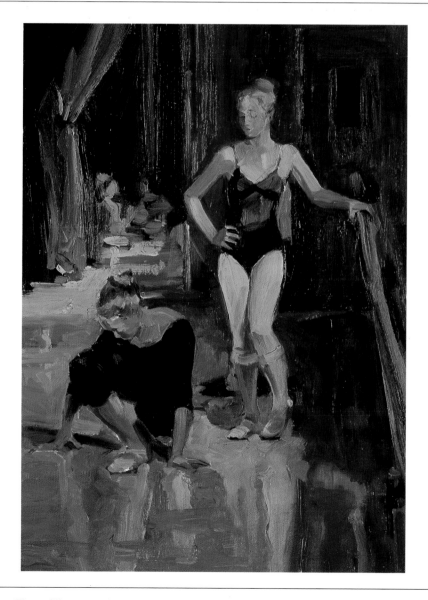

On Golden Floor. Oil on panel. 10" x 7"

Lack

Beryl Landau

Born and raised in New York City, Beryl Landau received an MFA from the San Francisco Art Institute. "I call my work symbolic landscape. The paintings depict geographical places, yet my intention is to evoke inner feelings that draw the viewer into a particular space and mood. I paint with acrylics on canvas using my own photographs as launching points. The square formats range from sixteen inches to six feet. The style, although realistic, carries an overall abstract design. Subjects span familiar Northern California scenes to locations from

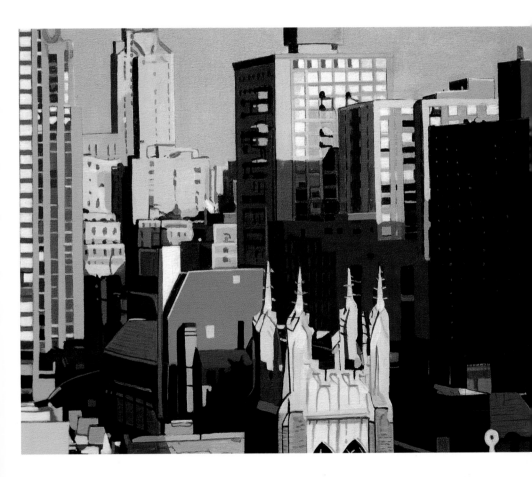

Wonderful Town. Acrylic on canvas. 24" x 24'

my travels. Many of my recent paintings are cityscapes of San Francisco, Oakland, New York and Europe. My work reflects a personal connection to these environments; the images vary from close-up studies of nature to large, ambitious panoramas of urban or rural settings.

The styles of Matisse, De Chirico and Diebenkorn have deeply influenced my artistic vision."

3290 Harrison St., San Francisco, CA 94110
415-285-6755 beebleberry1@yahoo.com

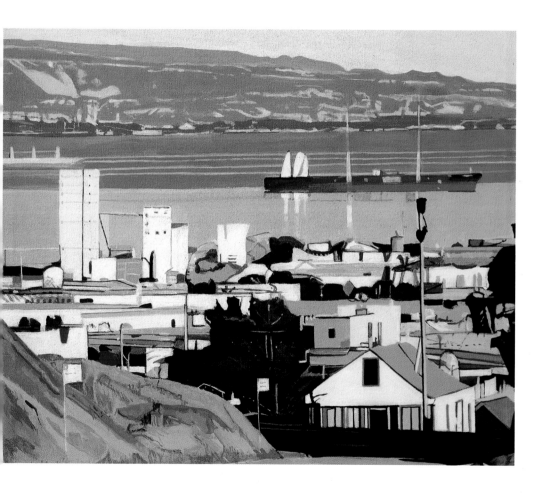

Open Air. Acrylic on canvas. 24" x 24"

Landau

Craig LaRotonda & Kim Maria

Craig LaRotonda received a BFA from the University of Buffalo, where he studied with Alan Cober. In 1996 he began working with Kim Maria, whose skills include assemblage and collage techniques, and together they formed Revelation Studios. "Our collaborative assemblages are unique wall sculptures fashioned from a thoughtful selection of hand-sculpted figures depicting ancient saints, sideshow freaks and mystical creatures adorned with antique relics, various found objects and organic materials. Both of us are

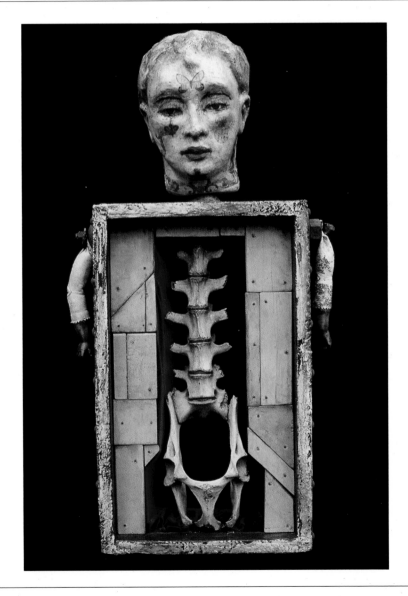

Weaselarmed. Oil, wood, paper, composite, collage, bone. 26" x 13" x 6"

captivated by found objects because of their rich patinas and connections to an unknown past. An object's color, form and significance to the subject are what we consider when selecting assemblage materials for our work. We intend to intrigue, provoke, challenge and inspire the viewer. Revelation Studios is about transportation for the mind."

1072 Folsom #275, San Francisco, CA 94103
415-551-1023 www.revelationart.net

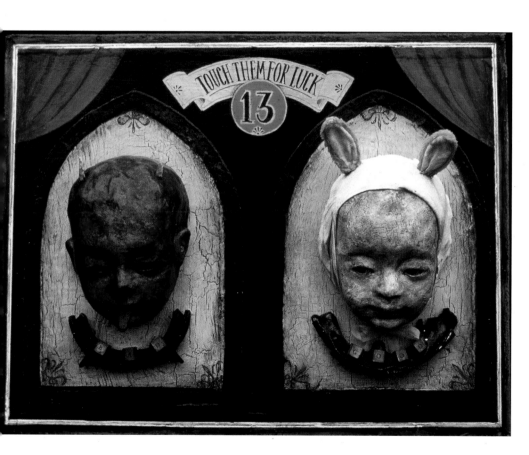

Touch Them for Luck. Oil, bone, paper, composite, wood. 21" x 27" **LaRotonda & Maria**

Carol A. Levy

Carol A. Levy received an MFA in painting from the School of the Art Institute of Chicago and has taught painting and drawing in art schools and colleges in the San Francisco Bay Area since 1977. "My painting is a search. It takes me to unknown places, brings insights and connects me to deeper truths. The process requires me to step out of the way yet be present for what is happening in each moment. I begin with not knowing. As one layer of paint partially covers another, the painting reveals its own life force. It is a dance we do together, a

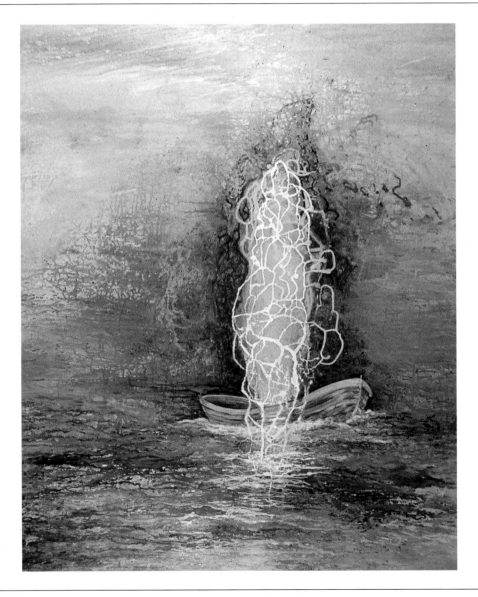

Mysterious Presence. Oil on canvas. 51" x 40'

movement back and forth, adding and subtracting. Movement is essential. I am interested in the spaces between lines and gestures, in the dualities of time and timelessness, form and formlessness. I want the paint to come alive and engage. The human form and the world of nature are always inspirations. There is no place where the sky ends and the water begins."

8 Moody Ct., San Rafael, CA 94901
415-456-3194 calevy@pacbell.net

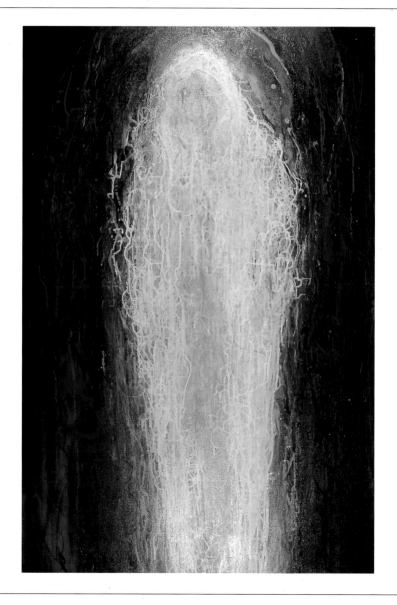

Guardian Presence. Acrylic on canvas. 63" x 43"

Levy

Geraldine LiaBraaten

Geraldine LiaBraaten received a BA from the University of Minnesota. "I am a longtime photographer who is intrigued by where we, as artists, put the 'frame' around life to present it to you, the viewer. I believe that art is changeable, over time, in form and in perception. My approach to art and life is impatient and non-technical, as I am largely self-taught in both. I rely on spontaneity and serendipity to locate my subjects, and on color and composition to present the images. The goal is to catch your eye and make you wonder

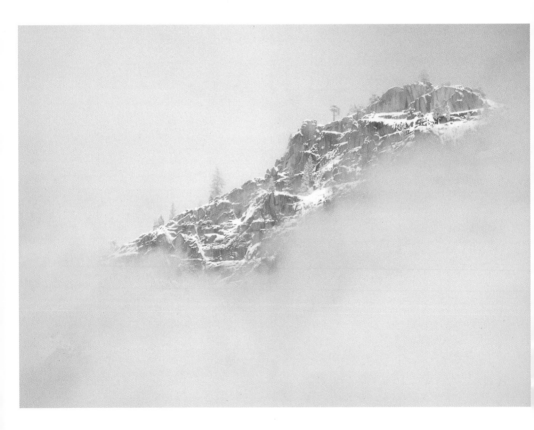

Frozen Mountain. Color photograph. 20" x 30"

what's going on. I am drawn to alternative processes such as image and emulsion transfer, gum printing, cyanotype and printing on watercolor paper and fabric. These methods require a high tolerance for uncertainty, so I've learned to enjoy surprises. My students teach me as much as I do them, making me eager for the adventure around the next corner."

480 Gate Five Rd. #205, Sausalito, CA 94965
415-332-9525 geraldine@flamboya.com

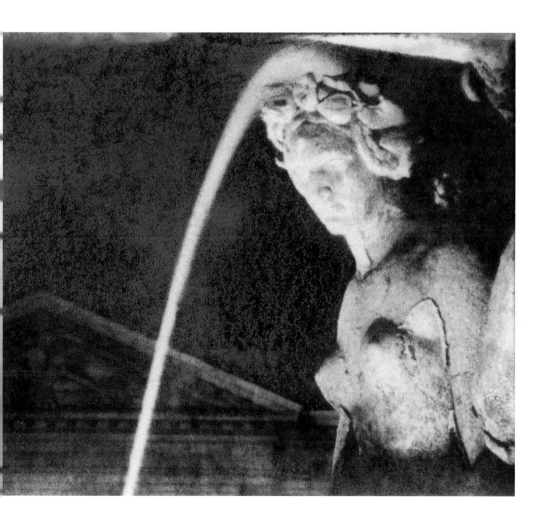

Nereid. Photo image transfer on watercolor paper. 8" x 10"

LiaBraaten

Jane Liston

Originally from Eugene, Oregon, Jane Liston received a BA from Dominican University in San Rafael, California. She has lived and painted in Marin County since 1965. "The ocean, rivers, mountains, sky and grasslands are all favorite subjects. They are treated in an emotional manner through the heavy surface buildup, the quality of reflecting light, and the contemplative composition, all of which come together to capture a moment in time that can stir the senses. My impressions are recognizable, but not literal. Included in the

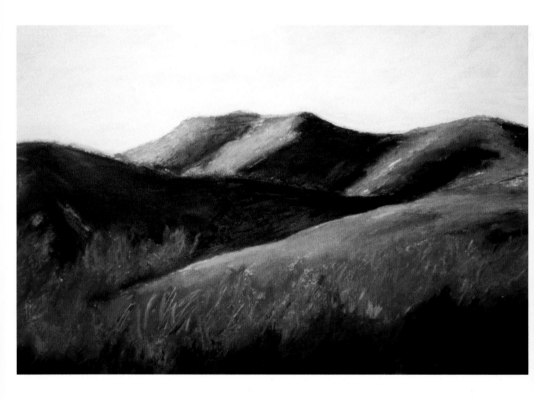

Headlands, Fort Cronkhite. Acrylic and oil pastel on paper. 11" x 14"

surface of some of the artworks are writings, which express my personal feelings at the time. These natural scenes comfort my mind and soul, and I find those collectors who are interested in my work feel a similar effect, and are drawn to the images in a way that somehow expresses memories and nostalgia of their own."

707 Sir Francis Drake, San Anselmo, CA 94960 415-456-3803 tvli@msn.com

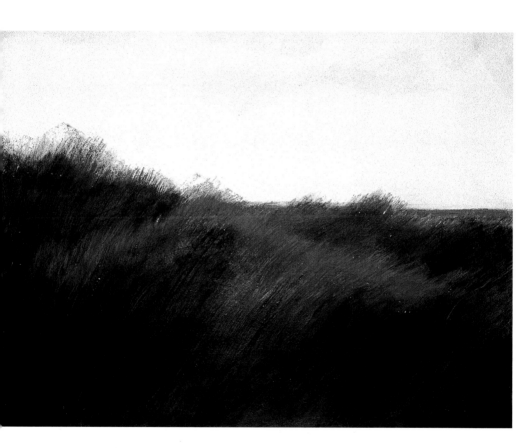

Pacific Ocean Grass. Oil pastel on paper. 22" x 30"

Liston

Jeffrey Long

Jeff Long received a BFA from the Rhode Island School of Design and an MFA from the California College of Arts and Crafts in Oakland. He has lived in California since 1973 and has been painting professionally since 1976. Formerly a landscape painter, his art is influenced by time spent in Asia and balances pure abstraction with the representational. "The wall (in both sacred and secular contexts) utilized as a repository for votive offerings is a durable tradition in many cultures: the Wailing Wall, its crevices crammed with prayers on

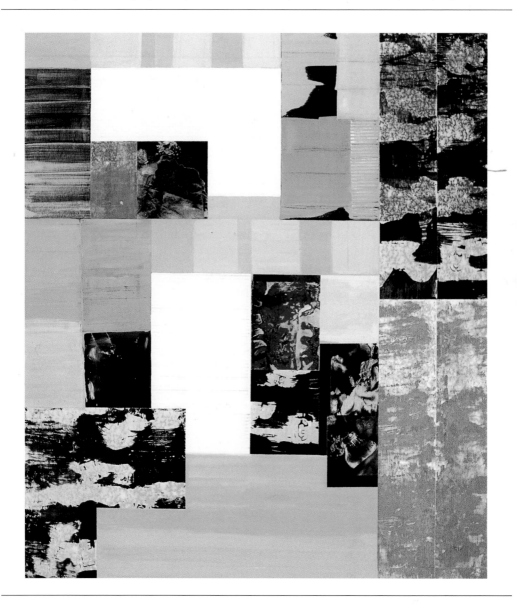

Bivalve. Mixed media on canvas. 83" x 72"

rolled-up scraps of paper, the walls of Buddhist temples festooned with bits of gold leaf, the Vietnam Veterans Memorial bestrewn with flowers. Some of my paintings reference this tradition of wishes, prayers and elegy through the accretion of layers of collaged materials.

Another source for my work is urban and natural landscape chopped-up and fragmented in the gridded patchwork of my pictures."

482 Liberty St., San Francisco, CA 94114
415-822-4714 www.jefflong.com

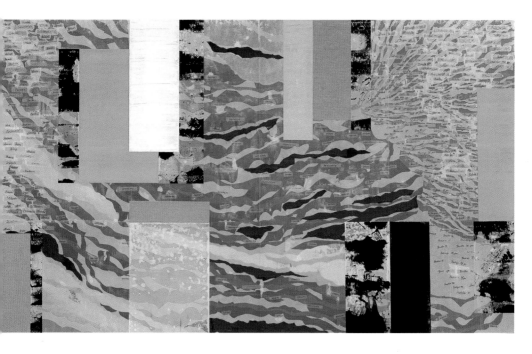

Middle Passage. Oil on canvas. 62" x 104"

Long

Paul Lorenz

Paul Lorenz received an architectural degree from the Illinois Institute of Technology and studied painting at the Art Institute of Chicago. He now teaches abstract painting at the Academy of Art College, San Francisco. "Bauhaus architecture and the Abstract Expressionists of the 1940s and '50s influenced my ideas on composition, use of materials and color development. The balance of these three is the core of my work. Working on canvas is much different than working on plywood, and the play of these materials is

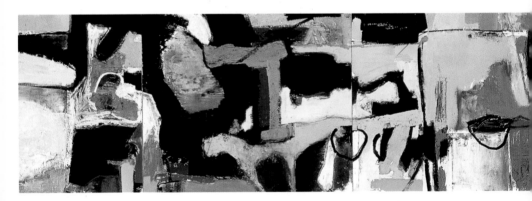

intriguing. By determining the structure (paper, linen, plywood), the play between the tools (brushes, scrapers, rags) and the materials (oil, enamel, pastel, polyurethane) can commence. The integrity and function of each element creates the finished expression.

The difficulty arises in staying free to explore without destroying the emerging logic."

2414 Hilgard Ave., Berkeley, CA 94709
510-845-8672 www.paullorenz.biz

Tenement. Oil and enamel over ply. 18" x 24"

Lorenz

Lilla Luoma

Originally from Minnesota, Lilla Luoma studied art at the University of New Mexico in Albuquerque. She worked as a graphic designer before opening her studio and gallery. "My work involves the unilateral connection to that which one may term the 'Zen Mind.'

This is a place of letting go of all attachments to the outcome of any piece of work. Hands to heart, focusing only on the moment, I make no plan, I enter the silence, I let go. Paint is then applied to the canvas using brushes, fingers, textured surfaces and anything that

Desert Walking. Mixed media. 18" x 20"

comes to mind during the process. Layer by layer, images begin to appear before me. Sometimes I enhance them, sometimes not. This freedom of expression and exploration is bringing forth images, which, I believe, possess the essential elements of personal healing and transformation. In the past, I knew I could paint what I see. I now believe it is more important to see what I paint."

P.O. Box 244, Valley Ford, CA 94972
707-876-1805 www.littleriverstudio.com

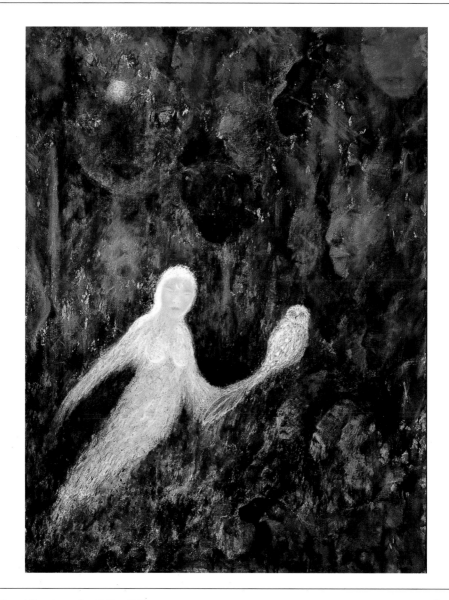

Guardian. Mixed media. 34" x 26"

Luoma

Jeannie Lydon

Jeannie Lydon received a BFA in painting from the California College of Arts and Crafts in Oakland and has worked as a gallery owner and art therapy teacher. "My paintings begin through a combination of ink and acrylic drawings on paper. To build up surface texture, I layer in ink, acrylic and oil while constantly using a printing method of linoleum, letterpress and screen-printing. I develop ideas through oil and printing as they expand on the wood or canvas. Paintings range from delicate six-inch paper prints to sixty-inch canvases. I work in a

French Breguet. Acrylic on canvas. 8" x 8"

simple reductive process, built on vintage shapes from objects used to simplify our busy lifestyles. I take inspiration from random patchwork surfaces and delicate compositions of our urban environment. Whether we use a simple metal blue fan or a Schwinn stick-shift bicycle, these objects are important in our daily lives and are missed when gone. They become an important connection to us as time passes."

3012 Harrison St. #7, Oakland, CA 94611
510-839-7063 jlydon@cbgb.net

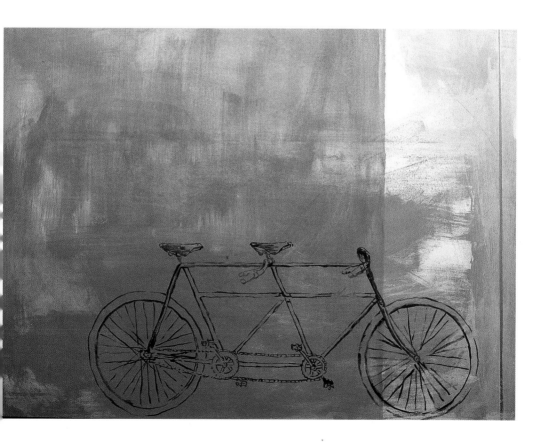

Built for Two. Acrylic on canvas. 38" x 48"

Lydon

Derek Lynch

Derek Lynch studied at the School of Visual Arts and the Art Students League, both in New York City. "My work is from nature and our environment. I collect botanical and man-made objects and use them as models for my paintings. I describe my works as 'fossil landscapes' capturing the unique forms and patterns of the natural terrain, placed in an abstract field. The work explores environments both natural and technologically altered. I use organic (branches, twigs, leaves) and industrial (motherboards, computer chips) elements,

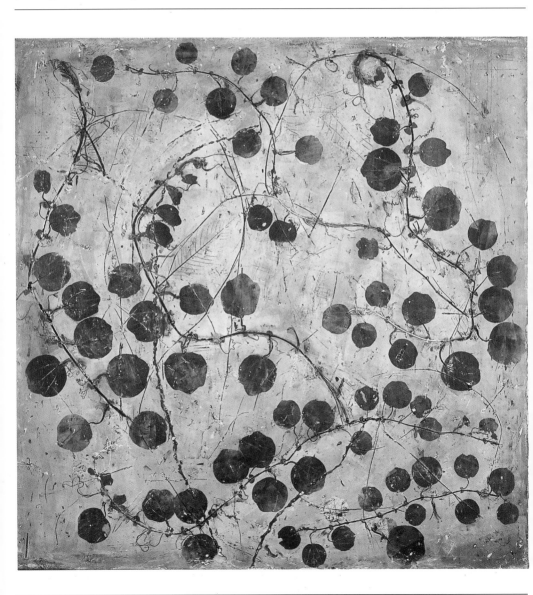

2002kinetic #2. Acrylic on paper. 50" x 40"

recalling the process of fossilization. My paintings suggest the evolution of how people have looked at, moved through, interacted with, and utilized the resources around them. They leave us to contemplate the direction in which that evolution will continue, and summon us to react. It is my personal belief that environmental art offers insight into how closely human life and meaning are tied to nature."

1517 Waller St., San Francisco, CA 94117
415-822-8377 www.lynchart.com

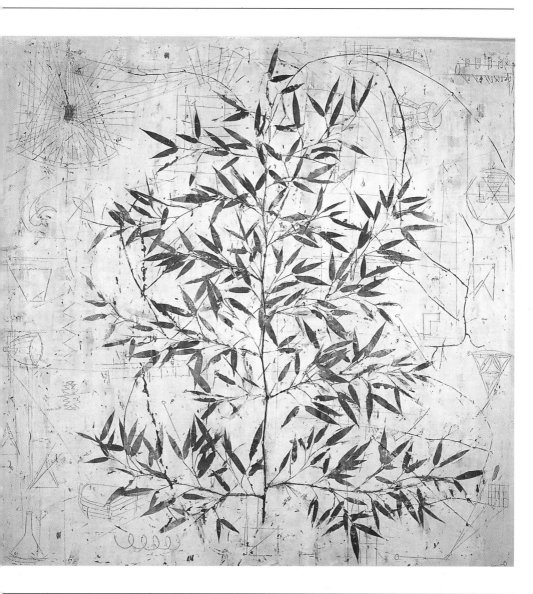

2002kinetic #1. Acrylic on paper. 50" x 50"

Lynch

Debra Maddox

Debra Maddox received a BA in art education from Arizona State University with a focus on painting and photography. "My medium is a non-traditional form of photography I call 'photopainting.' Others call it Polaroid manipulation, since a type of Polaroid film is used where emulsion can be maneuvered like oil paint. As a photographer and a painter, I find this the perfect melding of the two disciplines. Many of my images are enlarged onto watercolor paper so that I can apply pastels or paint to intensify the composition. Other

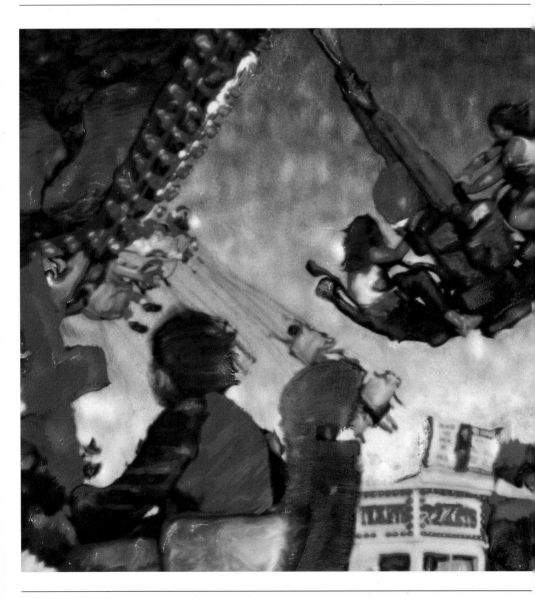

Ground Control. Hand-colored SX70 Polaroid enlargement. 16" x 15"

images are enlarged onto photographic paper using traditional photographic techniques. My work reflects two distinct components: visual and emotional. Each subject is selected to evoke an emotional response from the viewer, while capturing the relationship of light and shadow, color and texture, and shape and form." She was selected as commemorative artist for the 2000 Sausalito Art Festival.

131 Underhill Rd., Mill Valley, CA 94941
415-383-4065 dsm131@yahoo.com

Veiled Woman. SX70 Polaroid enlargement and pastels. 15" x 15" **Maddox**

Liz Mamorsky

Originally from New York, Liz Mamorsky studied painting with Paul Feeley at Bennington College in Vermont. "My paintings evolve from a tangle of brushmarks randomly applied to the canvas, obliterating the oppressive white space. I spend a lot of time viewing this grid from a distance, like staring at clouds or tree branches. Creatures emerge, morph, vanish and reappear. I develop the cast of characters by glazing in thin coats of oil and medium, ultimately creating a luminous surface. My paintings go through so many

My Grandma What Big Teeth You Have. Oil on canvas. 48" x 62"

changes and take a long time to finish, but the feeling is wonderful. I'm in a trance-like state where the moral censor turns off and everything flows. I have no sense of time, temperature or place. Like Alice through the looking glass, I enter the canvas—another world where I work feverishly. I am brave. I take risks. There are no mistakes."

739 Clementina St., San Francisco, CA 94103
415-863-1047 www.lizland.com

Mascaras de los Muertos. Oil on canvas. 24" x 24"

Mamorsky

Austin Manchester

Born in the U.S., Austin Manchester grew up living in Kenya, France, Switzerland, Nova Scotia and New England. He studied art at the University of California at San Diego, and independently in Cologne, Germany. "I make my paint medium myself by mixing dry pigments with oils and waxes. I think it is important to work from the ground up. This gives me a better understanding of my tools and provides the painting with resonance and meaning. My paintings incorporate smooth line counterbalanced by organic texture. Texture

The Mask. Oil on wood. 32" x 24"

adds life and movement to a world that could otherwise be perceived as alienating and stable. The natural earth colors are enhanced by the contrast of lights and darks. The paintings radiate with their own inner energy and touch on the surreal and figurative. They are emotional yet serene, possessing the power to reveal the essence of spirit."

79 Central Ave., San Francisco, CA 94117
415-255-4756 austinmanchester@mac.com

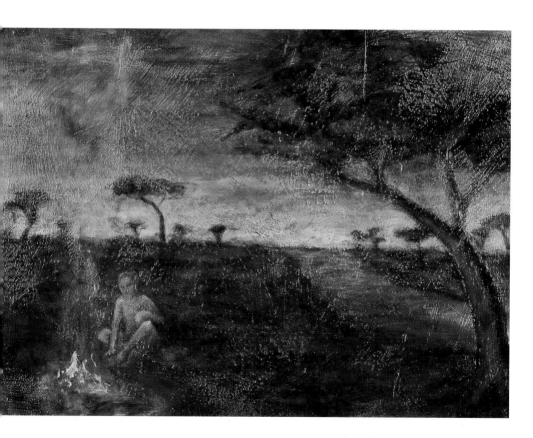

Sunset. Oil on wood. 18" x 24"

Manchester

Stela Mandel

Stela Mandel holds a BA in fine art and a MS in medical illustration. "My work reflects my training both as an artist and a medical illustrator. In *The Skyline*, my reflection of the events of September 11th, I used prints of spines that I had illustrated onto x-rays.

Vertebrae, their primitive shape, and how they protect the spinal cord fascinate me. Because their strength and vulnerability reminded me of the skeleton of a building, I explored this metaphor by constructing an underpainting of New York with fragments of

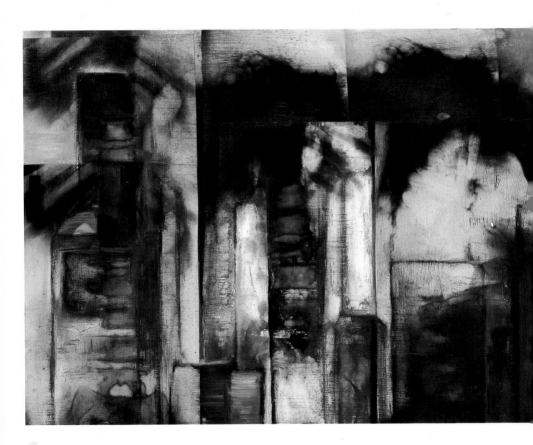

The Skyline. Mixed media. 18" x 24

damaged spines. I painted with layers of glaze in varying transparency to create the mood of the city while rubbing out the paint to expose the rawness of the underpainting. This process enables me to appreciate the pure beauty of the x-rays themselves as they expose the body's private textures and designs. The *Imaging* series attempts to examine these secrets."

480 Gate 5 Road #355A, Sausalito, CA 94965
415-461-9159 smandel334@aol.com

Imaging #2. Mixed media. 14" x 11"

Mandel

Joseph Mangrum

Originally from St. Louis, Joe Mangrum received a BFA from the Art Institute of Chicago. "After completing my degree, I traveled the world with only a backpack for four years to experience foreign cultures. During this time I created arrangements of found objects, to create an experience of art rather than a viewing. The shapes and patterns reflect both the natural and man-made worlds. Objects act as metaphor to redefine our life patterns and challenge our practice. In my sculptures I have used flowers, auto parts,

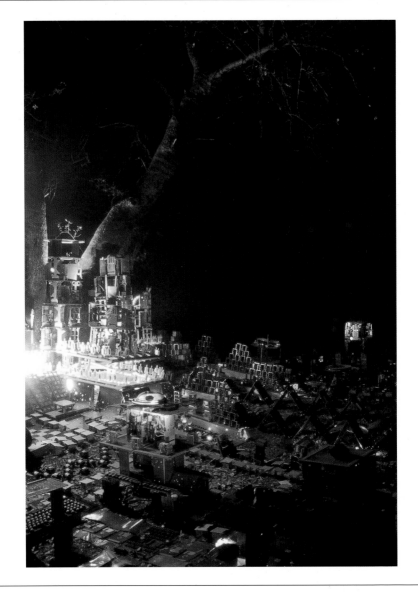

Colour. Installation. Recycled computer parts. 20'

dysfunctional technology, money, bullets and food just to name a few. Over time these objects, used repeatedly in different context, acquire a certain persona. They interact with their environment in a directed way, and gain history, to enhance the dialogue over time.

My greatest inspiration comes when people are emotionally touched by something I've created. It shows they are truly engaged in the work."

San Francisco, CA
415-643-3993 www.joemangrum.com

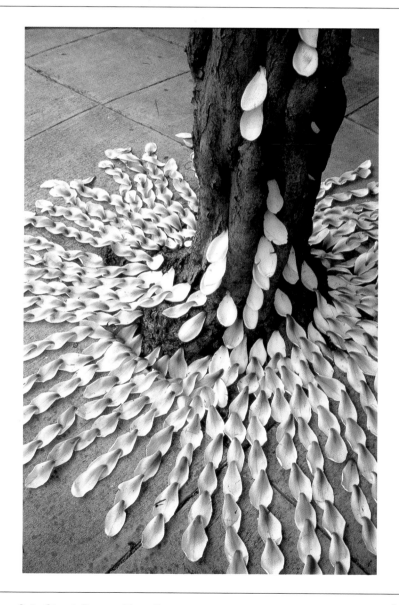

Magnolias on Cole Street. Composition. 6'

Mangrum

David S. Mark

David Mark received a BS in astrophysics from San Francisco State University and an MFA from the San Francisco Art Institute. He has written and directed short films and designed and built fine furniture. "The genesis of my work comes from spending many years observing the sky, and the transmissive qualities light has upon our atmosphere and the earth beneath. In certain instances, I will photograph the upper atmosphere in three dimensions to visualize the shapes and forms the changing light produces over many miles

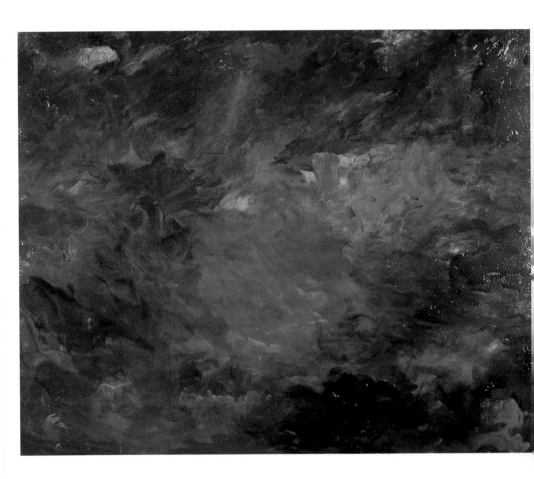

Internal Passages. Oil on canvas. 6' x 8'

across the sky. What interests me is that which has enabled life within our world, and the natural abilities that contribute to life, and where I find myself along this seemingly eternal pathway. I seek out a connectedness between the paint's translucent and reflective properties with those aspects I discover in the natural realm as a way of illuminating my place throughout this continuum."

194 Sagamore St., San Francisco, CA 94112
415-239-0230 davemk3d@earthlink.net

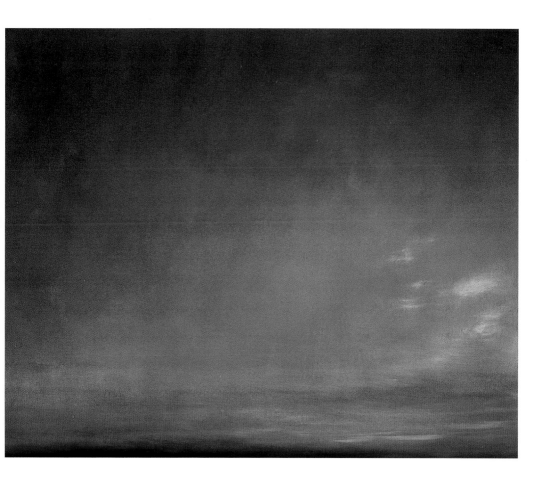

Atmospheric #7. Oil on canvas. 7' x 9' **Mark**

Marlo

Marlo Sass received a BFA from the University of Puget Sound in Washington and an MFA from the San Francisco Art Institute. "It is through the metaphor of bird symbols and imagery that I communicate visually. Wings, feathers, bird figures and suggestions of flight become symbols for passion, thought and imagination.... Creation becomes a personal expression of flight, transcendence and spirit. Vision resides between the outer world of appearances and the inner world of memory and intuition.

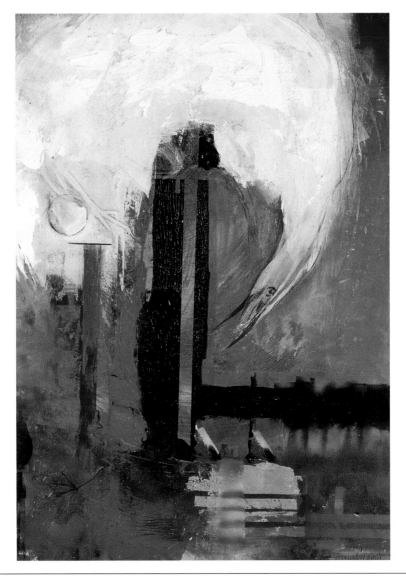

Night Heron. Oil and gold leaf on paper. 49" x 37"

Singers, lovers, scavengers, protectors and birds of prey become subjects for large paintings, sculptures and mixed media work. Artwork reflects aspects of life and survival. Birds are mystical creatures becoming the source of inspiration, caught for a moment in my process of an ongoing dedication to art. Content begins with paint and ends with a work to convey a bird's presence and journey."

947 61st St. #15
Oakland, CA 94608 510-652-6322

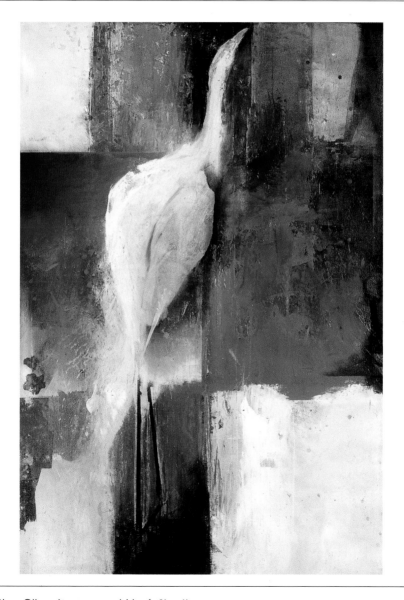

One with Blue. Oil and copper, gold leaf. 6' x 4' **Marlo**

Linda Masotti

Linda Masotti received a BFA from Sacramento State University. She is both a mixed media artist working with construction assemblages and a printmaker combining etching with *chine colle´* and collage to create monotype prints. "Whether through assemblage and construction or through the printed medium I view my artwork as containers. A shelter as the object itself holds an idea or a personal history. A book as a container of images and words adds the dimension of time. The *Mail-Art* envelope with artist's postage stamps becomes a small

Pandora's Box. Mixed media. 6.5" x 3.5" x 3.5"

canvas created for the viewer alone. The vehicles of mixed media, collage and the monotype print give expression to the accumulating layers that shape who we are. The spontaneity of its chance effects gives way to a means of communication. Fragments of images are re-shaped, altered or replaced by a later choice. It is the experience and response to our place, space and time."

2051 10th Ave.
San Francisco, CA 94116 415-665-1940

Burt's Place. Mixed media. 6.5" x 5"

Masotti

Liz Maxwell

Liz Maxwell dropped out of art school to start a family and received a statistics degree from the University of California at Berkeley at age forty. She retired early from teaching math to pursue art. "A few years ago I was working on monotypes in a spur of the moment fashion.

Starting with one or two color fields on the plate, I would let the appearance of the first print suggest what to include in the next run through the press (contrast, composition, color, line, texture, shapes or symbols, for instance). I would stop when the print looked satisfying to

So Many Heroes. Oil on canvas. 72" x 48'

me. I began a series of paintings inspired by these monotypes, and at first thought they were simply products of the same process. I began to see that most of these paintings could be viewed as landscapes containing no hint of human interference (no billboards, freeways, telephone poles, strip mines, junkyards, concrete). In recent paintings I look for ways to represent an unadulterated earth."

5805 Chabot Road, Oakland, CA 94618
510-654-5741 www.lizmaxwell.com

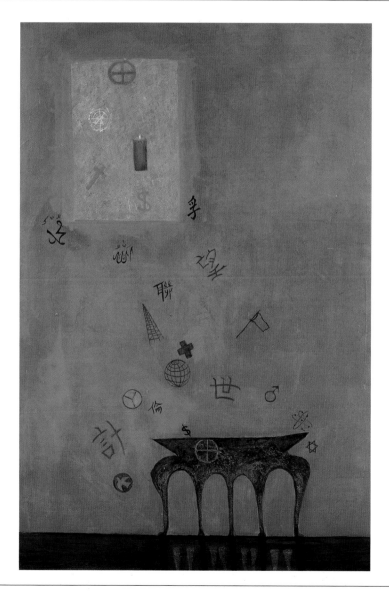

September Symbols. Oil on canvas. 72" x 48"

Maxwell

Clem McCarthy

Born in San Francisco and raised in Marin County, Clem McCarthy studied art and design at Pratt Institute in Brooklyn, and spent over thirty years as an art director with advertising agencies in San Francisco and New York while continuing to paint. "I think a successful painting has both visual and emotional appeal. Sometimes I'll involve a person in a landscape to suggest a narrative or story. I've always considered painting a visual form of writing. People read a story or a book, and if it's a good one they are impressed and moved.

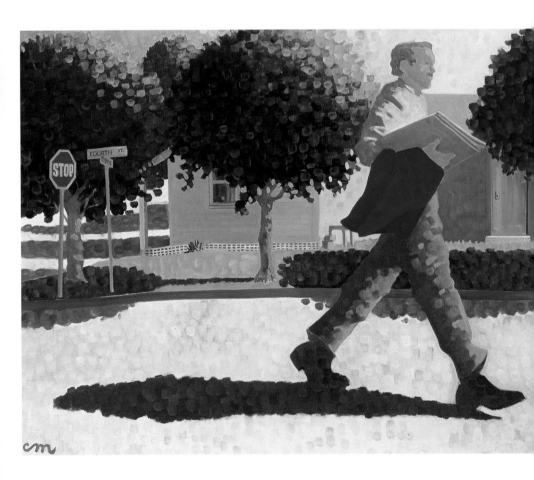

Point Reyes Station. Oil on canvas. 24" x 30"

A good painting should do the same thing: impress and move the viewer. Since paintings don't come in pages, it has to be done quickly. First, grab the viewer's attention visually. Then, offer something in the painting that suggests there might be more to it than just a pretty picture. What are they doing there? Where are they going? I leave that up to the viewer to decide."

Sausalito, CA
415-331-1560 taramac@earthlink.net

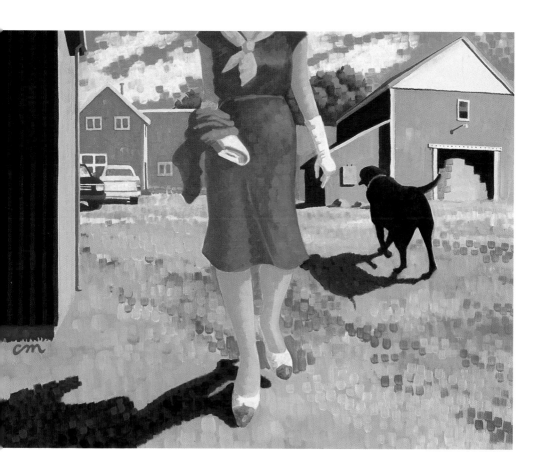

Lady in Red. Oil on canvas. 24" x 30"

McCarthy

Maralyn Miller

Originally from Fresno, California, Maralyn Miller received a BFA from the California College of Arts and Crafts in Oakland. "I have been painting in oils, acrylics and pastels for over fifty years, and recently focused my attention on the endangered oaks and open spaces of Northern California. Having roots in the Sierra Nevada and the San Joaquin Valley, I feel a strong connection to the oaks and hills and try to preserve on canvas from my perspective the natural beauty I see and want to remember and share with others. I work in

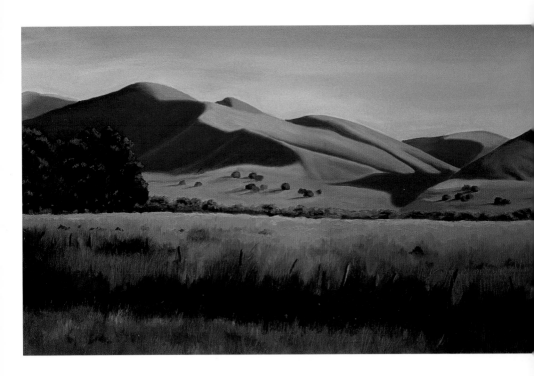

Valley View. Oil on canvas. 18" x 36'

my studio daily using my photos as reference and inspiration, but a lot of my paintings are from memory as well. Occasionally I break from realism and do abstracts as a way to loosen up. I find myself always aware of my surroundings as possible paintings. I especially look for interesting ways that light falls on things, creating shadows."

Los Gatos, CA 408-354-6747
www.geocities.com/maralynmiller

California Hills. Oil on canvas. 30" x 40"

Cindy Miracle

Cindy Miracle received a BFA from the University of California at Fullerton and an MFA from the Claremont Graduate School in Claremont, California. She worked in graphic design, mapping and technical illustration before focusing on painting. "Many things inspire my paintings, but I am especially drawn to patterns and textures around me. Something as ordinary as a crumbling wall or an old and peeling coat of paint can give me an idea for a painting. When traveling in Europe, especially in Southern France, Italy and Greece, I am

Villa de Poppea, Oplontis. Oil on canvas. 30" x 40'

constantly attracted to the many ancient surfaces and textures that surround me. I love examining the layers of a two thousand year old wall in Pompeii, the pitted and broken wall of a building in Trastevere, or the mosaic stone floor of a basilica where Attila once stood.

The challenge is to capture some of that sense of magic and mystery, and convey it through my paintings."

ICB Studio 355A, Sausalito, CA
415-331-5939 chmiracle@yahoo.com

Stone Floor, Basilica of Santa Maria Assunta. Oil and wax on panel. 16" x 24" **Miracle**

Michéle B. Montgomery

Michéle B. Montgomery studied at the Cleveland Institute of Art and received an MFA in sculpture from Cranbrook Academy of Art in Bloomfield Hills, Michigan. "My work draws from the domestic landscape to share common ground with the viewer. The imagery is not abstract but comes directly from everyday life. The interplay of image, form and materials is central to my approach, allowing me to construct complex psychological webs of meaning by evoking history, culture and science through visual language. The choices

Loveseat. Steel. 4' x 2' x 5'

I make offer paradoxical relationships between the domestic image and its new habitat. It is important for the work to support many interpretations. For example, my draped figures juxtapose neo-classical sculpture and the vernacular wire hanger. This recycling of the ordinary to the 'extraordinary' provides an opportunity to see with a new perspective."

Kentfield, CA
sixtyone@pacbell.net

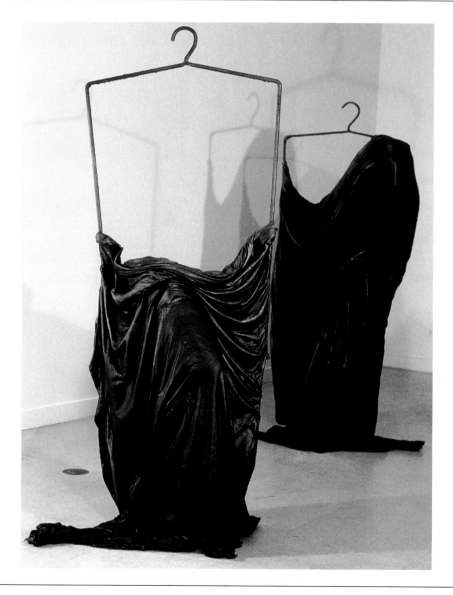

Figures. Steel, hydrocal, cloth. 60" x 24" x 24"

Monty Monty

Formerly a professional graphic artist, Monty Monty creates antique assemblage. "I have titled my work *Vintage Collectible Sculpture and Assemblage*. I often use the cast-off objects of our throwaway society: antique collectables, curios and sometimes family heirlooms to create a vintage essence. I enjoy finding useful and creative ways to breathe soul into these objects and bring kinetic dreams to life. This is not junk art. Whether creating a functional fountain from vintage appliances or a commissioned work in

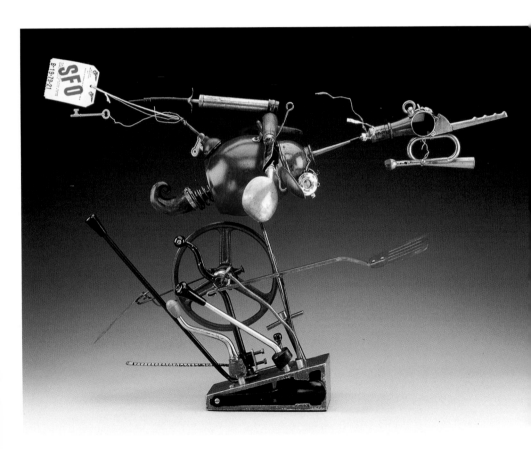

Goose. Assemblage. 13" x 29" x 10

memory of loved ones, I take great care in restoration and treat each component with respect. My approach is to create a natural look to the assembled work by using creative methods. I do not weld. Each piece includes an autographed photo page with an artist's statement, poem, story or inside information on the utilized components."

P.O. Box 2734, Santa Rosa, CA 95405
www.montymontyart.com

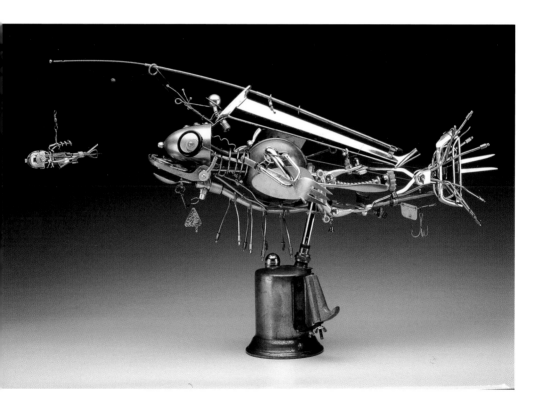

The Brass Bass. Assemblage. 16" x 25" x 10"

Monty

Mitsuyo N. Moore

Originally from Tokyo, Mitsuyo Moore studied painting with Carol Levy and printmaking with Sherry Smith Bell. She received a BFA from the Academy of Art College in San Francisco. "To my mind, line is the most basic element of vision, as it reveals rhythm, movement and spiritual aspect. Color enhances the vision and also stimulates emotions. Prior to starting work, I meditate. This allows me to encounter my spirit to communicate with my feelings, and to translate them into line and color. An illness in Japan resulted in two close encounters with

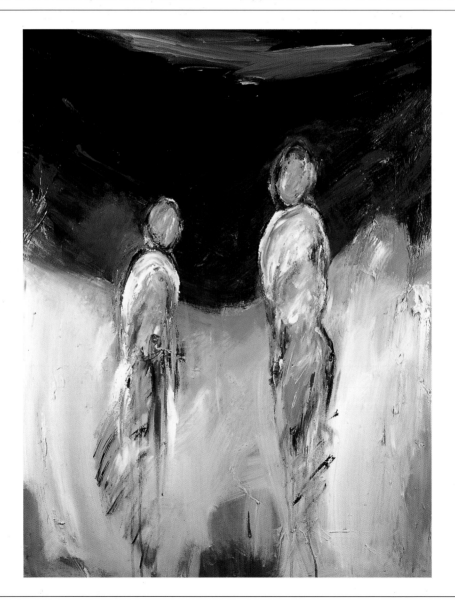

Connection 1. Acrylic on canvas. 40" x 30"

death. As a result, my consciousness of life and the human spirit were intensified. I came to the U.S. in 1991, merging two different cultures. I realize that life is a continuous learning experience and seek to share knowledge and impressions with others.

Henry Bergson's philosophy of *élan vital* has deepened my appreciation of the intuition and inner spirit of human beings."

2913 Putnam Blvd., Pleasant Hill, CA 94523
925-930-0661 www.ronwoodsonfineart.com

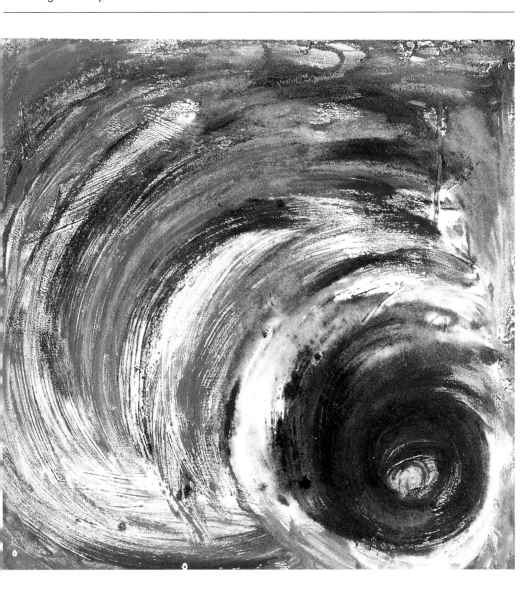

The Passage 1. Monotype. 19.5" x 19.5" **Moore**

Larry Morace

Originally from Louisiana, Larry Morace was an industrial engineer and videographer before becoming a painter. "I celebrate place and how it is defined by light. I love cities. They're our cultural national parks, full of beautiful visual moments. There's a ready-made structure to a city, with its rectangular and cylindrical forms. I find the structure appealing. As I observe the way light falls across buildings, streets and cars, I sense pleasing rhythms and search for essential visual patterns I can simplify. I start the

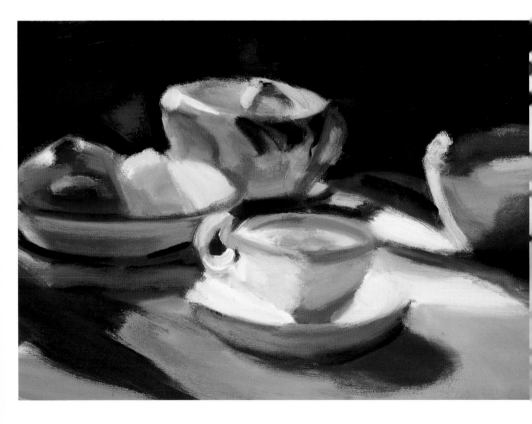

Once More with Feeling #13. Oil on canvas. 12" x 24"

drawing from what I see, like a musician playing from sheet music. But drift quickly sets in. The painting takes on a life of its own and I find myself improvising. The drawing never becomes abstract, but can hover on the border of perception. I am reminded constantly when I work that too much clarity can obscure."

San Francisco, CA
415-759-5755 larry@moraceart.com

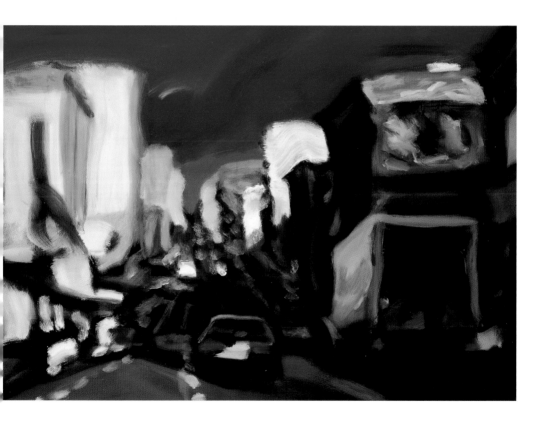

Purple Sky #3. Oil on canvas. 40" x 48"

Morace

Aiko Morioka

Aiko Morioka studied ceramic sculpture at the College of Marin in Kentfield, California and privately under sculptors Carol Fregoso, Marco Berti and Shray. "I let my hands release the image concealed in the clay. Nature, the human form and themes based in ancient wisdom are a recurring presence in my sculptures. I am intrigued by the surprise of evolving shapes and how a simple shadow becomes a story. Malleable, constantly changing, the clay is symbolic of the self; locked within is a potential awaiting

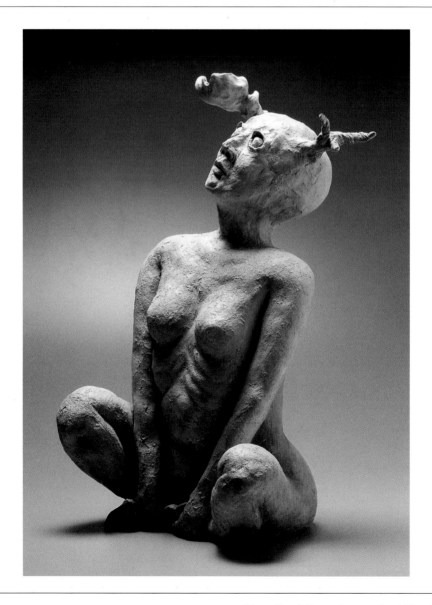

Transfixed. Ceramic, acrylic. 19" x 12" x 10"

manifestation. It is the metamorphosis. The caterpillar becomes the butterfly. My sculptures almost always tell a story unless I'm working on a representational figurative piece. I like the use of paint and patinas as a surface treatment as they allow greater flexibility in coloration and shadow. I've worked in marble and am casting to bronze, but clay remains my touchstone in the world of light and shadow."

1337 Fourth St. #11, San Rafael, CA 94901
415-457-4498 artbyaiko@aol.com

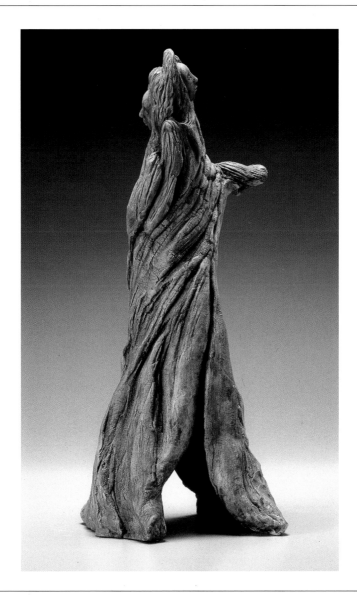

Two Grew as One. Ceramic, acrylic. 14" x 6.5" x 6.5"

Morioka

Zenaida Mott

Wildlife and landscape painter Zenaida Mott has lived and painted in Nigeria, Japan, Massachusetts and California, and studied painting with Elizabeth Holland, William Scott Jennings and George Strickland. "I enjoy painting a broad range of subject matter, but the most important thing is just being outside, trying to capture the fleeting light of some particularly beautiful early morning, late afternoon or stormy day. I try to catch these effects by painting *plein air*, and usually end up finishing in the studio. We have a remote cabin

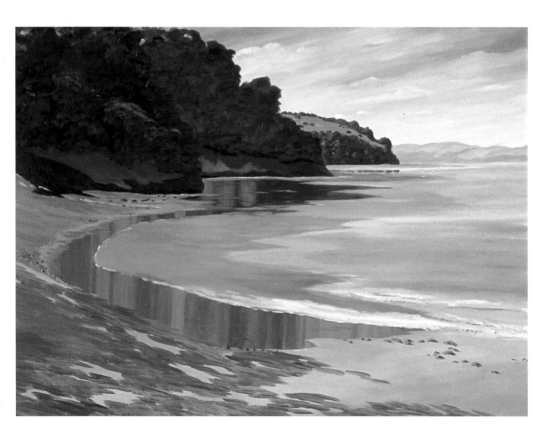

Tomales Bay Shadows. Oil on canvas. 30" x 40"

in the Sierra, which is my studio in the summer. I try to convey the love I feel for these special places and the excitement felt in viewing them." Mott is a signature member of the American Impressionist Society and a co-founder of BayWood Artists, a group of artists working to preserve the open spaces of Marin County and the Bay Area.

P.O. Box 1394, Ross, CA 94957
415-457-5292 zeezee@aglandinvest.com

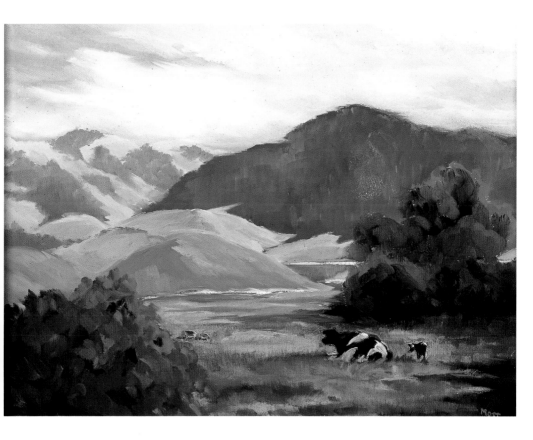

Lazy Day, West Marin. Oil on canvas. 12" x 16"

Mott

Reiko Muranaga

Originally from Tokyo, Reiko Muranaga studied art with Nathan Oliveira and Frank Lobdell at Stanford University. "I work in oil, charcoal, ink and ink wash, preferring found objects as tools: tree branches, palm fronds, wooden sticks, cardboard strips. My best tools are my hands.

I believe my hands and arms remember Japanese calligraphy strokes from childhood. The Abstract Expressionism of my oil painting style contrasts with the more figurative charcoal and ink scrolls, which reach lengths of sixteen to sixty feet. What I create is the

Untitled #3. Oil on canvas. 24" x 24"

accumulation of accidents that occur during the process of experimenting and exploring—like a jazz musician adding, modifying, changing and often deleting scores. Without consciously planning to finish the piece, at some point it is done. One can see images in the abstract work: deep space, animals, places and even certain stories can be visually interpreted from the overlapping layers of color and form."

Hunters Point Shipyard, San Francisco, CA
415-668-7538 www.netwiz.net/~muranaga

Blue Mythology. Oil on canvas. 7.5' x 6.5'

Muranaga

Meredith Mustard

Originally from Riverside, New Jersey, Meredith Mustard received a BFA from Cooper Union in New York City. "Painting is an adventure, going into the unknown. I do not plan my paintings before I begin. If I do have a germ of an idea in my mind when I begin, it is soon lost to the moment as I engage in what is unfolding before me. Since I can paint anything that I can see, the challenge remains to express something that I cannot see. Can my soul speak to your soul using a primal language that I have to discover? I am

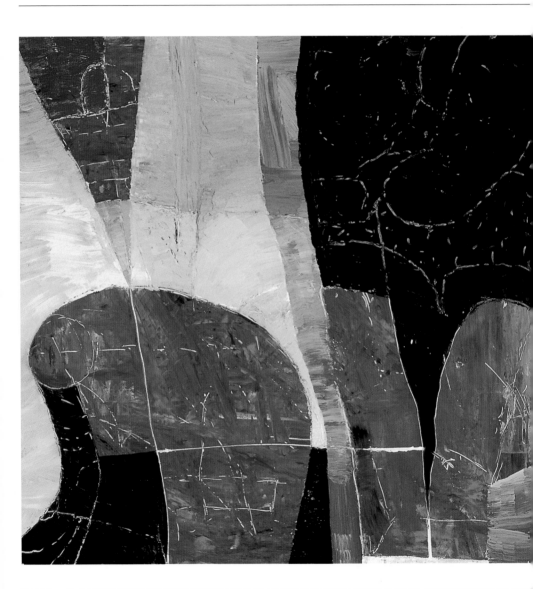

Extracting from Landscape. Acrylic on wood. 24" x 24'

attracted to bits of things and accidental marks that slip out past my intellect. I don't know if I can create directly what I am looking for. Perhaps I will accidentally make it. Something is revealed when images are juxtaposed. I do the work and then I look to understand what I have created. I just have to be present in order to see what happens."

175 Tulare St., Brisbane, CA 94005
415-467-8656 mmmmustard@aol.com

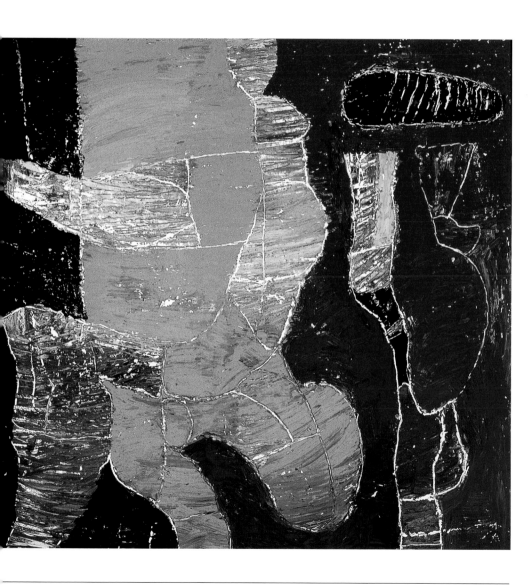

Things Are More Like They Are Now. Acrylic on wood. 24" x 24" **Mustard**

Nienke

Of Dutch and Japanese descent, Nienke Sjaardema grew up in India, Turkey, Nigeria, Spain and Panama. She received a BFA in painting from the California College of Arts and Crafts in Oakland and an MFA from JFK University in Orinda. "My painting is about uncertainty. Uncertainty is created when one level of perception conflicts with another. Visually the paintings look simple, psychologically they are complex. The houses could reflect the inner self—the vehicles, how we present ourselves to the world. The animals

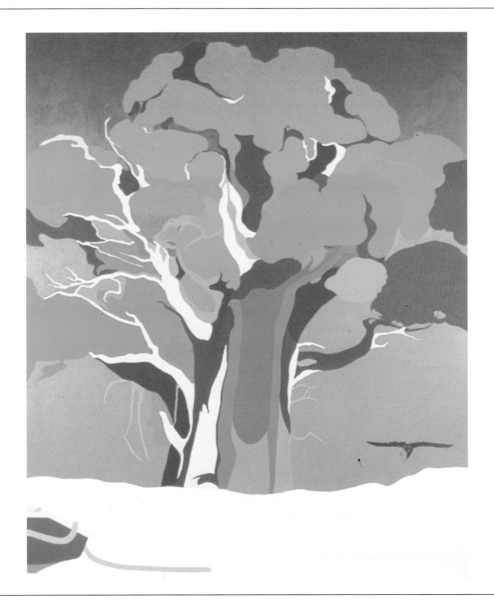

Sled. Acrylic and flashe on canvas. 72" x 60'

are the instinctual self. The trees are the condition of the natural self. Look at the placement, color, the size of each element as composed against each other. On an instinctual level the conflict between the visual and the intellectual is unsettling. My painting directs the viewer to question what he sees in relationship to what he knows and feels. You, the viewer, complete the painting."

2934 Ford Street #5, Oakland, CA 94601
510-465-1375 nienke@iopener.net

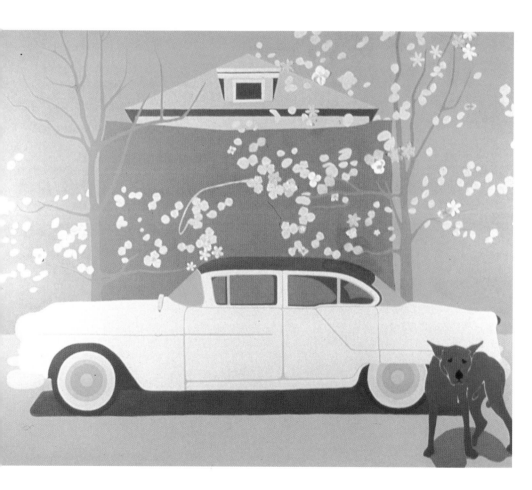

Veil. Acrylic and flashe on canvas. 60" x 72"

Nienke

Barbara Nilsson

Barbara Nilsson is a self-trained painter and printmaker. "It is people being themselves that keep me mystified and mesmerized, that bring me an awareness of the external and the internal. As a middle child in a family of thirteen, I was lost in the crowd, so to speak, of multiple personalities and relationships. I observed actions, interactions and emotions around me, noticing, assessing and digesting. I am always struck by the nuance of a look, a stance, an attitude, a gesture so common that it goes unnoticed. But this is what catches my

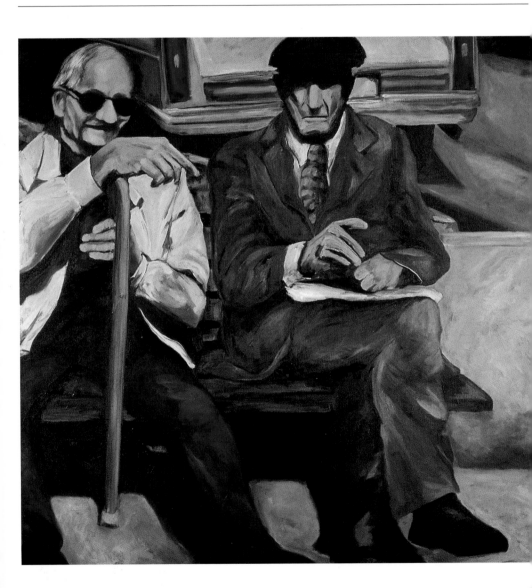

The Bench. Oil on canvas. 48" x 48"

eye. That split second happening speaks to me. That MOMENT is what I paint. What I create are snapshots of those emotions, attitudes, fears or desires catching glimpses of our momentary selves. I hope that upon viewing my work one would stop to reflect upon one's environment—not just the physical but also the spiritual self."

Camino, CA
530-644-5294 www.barbaranilsson.com

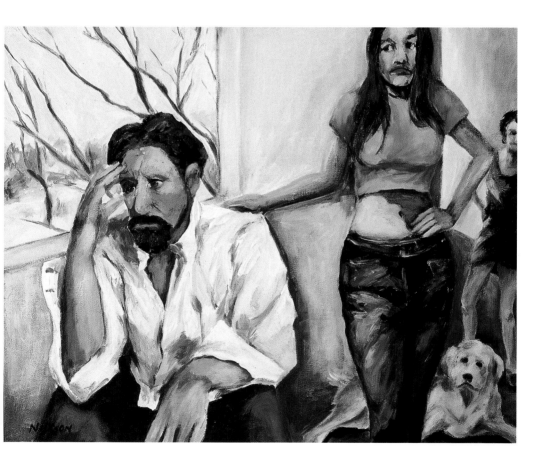

The Decision. Acrylic on canvas. 16" x 20"

Nilsson

Will Noble

Will Noble started selling his paintings in 1962 and in the 1970s began a career in animation. "In the '90s, as animation became increasingly mathematical, I found myself wanting to return to painting. My work focuses on the interaction of water with other natural elements: water cascading across rock, surface patterns and reflections. I am more interested in the rich patterns and detailed activity of an intimate event in nature than in the broad panorama of a typical landscape. Water is a constantly moving, changing element that provides infinite

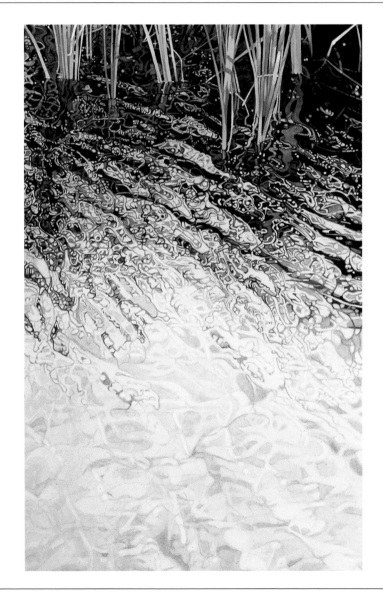

Reeds III. Watercolor. 30" x 14"

visual stimulus. Yet water is a finite resource of central importance to the well-being of the planet and us. My painting process begins with an intense period of detailed drawing with a blue water soluble pencil before applying any watercolor. A painting can take up to 600 hours to complete. For this reason I also offer my work in limited edition archival prints."

11 Meyer Road, San Rafael, CA 94901
415-453-5360 www.willnoblestudio.com

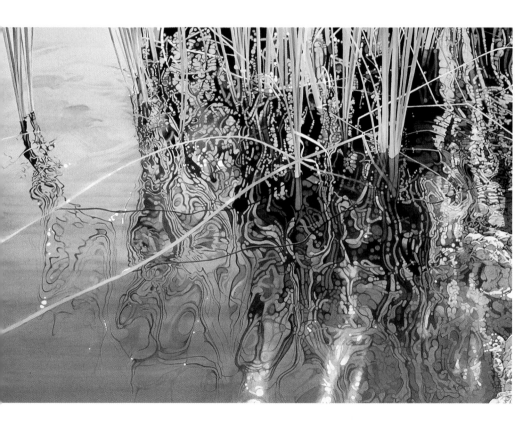

Reeds II. Watercolor. 30" x 42"

Noble

Connie Noyes

Originally from Washington, DC, Connie Noyes received an MFA from the School of the Art Institute of Chicago. She moved to San Francisco in 1992. "As an intuitive painter, my paintings lie in the core reality of struggle and chaos. From this core I work to extract a sense of elegance and hope. I begin by covering the canvas with layers of thick gesso and then a layer of sludge. The sludge, the waste of past paintings, transforms into something useful as the layers are alternately built up and scraped away. This constant reworking of the surface

Ruby Root. Oil and sludge on canvas. 18" x 18"

forces a connection between past and present. Through this sense of history or continuity, the richly layered canvases seem to erupt with a physical energy that has been quieted in the process of being created. When a balance is reached between chaos and control—when the intensely physical has connected with stillness—then the painting is complete."

1606 33rd Ave., San Francisco, CA 94122
415-533-2953 www.connienoyes.com

Hover. Oil and sludge on canvas. 30" x 30"

Noyes

Mark Paron

Mark Paron grew up in Ann Arbor, Michigan and is self-taught as a sculptor. He moved to San Francisco in 1984 and began showing his art. "My sculpture is abstract and conceptual—inspired by microbiotic, organic and synthetic things we come in contact with each day. I work in fabric, metal, rubber, plastic, wood, paper and more. I love layering materials that people are familiar with but wouldn't think of using in art—such as being in a hardware store and wondering what a mass quantity of a certain electrical wire might

Untitled. Aluminum. 12" x 43" x 10"

ook like…. Though I have no formal training, I have done artwork ever since I was a child, partly influenced by a steady diet of science fiction television and movies like *Lost In Space* and *The Thing*." Paron is a member of the San Francisco Art Institute's artist committee and has worked on the annual *Bio-Hazard* exhibition.

146 Portola #202
San Francisco, CA 94131 415-826-9478

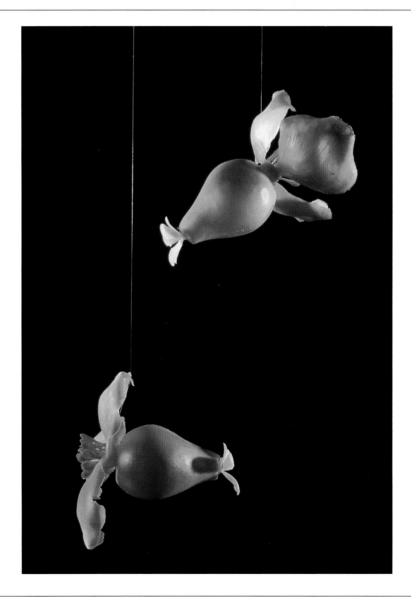

Pair of Puckers. Detail. Plastic. 29" x 29" x 30"

Paron

Sharon Paster

Originally from Oak Ridge, Tennessee, Sharon Paster received a BA from Brandeis University in Waltham, Massachusetts and studied painting at the College of Marin in Kentfield, California. "I tend to work with cropped, simple images because, for me, they have the surprising ability to express action or potential action. The rich immediacy of the oil paint, the unfussy gestures of my brush, and my somewhat awkward compositions, serve to define my real subject matter: a pair of shoes poised for movement, a chair awaiting its sitter,

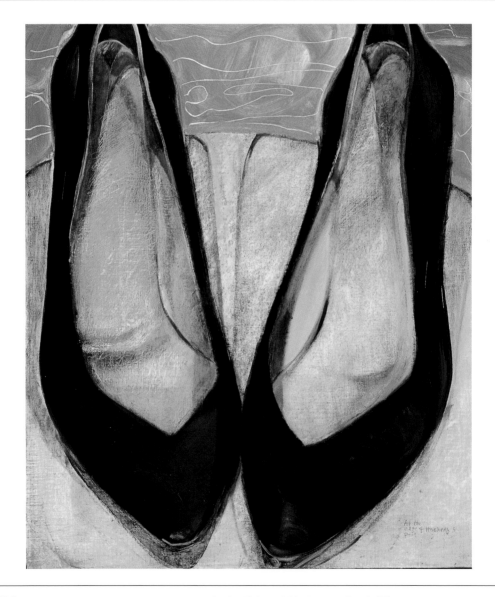

At the Edge of Hockney's Pool. Oil on canvas. 26" x 22"

a face quickly burned into consciousness. I also like to repeat forms in a single painting to reinforce their transience and project their evolution over time. Sloped curves, whether in the dramatic arch of a high heel or the subtle rounding of the lips, appeal to me for the simple reason that they feel energetic and active, part of a vital life force I aim to capture and express."

201 Laurel Grove Ave., Kentfield, CA 94904
415-457-8671 thepasters@earthlink.net

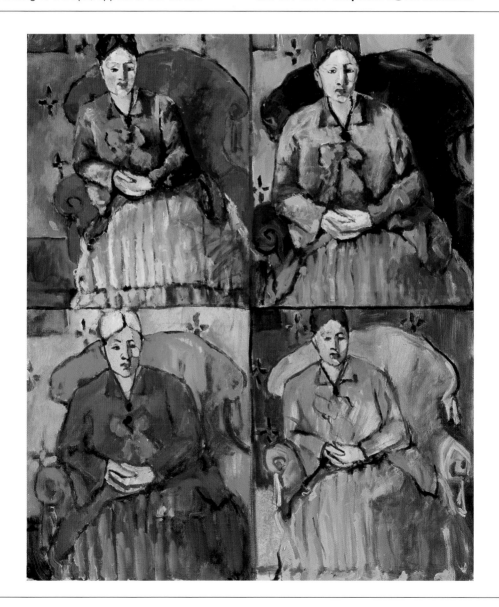

Morphing Cezanne. Oil on canvas. 24" x 20"

Paster

Frank Patt

Frank Patt grew up in DuBois, Pennsylvania, and received a BS from Pennsylvania State University. "When I set out to make a painting I have no preconceived intent regarding the images or symbols I might use. My imagery and symbols are personal, intuitive and emotional. I use visual elements of design, color, symbols and numbers to give order and rhythm to my paintings. I work on complex layers of oil paint, revealing surfaces within previous layers of paint and revealing a personal history of my interaction with the paint

Few and Far. Oil on canvas. 60" x 48"

and the canvas. Although I have no initial plan, the images and symbols that come through evoke specific memories and emotions. But whether these feelings have been felt in the past, are being felt, or need to be felt I cannot say. The most interesting aspect to me about painting is trying to understand the feelings and emotions of what I have made after the fact."

893 Wisconsin St.
San Francisco, CA 94107 415-826-2126

Here and There. Oil on canvas. 60" x 48"

Patt

Francesca Pera

Francesca Pera received a BA in painting and printmaking from San Francisco State University, where she studied with Robert Bechtle and Rupert Garcia. She has worked as a typographer, graphic artist and art educator. "My parents were both artists.

As artists and individuals they walked through 'fire.' I watched them turn inside out and they were scarred. I, too, have felt and fanned the flames. As a child I lived in the world of my dollhouse. Loving the beds and the chairs, the dishes and the tables, I made it mine—all

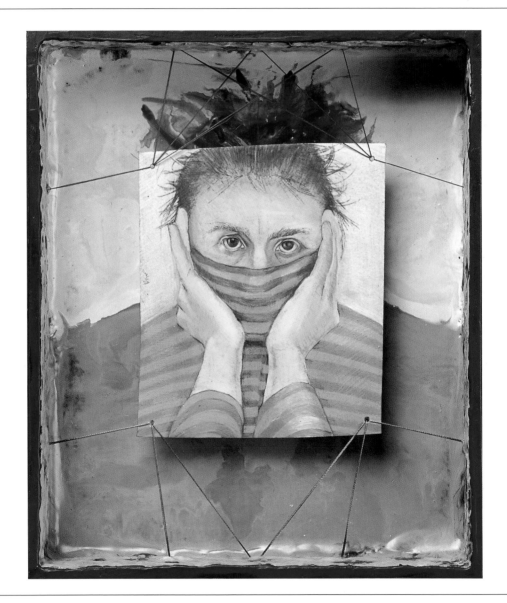

Face and Hand Series #5. Mixed media, encaustic. 9.5" x 8" x 2.25"

mine. My aunt and uncle were picture framers. In retirement, my aunt discovered the interior world of shadow boxes. With miniature furniture, she made elegant and delightful rooms. They took me back. A box becomes a place to dwell. It can be a place to pay homage or a place to remember. With a feeling of intimacy and fragility, one is asked to enter."

762 23rd Ave., San Francisco, CA 94121
415-387-2731 www.francescapera.com

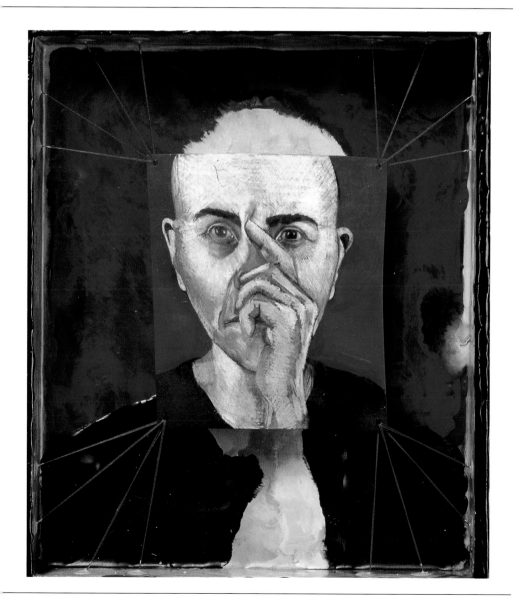

Face and Hand Series #2. Mixed media, encaustic. 9.5" x 8 " x 2.25" **Pera**

Richard Perri

In the 1970s Richard Perri owned Cavanaugh's Bar at 29th and Mission in San Francisco and created underground comics with cartoonists Robert Crumb, Art Spiegelman and Rory Hayes. He is now a fine artist who paints the disappearing blue-collar coffee houses in the area south of Market Street (SOMA). "Change happens. Time lends a hand. People, places and things come and go—dynamic transitions from social change and the wrecking ball. San Francisco's java huts are memorialized in these pictures. Temporary monuments, they

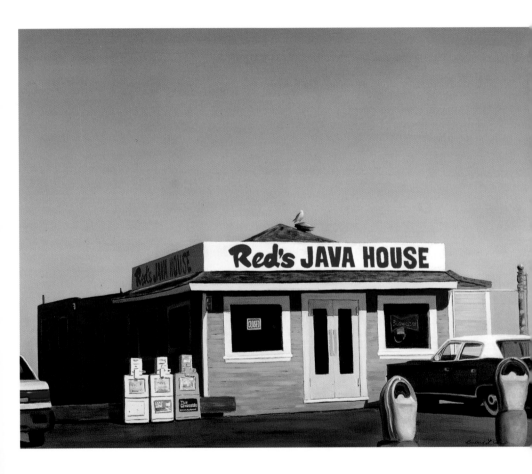

Java House. Oil on canvas. 4' x 5'

characterize San Francisco, identify the historic guts of this town, and portray an era when the waterfront was teeming with a life that was the heart blood of this great city. I see color and atmosphere in a place where time has left its mark—memorializing places in a unique environment, creating an experience austere and challenging to the imagination and rife with significance."

P.O. Box 330151, San Francisco, CA 94133
415-931-3993 www.richardlperri.com

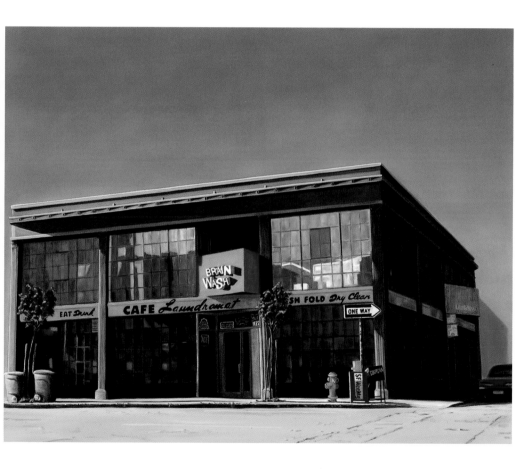

Brainwash. Oil on canvas. 4' x 5'

Perri

Lisa Pfeiffer

Formerly a professional illustrator, Lisa Pfeiffer received a BFA in illustration from the Rhode Island School of Design and studied painting at Studio Art Centers International in Florence, Italy. "My recent work reflects a personal journey concerning aesthetic experimentation— using color and composition, and the rethinking of my own use of visual language. From simplifying and abstracting my surroundings an image is found and color applied. I work on clear vinyl, gradually applying paint in layers while allowing a certain amount of vinyl to

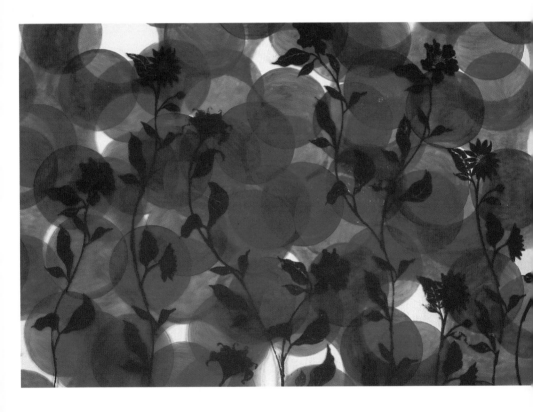

Red Blood Cells #4. Acrylic on vinyl. 36" x 40"

show through. When a painting is complete, the painted surface is then turned around and mounted opposite the direction it was painted. The transparent surface merges the foreground with the background by the texture and color of the wall behind it. In the end I try to match the color and shape with the composition that I originally envisioned."

Oakland, CA
510-381-2403 pfeiffer_lisa@hotmail.com

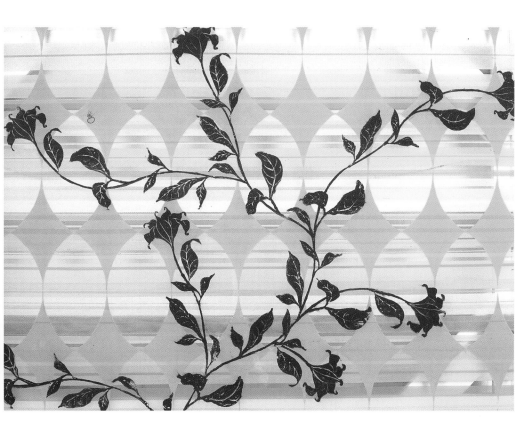

Blue Loves Orange. Acrylic on vinyl. 36" x 48"

Pfeiffer

Daniel Phill

Originally from Tacoma, Washington, Daniel Phill received an MFA from Stanford University. He has been living and painting in San Francisco since 1977. "I am interested in the balance of biomorphic shapes with unexpected colors. Working within the tradition of Abstract Expressionism and living among the history of Bay Area painting, I seek a uniqueness and tranquility in the paintings. I often apply multiple layers using acrylic, oil, gouache, ink, spray paint, charcoal, pencil and crayon. Color plays a psychological role in animating and further

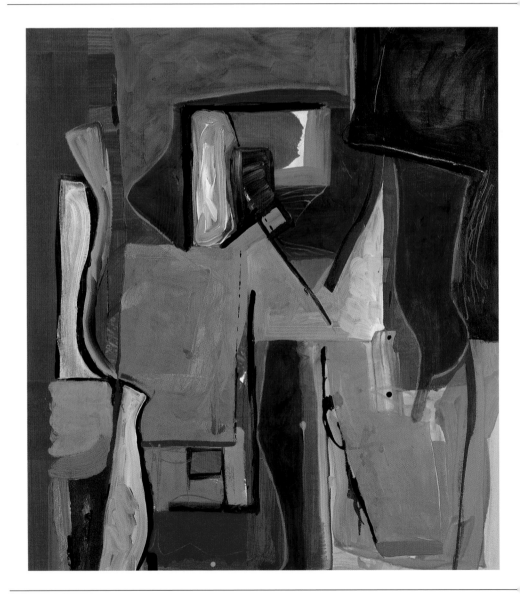

August. Acrylic and mixed media on paper. 36" x 32"

defining the forms. I create through a rhythm that is organic and unpremeditated. There is an intuitive, spontaneous use of shape, texture and color that is eventually grounded through a more controlled and ordered completion. Monotype and drawing are quite important in developing my personal vocabulary of symbols. These gestural, raw works provide a format for synthesis and refinement of images."

Pier 70 Bldg. 11 #208, San Francisco, CA 94107
www.danielphill.com 415-864-2284

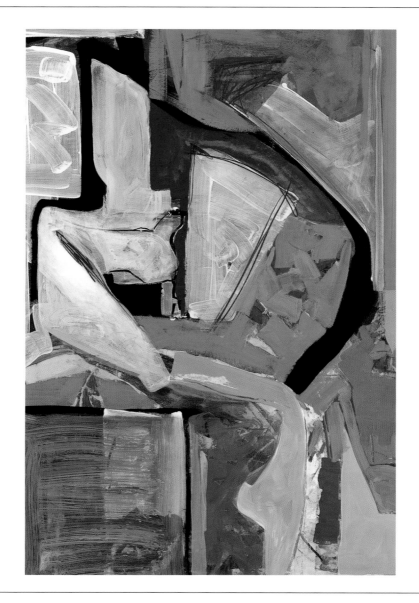

Sandbank. Acrylic on paper. 42" x 30"

Phill

Leslie N. Piels

Leslie N. Piels received an MFA from the San Francisco Art Institute and has been painting since 1982. "I paint everyday objects from my home and the natural world outside. Often I abstract the forms and place them in unusual compositions. From my attic studio window I watch the birds, squirrels and leaves of the trees live through the changing seasons. I use forms and beauty found in my world to examine my personal experiences with emotions, death and time. As I observe time passing, I am aware of nature changing with

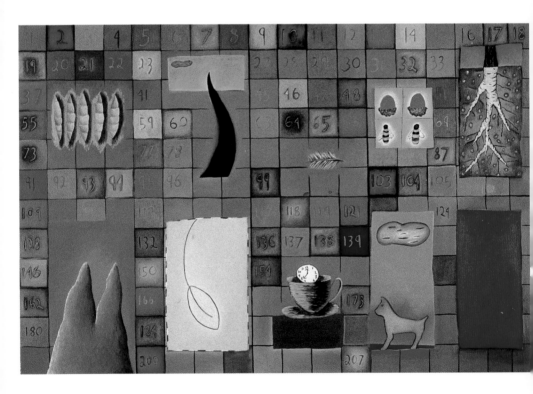

Greatest Hits. Acrylic on wood. 24" x 36"

the seasons and my children growing up. I paint the tension between the rigidity of the way time is marked and natural growth. At times I see the beauty and wonderment of the conflict and at times, the sorrow and pain. I use grids and open fields of color to demonstrate the set marking of time versus the natural rhythm of change."

Oakland, CA
510-834-8451 lmjpiels@pacbell.net

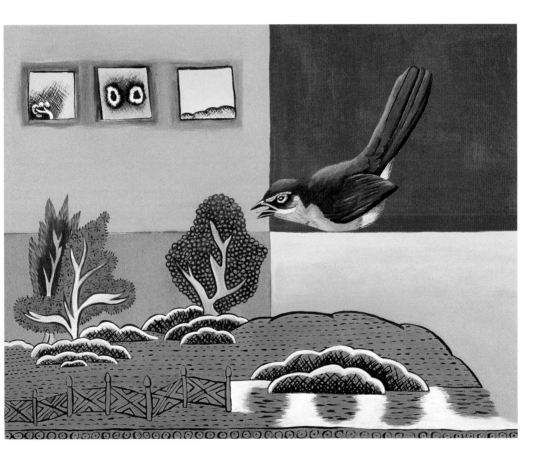

The Lovers. Acrylic on wood. 12" x 16"

Piels

Silvia Poloto

Originally from São Paulo, Brazil, Silvia Poloto has a permanent exhibit at the Brazilian Embassy in Los Angeles and was an artist-in-residence at the Fine Arts Museums of San Francisco in 2001. "Through my sculpture and painting I bring together an assortment of thoughts and images. I do not strive to portray the obvious but instead push the viewer to rely on intuition. I challenge the viewer to translate my visual language from a subjective position. Whether it is sculpture or it is painting, I work in series. Once I envision a concept, I

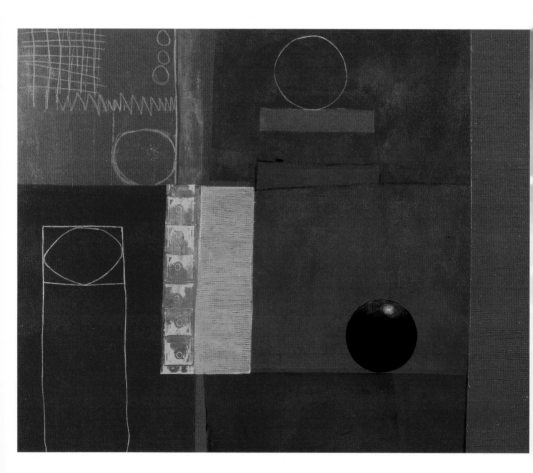

Spheres on Surfaces #18. Acrylic on canvas. 48" x 60"

start exploring it until I feel I have expressed what I wanted to say. I have no preconceived idea of my finished work. For me it has everything to do with the process, which inevitably will express my self and aspirations. It is a dynamic process; ideas develop and evolve as I work on them. I let it find what it wants to be."

442 Shotwell St., San Francisco, CA 94110
415-641-5878 www.poloto.com

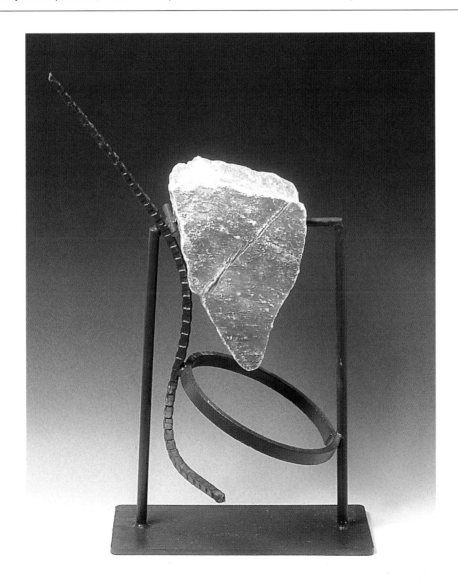

Suspended Alabaster #1. Steel, stone. 36" x 20" x 12"

Poloto

John Poon

San Francisco Bay Area native John Poon received a BFA from the Academy of Art College in San Francisco, where he now teaches. "I have always been encouraged by the profusion of varied landscapes and artist interpretations in the Bay Area. With such early experiences as viewing Van Gogh's exhibition at the de Young Museum in San Francisco, my appreciation of art emerged at an early age. A childhood full of drawing and painting foreshadowed for me an artistic future. For me, there is a beauty in the earth, in all its

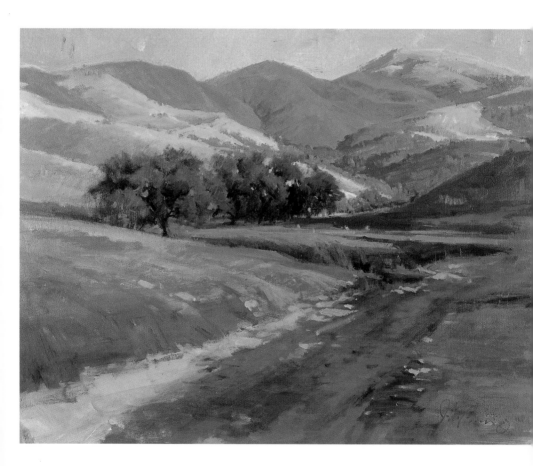

Autumn Oaks. Oil on canvas. 24" x 30"

expressions and moods. The hills and valleys of California where I live, the country roads, the vineyards, trees, meadows, grazing cows and horses—these are the things that captivate me. They stand as a visual array of texture, shape and color, to be observed, arranged and organized by the discerning eye onto canvas, an infinite spring of inspiration for the landscape painter."

2018 Risdon Rd., Concord, CA 94518
925-687-6156 jpoon@onewest.net

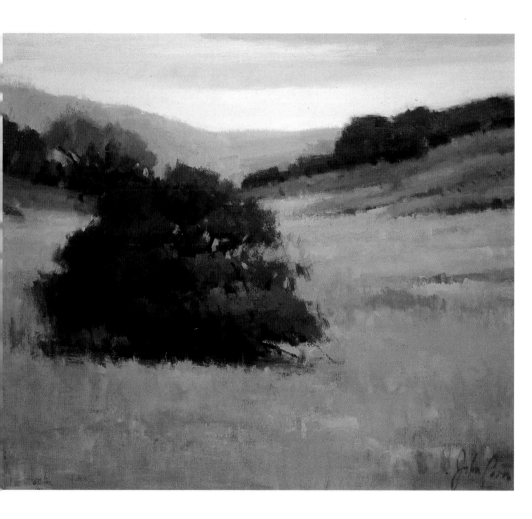

Winter in Bloom. Oil on canvas. 20" x 24"

Poon

Eric Powell

Bay Area native Eric Powell studied painting and sculpture with Robert Colescott and Dennis Levine and metalsmithing with Fred Kabotie and Jan Peterson. "My relationship to iron involves bringing flexibility and malleability to a material that is inherently resilient and resistant. In the process of interacting with it, the metal reveals its secret properties. I have alternated between commissions and direct studio work for the past fifteen years. The two processes are different in some significant ways. The commissions are collaborative and

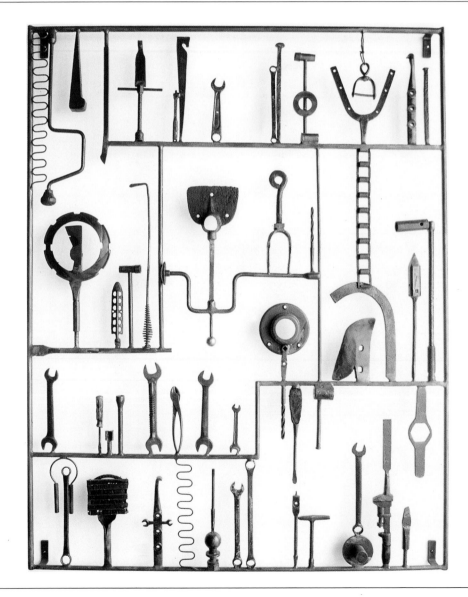

Untitled. Composition. Steel, cast iron. 60" x 48"

the studio work is much more improvisational. However, they inform and feed ideas to each other. The work includes sculpture, architectural elements like gates, one of a kind and limited edition furniture designs and drawings. The underlying thread is the compulsion to create something that works, which is sometimes difficult to define, and that draws you in and invokes a sense of wonder."

1777 Yosemite St., San Francisco, CA 94124
415-822-1876 www.ericpowell.com

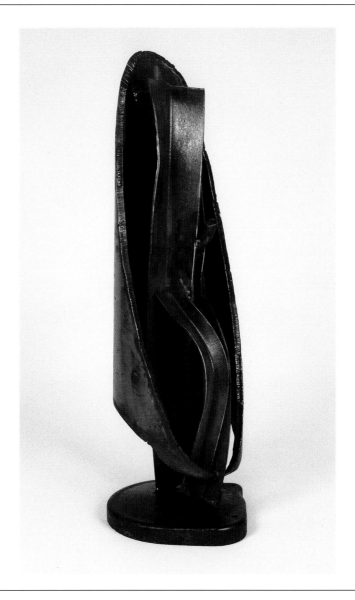

Yoni. Steel. 32" x 10" x 10" **Powell**

Camille Przewodek

Camille Przewodek received a BFA from the Academy of Art in San Francisco. She is a signature member of the Laguna *Plein Air* Painters Association and the Oil Painters of America. "Color that expresses the effects of light and atmosphere can make even the most mundane scene strikingly beautiful. I often go back to the same place at different times of the day in order to capture the nuances of different light effects. I learned my color from the Impressionist master, Henry Hensche, at the Cape School of Art in

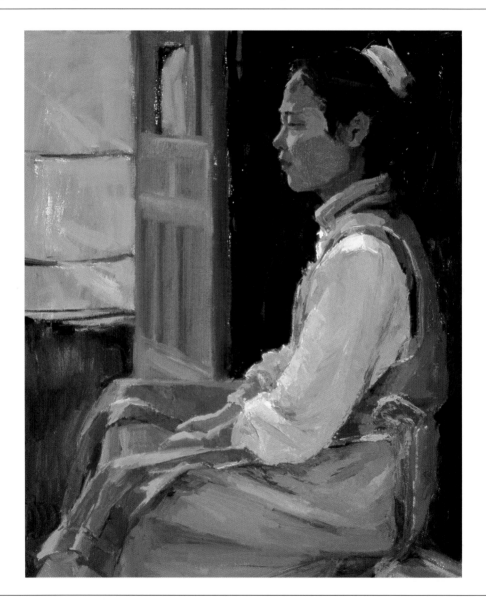

Mongolian Memories. Oil on canvas. 24" x 20"

Provincetown, Massachusetts. Henry opened my eyes to a new way of seeing. Through my workshops, I am trying to keep this tradition alive. Each time I set up on location, I am humbled by nature. The more I observe and learn about color, the more I realize that I have a lot more to learn. It is this knowledge that keeps me striving for excellence."

Petaluma, CA
707-762-4125 www.przewodek.com

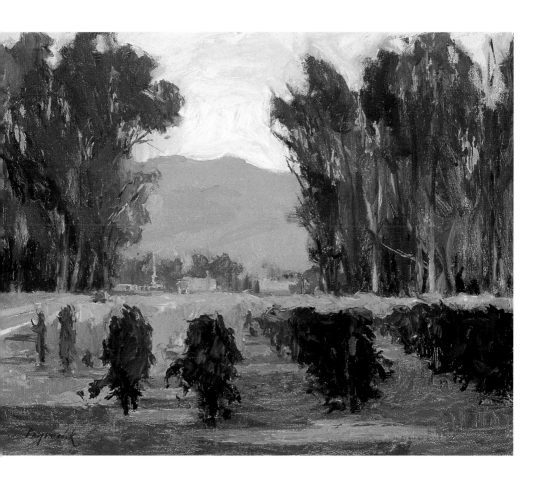

Vineyard Sunset. Oil on canvas. 16" x 20"

Przewodek

Joe Ramos

Originally from California's Salinas Valley, Joe Ramos received a BFA from the San Francisco Art Institute and an MA from San Francisco State University. He works in monotype, painting, mixed media and photography, and has served on the board of the California Society of Printmakers. "My monotype imagery is abstract but is inspired by natural and botanical forms. I do occasionally insert literal elements into the work. Since a monotype is a medium where only one print is made, I prefer to take the monotype to its

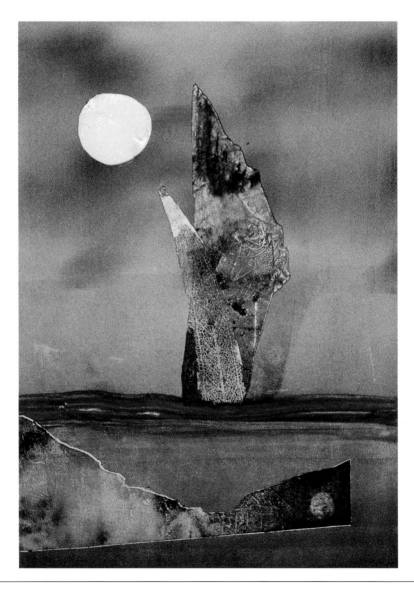

Untitled. Monotype. 7" x 5"

limit. After I have the first impression, I use the residue ink left on the plate (called the ghost) and further manipulate it by adding or subtracting ink, rearranging stencil elements and continue to make more images. The resulting imagery is more subtle, transparent and almost ethereal in quality. I am able to get a series of images that, while not identical, do have a thematic relationship."

276 Fourth Ave., San Francisco, CA 94118
415-386-8659 ramosart@pacbell.net

2 Calas. Monotype. 8" x 8"

Ramos

Mary Curtis Ratcliff

Mary Curtis Ratcliff worked as a sculptor for twenty-five years before experimenting with image transfers during a residency at the Virginia Center for the Creative Arts. "I drew on images from a photo archive that goes back fifty years, including involvement in the early video movement in New York. The kinds of overlays and effects these works create may be evocative of video montage or edits, but have a much more hand-rubbed, personal touch, and real human warmth. I rework the images with graphite, prismacolor, paint and

Two Birds. Mixed media on wood. 44" x 66.5" x 3.75"

collaged xerography. While these compositions are superficially two-dimensional, they play not only with the third dimension, but also with that fourth dimensional space of the imagination: memory and time. So one might say I have moved from cold time-based electronic media to warm hand-based works on paper, intricate visual scaffolds that evoke the texture of a life lived from the inside."

630 Neilson St., Berkeley, CA 94707
510-526-8472 mcratcliff@earthlink.net

Statue of Liberty. Mixed media on paper. 22.5" x 30" **Ratcliff**

Walter Robinson

Walter Robinson received an MFA from Lone Mountain College in San Francisco. "Growing up in the San Francisco Bay Area in the 1960s, I was influenced by the Funk movement, Pop Art and California cartoon culture, and began making goofy, psychologically loaded painted wooden objects that challenged the viewer with a visual conundrum. My new work tends to be less representational, while still being referential. This allows people more room to interpret the work with their own set of references.

Sparkle Pups. Wood, epoxy, metal flake. 19" x 26" x 9" each

This menacing, yet cute series of abstracted, reduced animal forms is made of carved wood and tree limbs. They are coated with a tinted and metal-flaked industrial epoxy. Wood is a material I feel comfortable with, having worked continually with it since childhood.

By challenging myself technically and pushing the material in new ways, I have developed a growing understanding of the medium."

San Francisco, CA
415-643-3102 walterrobinson@hotmail.com

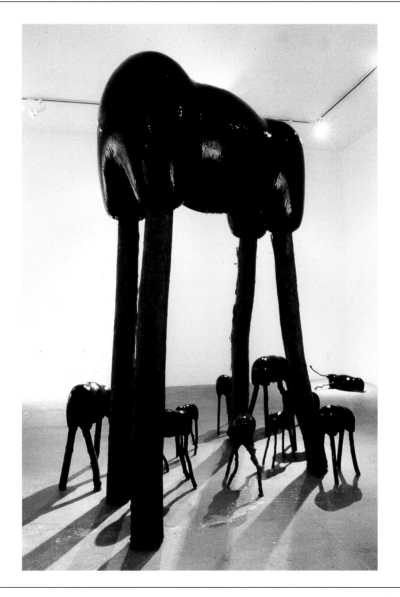

Tar Pets. Wood, epoxy. 12" x 9" x 4" each, and 96" x 65" x 30"

Robinson

Jonathan Russell

Originally from Boston, Jonathan Russell has taught sculpture at the University of California at Santa Barbara and Harvard University. "Texture, form and line are the important elements in the creation of each sculpture. I seek the correct balance of forms within each piece to create unity and harmony, as my interest is in the dialogue that takes place between these elements. My surface treatment emphasizes the texture and shadows behind the beauty of the exterior form. Copper and steel are my essential materials. The copper

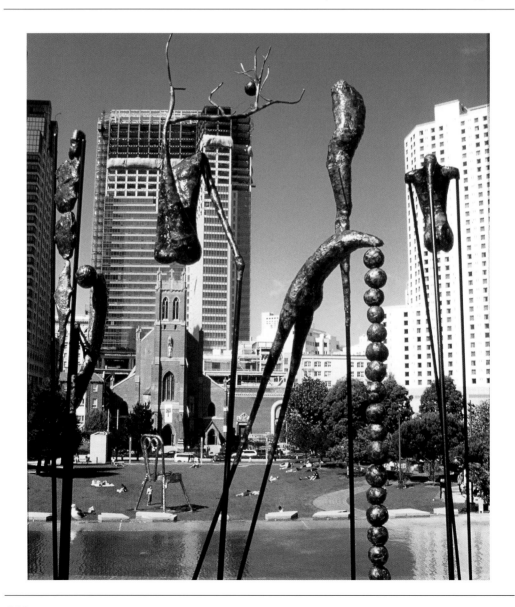

Winter Landscape. Copper, steel. 8' x 12' x 16'

elements are created using an electroforming technique. This is done by dipping the original form, which is coated in a metallic powder, into an electrolytic bath where copper is slowly built up on the surface. When the desired thickness has been achieved, the form is removed from the bath. The copper is then separated from the original form, leaving a self-supporting copper shell."

1777 Yosemite #150, San Francisco, CA 94124
415-671-0120 www.redmetalarts.com

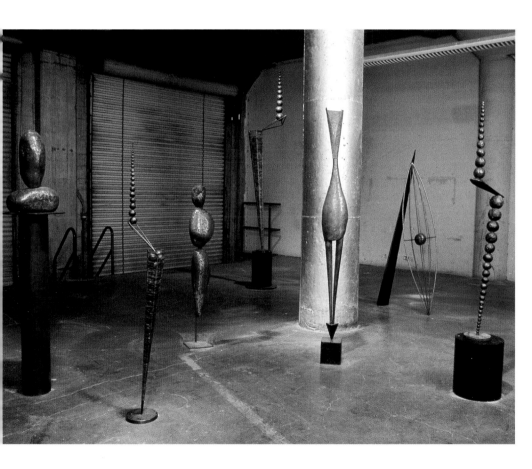

Untitled. Installation. Copper, steel. 10' x 20' x 20'

Russell

M. Scott-Kirby

M. Scott-Kirby studied illustration at Art Center College of Design in Pasadena. "The majority of my work is in transparent watercolor, though I am sometimes commissioned to do large-scale graphics, murals, sculpture and art furniture. I enjoy the fragility of watercolor paint and the design found within architectural planes and divergent patterns of street signage. I use a nontraditional approach when painting, boldly laying in the background first to set the composition, working from dark to light, using stains and lifting thick layers of color,

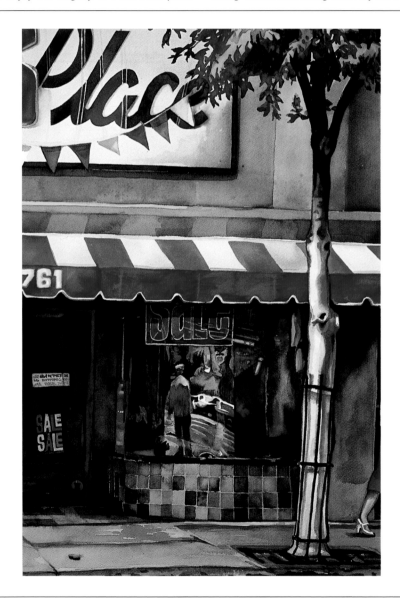

Place 761. Watercolor. 25" x 20"

allowing the delicate nature of the paint to emerge. I manipulate the colors and then just let mistakes happen. The various textures, subtle hues, and patterns playing against the strong angles of light and shadows intrigue me as I intuitively lose myself in detail. For this reason, though my work leans toward realism, I like to think of myself as an expressionist."

10400 Wood Bridge, Rancho Cordova, CA 95670
www.absolutearts.com/portfolios/m/mskreate

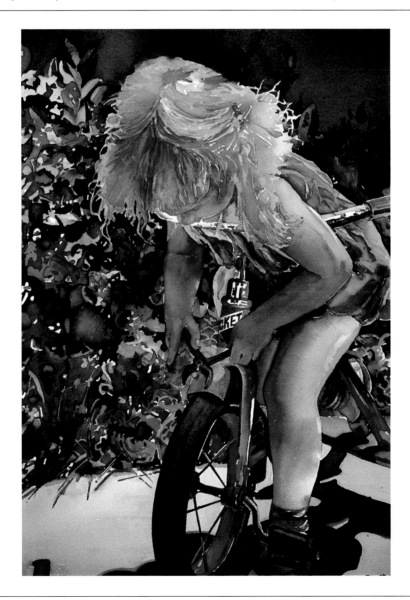

Mechanic. Watercolor. 18" x 14"

Scott-Kirby

Judy Seidel

Judy Seidel received an MBA from the University of California at Berkeley. "My relationship to art is about transformation. Many external stimuli inspire my work. Weathered, aged surfaces particularly capture my attention because they came about through transformation, and often reveal a sense of dimension. The visual and tactile impressions I take in are condensed and abstracted, then represented by shapes, colors and layers. A frequent motif within the layers is primitive goddess symbols, many of

Passage #65. Acrylic on paper. 24.75" x 18"

which are also nature symbols. The goddess symbols are meaningful to me because they are organic and represent various aspects of transformation. Yet my work is modern and essentially abstract. My overall intent is to create a sense of perspective, of multiple vertical planes, and to consolidate into a multi-dimensional one the old and the new, a kind of purposeful *pentimento*."

1211 Cedar St., Berkeley, CA 94702
510-524-3915 www.judyseidel.com

Ode to Peace and Harmony I. Acrylic on paper. 21.5" x 14.5"

Seidel

Mick Sheldon

Mick Sheldon received an MFA from the University of California at Davis and teaches art at Sierra College in Rocklin, California. "I first used the wood block printmaking method after seeing an exhibition of German Expressionist works. I have now carved hundreds of blocks and made them into hand-colored pictures. All these images are carved into birch plywood, printed black on white by driving over them with my car or dancing on them until the ink is worked into the paper. They are then colored with various water

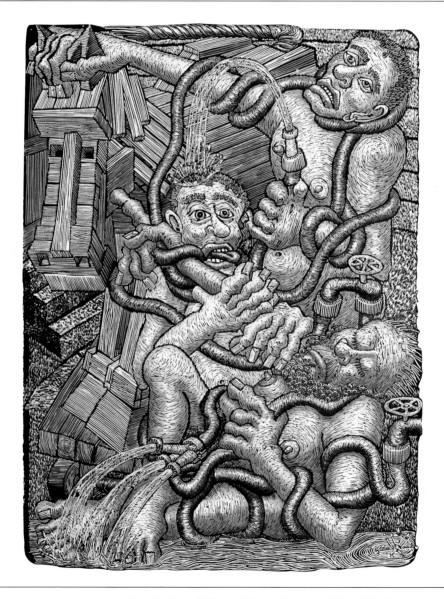

The Backyard Citrus Heights Laocoon. Wood block print. 48" x 36"

media, making them both individual and multiples…. The 15th century painting titled *St. Wolfgang Forces the Devil to Hold His Prayerbook* by Michael Pacher and El Greco's *Laocoon* contain stories and images just too good not to employ in my work. I update those stories and images to these suburban times. I also use humor as an access to each piece. This is usually as harmful as it is beneficial."

P.O. Box 427, Yolo, CA 95697
530-662-0923 www.micksheldon.com

Amidst the Noxious Stenches of Hell St. Wolfgang Forces the Devil to Hold His Prayerbook **Sheldon**

Henry Sides

Henry Sides received a Ph.D in philosophy from the University of North Carolina at Chapel Hill and has lived and worked in San Francisco since 1970. "My work has been called both sensual and philosophical. When I paint I try to produce something that has a sense of mystery. I want my work to make people think about the strangeness of life and, perhaps, its brevity because, for me, painting is a meditation on life. I would like the work to draw people in and make them want to return to it. I hope that the work is beautiful. I always work

Symbol Series II. Oil on panel. 43" x 36"

in series. Symbols and figures integral to an earlier series appear in later series, providing a totality to the work. These two paintings are from the *Symbols* series. Many of the symbols used, both religious and otherwise, are ancient and have had different and even opposite meanings in our history. In my paintings, these symbols appear in strange terrains."

San Francisco, CA
415-665-4611 www.henrysides.com

Symbol Series #10. Oil on panel. 24" x 22"

Sides

Claus Sievert

Originally from Detmold, Germany, Claus Sievert creates intricately rendered etchings of the natural world. "During my art school years I was drawn to the style and technique of the old European masters of printmaking. I found the slow and detail-oriented approach to be uniquely suited to portray the visual richness of nature. Since early childhood I've found much inspiration there, and from trees in particular. The finely-etched lines pay tribute to the intricate detail and venerable age that I cherish in my subjects. Timelessness in a fast-moving

Bennett Juniper. Hand-colored line etching. 8" x 6'

world is also a concept embodied in this kind of work. In 1981, after giving up a teaching career in Germany, I found my greatest inspiration in California's natural treasures, among them the oldest, tallest and biggest trees in the world. I create varied editions by hand-coloring each print, a time-consuming technique allowing for rich subtlety and variation of each piece."

Grass Valley, CA
530-273-0237

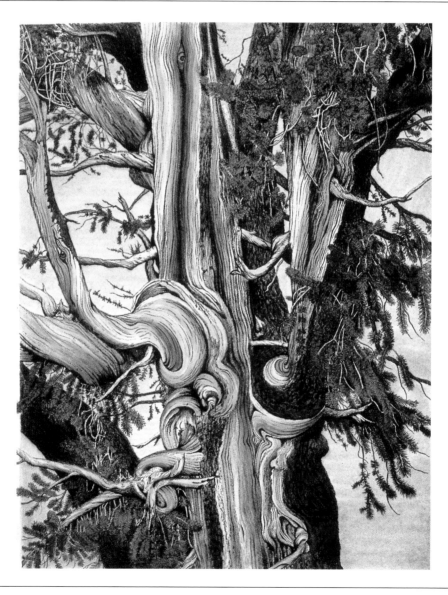

Ancient Bristlecone Pine. Hand-colored, soft-ground etching. 18" x 14"

Sievert

Mel Smothers

Mel Smothers received an MFA from the University of Idaho and teaches painting at the University of California at Davis. While in graduate school he began designing paintings using a computer, and has developed a blend of computer technology and studio practice using single image random dot stereovision (SIRDS). The artwork is three-dimensional when viewed through video game glasses. "My work is a personal vision of the art of painting. I say this because it's very hard to explain in academic terms what it is I'm doing. Like

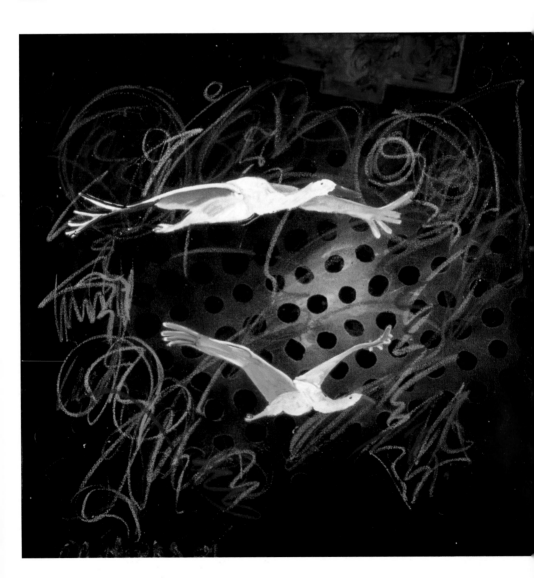

Flying Lessons #18. Acrylic on canvas. 40" x 40"

hearing two conversations at once, or maybe three or four. I've stolen heavily from current computer color theory because I like what I see on the screen, yet I hate what I feel like after a day in front of a computer." A current public arts project at a Sacramento light rail station uses stereovision on a wall mural, and reproduction image technology to create a holograph effect on the windows of arriving passengers.

1823 Carlsbad Pl., Davis, CA 95616
530-756-6635 emsmothers@ucdavis.edu

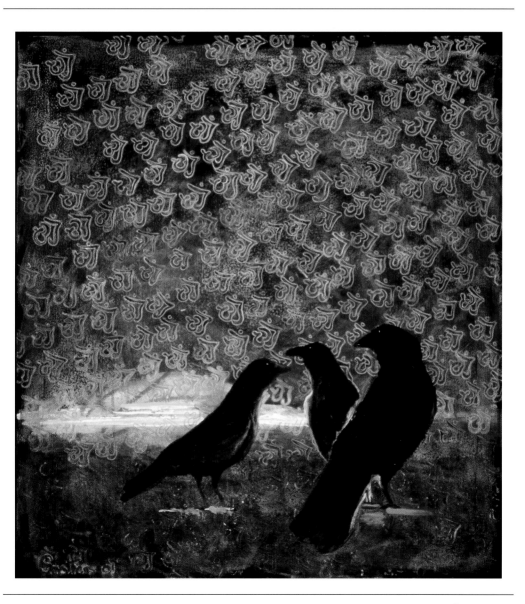

Crow Stories #13. Acrylic on canvas. 52" x 48"

Glenn R. Steiner

A professional photographer since 1977, Glenn Rakowsky Steiner received a BFA from the San Francisco Art Institute. "My goal is to create exhibition quality, abstract location photography in the tradition of the old masters with whom I have studied: Wynn Bullock, Aaron Siskind and Cole Weston. A century ago, my family owned the Warren Cannery in Cathlamet, Washington. As a young boy, Pop would take me down to the cannery, spinning wonderful tales about the turn of the century, the fishing industry on the river, and his own childhood. This was

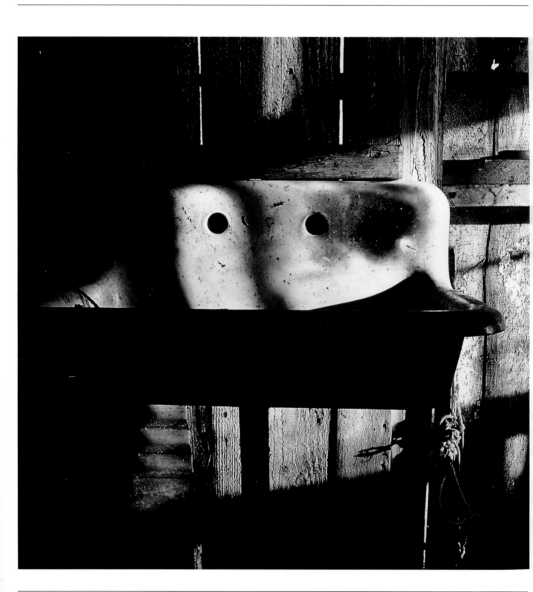

Washing Sink. Split sepia-toned gelatin print. 10" x 10"

fantastic stuff and sparked my imagination. Twenty-two years later, I recorded Pop's oral history and then went to the cannery, finding a world of darkness illuminated by moving pools of liquid light, filtering through gaps in the roof, reflecting through the floor boards off the river water below. Photography in this way is a process of discovery and enlightenment. The series built itself."

220 Ridgeway Ave., Fairfax, CA 94930
415-459-2001 www.glennsteiner.com

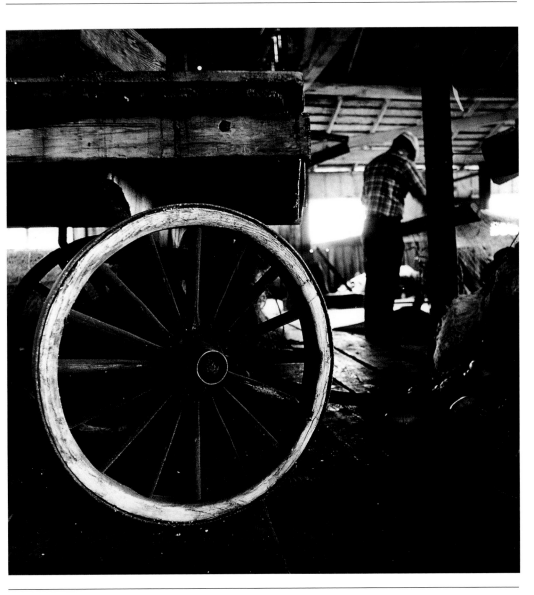

Old Wagon. Split sepia-toned gelatin print. 9.5" x 10" **Steiner**

Arthur Stern

Arthur Stern studied architecture at the University of Illinois and environmental design at the California College of Arts and Crafts in Oakland. "While best known for my commission work in architectural glass, I also work in mixed media on canvas and create works on paper. Over the years I have developed and refined a personal abstract vocabulary. I often work within a family of design, or variations on a theme, and have evolved a language of certain geometric symbols and repeating motifs. Much like a

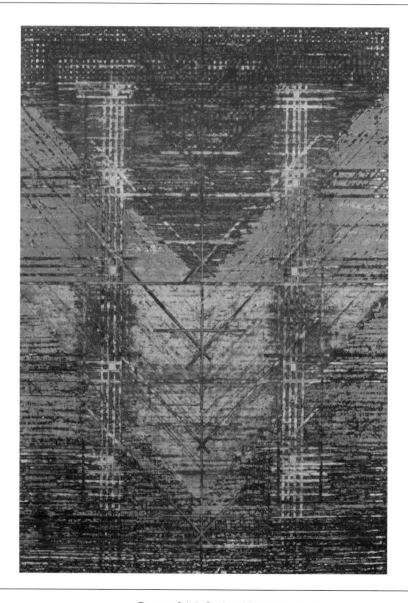

Prayer Stick Series. Mixed media on arches paper. 46.5" x 34"

musician, I use this language as a basis for improvisation. All my work shares a similar evolving design vocabulary. My works on paper are complex layered and textured pieces, originally created in oil pastel on arches, and more recently as hand-colored and collaged prints. I call them 'techno-primitive' pieces, as they evoke feelings of both the past and the future. Geometry is timeless."

1075 Jackson St., Benicia, CA 94510
707-745-8480 www.arthurstern.com

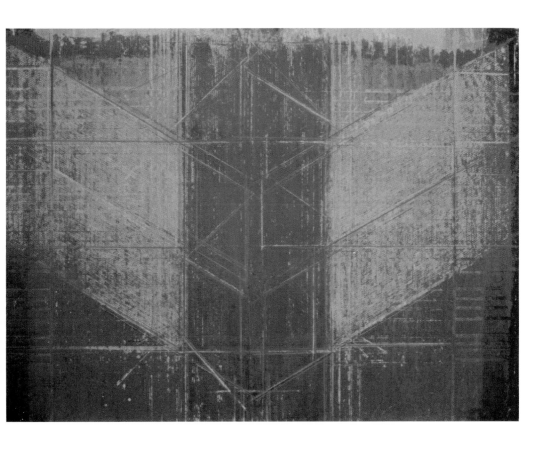

Prayer Stick Series. Mixed media on arches paper. 34" x 46.5" **Stern**

Charles Stinson

Charles Stinson studied drawing, photography, printmaking and sculpting at the Museum of Fine Art School of Art in Houston and learned Japanese brush techniques in San Francisco with master calligrapher Shioh Kato. "My art shapes ideas that come to me in flashes of inspiration or lucky accidents of exploration. The medium is just a vehicle for metaphoric lessons. Revisiting and reworking ideas and images over time infuses my pieces with layers of meaning. One series builds

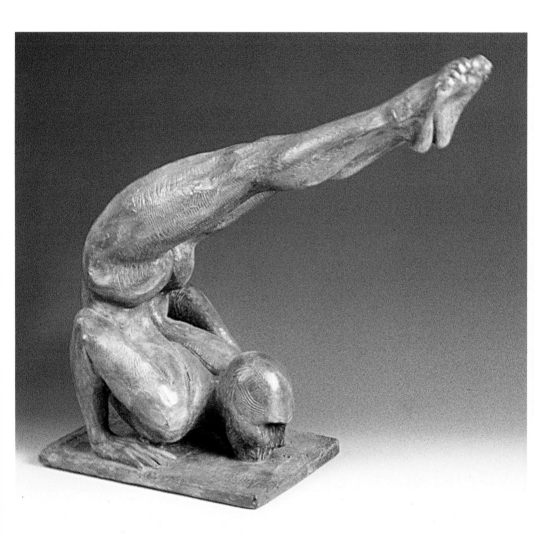

Ganda Bherundasana. Bronze. 15" x 15" x 7.5"

on over two decades' practice of yoga. Each figure, intentionally raw or incomplete, is a reminder that these imperfect bodies and minds are our tools for shaping this brief flash of life. *Waiting*, shown below, is a study of textural contrasts and ambiguity, and an exploration in combining low and high bas relief."

San Francisco, CA
415-626-8349 www.charlesstinson.com

Waiting. Bronze relief. 9.5" x. 9.5"

Stinson

Mary Street

Mary Street received a BFA from the California College of Arts and Crafts in Oakland. "I began my art career creating one-of-a-kind vests, then explored papermaking, bookmaking and printmaking. All these design skills influence the way I make paintings and prints today.

Current work portrays my experiences in a colorful, graphic and often playful approach. My palette is usually limited to three or four colors blended into a cohesive variety in the composition. Everyday objects in my compositions are linked to a 'collective

Mind Noise. Acrylic on canvas. 50" x 44"

consciousness.' For example, the chair could represent my sense of place, an arrow my search for direction. Graphic elements like dots and dashes, arrows and X's add to my visual language, forming riddles, questions or statements about life's journey. If I keep a sense of humor through all the peaks and valleys of the creative process, both life and art are more colorful, spontaneous and playful."

P.O. Box 1834, Nevada City, CA 95959
530-265-9674 www.marystreet.com

Game Board #39. Mixed media on paper. 20" x 16" **Street**

Toru Sugita

Toru Sugita was born in Shiga, Japan and received a degree in painting from Kyoto University of Education. "I have been working with the theme of light and shadow. I feel moved when sunlight touches an object in the afternoon, making a momentary drama of color and shape. These shapes and colors may change or disappear in the next moment. I try to capture this moment and express it in my work. Since the printmaking process is reminiscent of the relation between light and shadow, I have chosen to work in this medium

　　　Roommate on Balcony. Etching, aquatint, drypoint. 6" x 9"

for a long time. Working with etching and aquatint, I can express my feelings towards light and shadow best by using tones of black and white. The graphic nature of black and white allows me to follow the directions of lines and shapes to describe architectural elements. Once I eliminated color from my work, I found myself drawn towards exploring physical 3-D space."

P.O. Box 880092, San Francisco, CA 94188
415-643-5723 www.torusugita.net

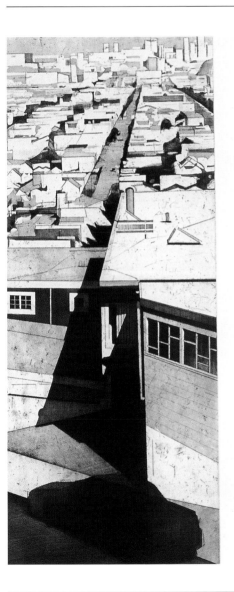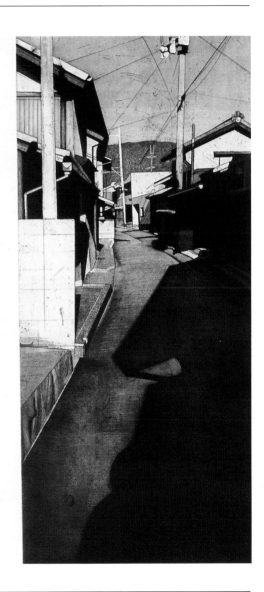

A Street (Combination). Etching, aquatint, drypoint. 36" x 15" and 36" x 16" **Sugita**

Ann Switzer

Ann Switzer received a BFA from the California College of Arts and Crafts in Oakland and is a signature member of the California Watercolor Association. "Nature is a wonderful art teacher. I am continually surprised and fascinated by the variety of beautiful color combinations, shapes and patterns that occur in our natural environment. I enjoy painting intimate floral portraits, often from a new or unusual perspective. I may zoom in to capture an interesting detail, or focus on the gracefulness of the back of the flower. Each blossom is

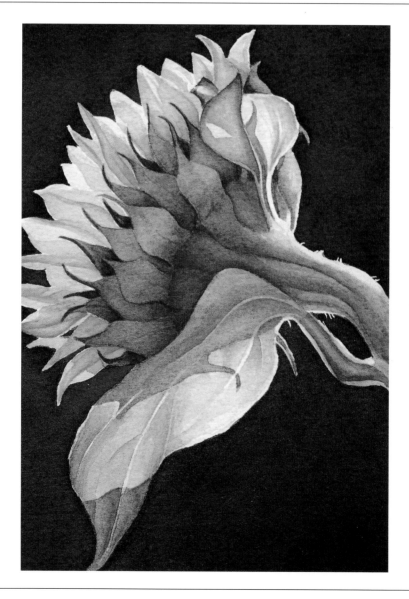

Sunrise. Watercolor. 14" x 10"

created with unique qualities. It may not be fresh; the petals may even be torn. My paintings often show the contrast between these delicate creations and the harsh world in which they must survive. The dramatic effects of light continually inspire me. I find that watercolor best allows me to capture the wonderful luminosity, transparency and rich color variations that light creates."

1337 Fourth St. #3, San Rafael, CA 94901
415-927-9002 aswitzer@attbi.com

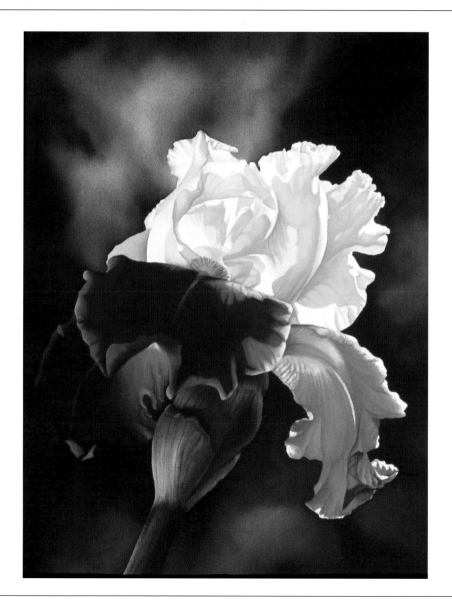

Last Light. Watercolor. 24.5" x 22"

Switzer

Brenda Tharp

Brenda Tharp has conducted wilderness photographic workshops since 1986 in Alaska, Maine, Colorado, Florida, New Mexico and California. Her work has been published in *National Geographic*, *Outside* and *Sierra* magazines. "My landscape photographs are the result of combining those moments when color, form and light all come together in one magical situation. Yet it's not always about dramatic light. I also love to create images that portray the inherent designs found in nature— the lines, textures, patterns, forms and shapes

Late Autumn Aspens, Utah. Archival photo. 20" x 30"

that exist everywhere. Extracting details of a larger scene simplifies the statement I am making about what I am seeing. My goal is to find a personal expression for that which I am both viewing and experiencing. As I open my eyes to see my subjects more deeply, the results often transcend the literal and become more abstract representations of nature's beauty and mystery."

1017 Margaret Ct., Novato, CA 94947
415-382-6604 btharp@earthlink.net

Painted Hills, Oregon. Archival photo. 13.75" x 19"

Tharp

Elizabeth Tocher

Originally from Yonkers, New York, Elizabeth Tocher received a BFA from the California College of Arts and Crafts in Oakland and an MFA from the University of San Francisco. "I work with acrylic paint on paper and on canvas, superimposing images such as architectural elements, geometric shapes, vegetation and sometimes figures, to develop interesting relationships of elements and shapes. It is a great challenge for me to follow an inspiration for a painting and to plan color shapes and color relationships

Zigzags. Acrylic on paper. 24" x 18"

to flow in harmony with original inspiration. Line, texture and various color values are used to stimulate directional movement. I wish to express a feeling of mystery in a complete and unified composition, and trust that the abstract quality in my paintings will encourage the viewer's imagination and perception of the work."

15 Santa Maria Ave. #3
Pacifica, CA 94044 650-359-6624

Running Horse. Acrylic on paper. 24" x 18"

Tocher

James Torlakson

James Torlakson has been a professional artist since 1971. "I feel a great deal of empathy and attraction toward ordinary things and places, especially if they are discarded or deserted. I express my intrigue through extremely realistic (and mildly surreal) watercolors, oils, and aquatint etchings. The realism in my work is oriented toward the sensuous consumption and reinterpretation of the world I see. I am not interested in how closely I can mimic physical images in paint, but rather in how I can change and distort them to suit my personal aesthetic.

Airport Drive-In. Watercolor. 10" x 15"

When I paint an image, I break it down in my mind and put it back together in the second dimension as if it were a puzzle. The pieces of the puzzle are the compositional elements of shape, texture, light, value, hue, line, etc. If the elements are assembled harmoniously, the painting will function well as both an abstract composition and a realistic image."

433 Rockaway Beach Ave., Pacifica, CA 94044
650-359-6106 www.torlakson.com

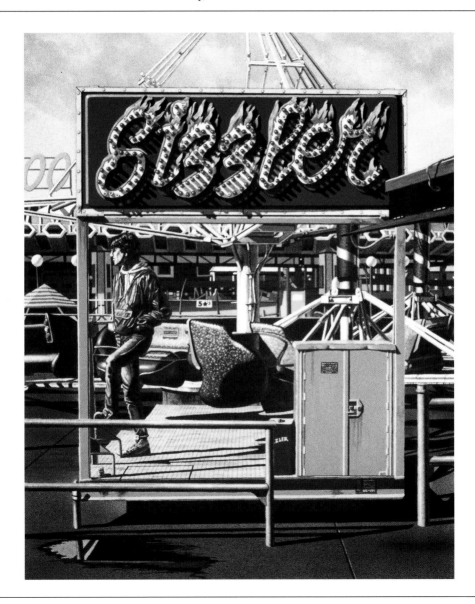

Sizzler. Watercolor. 20" x 16"

Torlakson

Ann Curran Turner

Ann Curran Turner studied drawing as a teenager in Le Havre, France, and received a BFA from the University of California at Berkeley. She now teaches painting and drawing at the College of Marin in Kentfield, California and Skyline College in San Bruno, California. "I have always been drawn to the human figure, fascinated by people and their unending complexities. They are my motivation to paint and draw. They are the primary source for my work. I am driven to capture their elegance, ornamentation, humor, fragility,

Life with the Right Shoes. Oil on canvas. 60" x 48"

absurdity—the common vulnerability of our skin, guts, hearts—most importantly—their attitude, spirit, energy, life force and their engagement in our long shared journey. I consider my paintings a celebration of those who upset prescribed norms of behavior and appearance, and who embody that which is central to the core of the human spirit and its creative expression."

Industrial Center Building, Studio 302
Sausalito, CA 94965 415-331-5126

The Bridesmaids. Oil on canvas. 48" x 36"

Turner

Alison Ulman

Alison Ulman was born in Oakland and received a BFA from the University of California at Santa Cruz. "I have a cauldron in my core, so I distance myself from the next melting point in order to control the creative process. Distance is something I think about a lot. I play with it internally. If someone comes too close, I make it happen. Distance seems to lend itself to observation and art. In the process of making a sculpture, I often look at photographs of the work in progress to decide on my next move toward shaping its

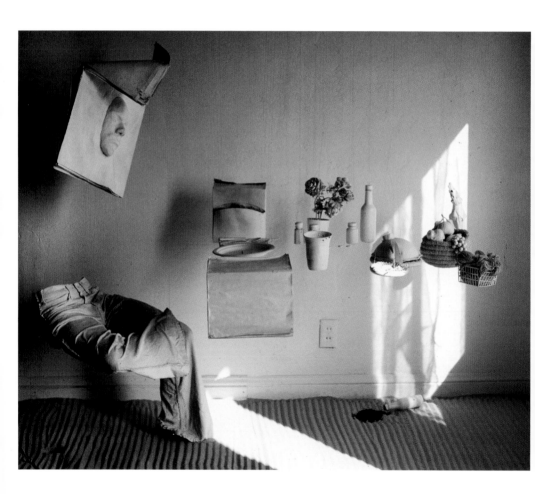

Adjectives without Nouns. Fiberglass, clothes, mixed media. 7' 3" x 7' x 6' 9"

form. In other words, I can see better, more closely, when I step back and look at it one step removed. Of course we all get carried away with this, frenetically separating ourselves from where we are … or the opposite, trying to be present in what doesn't involve us. Too close, too far, it's a tricky business, this present moment."

1148 East 18th St. #1, Oakland, CA 94606
510-532-6179 www.endlessprocess.com

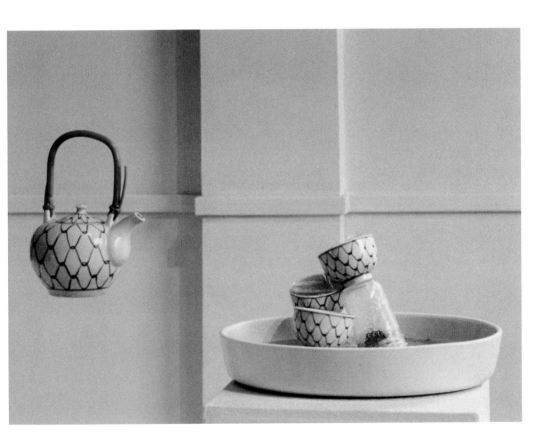

Continua. Fountain with crushed glass and tea set. 18" x 20" x 12"

Ulman

Mark Ulriksen

Mark Ulriksen received a BFA from California State University at Chico and was a graphic designer and magazine art director before becoming an illustrator and artist. He has illustrated covers for *The Atlantic Monthly, Time* and *The New Yorker*. "Being an artist means being alone a lot, and while I love solitude I am also totally fascinated by people and spend a lot of time painting pictures of all sorts of folks. As an illustrator I'm often asked to portray the famous or notable; as an artist I almost always gravitate towards the interactions of people.

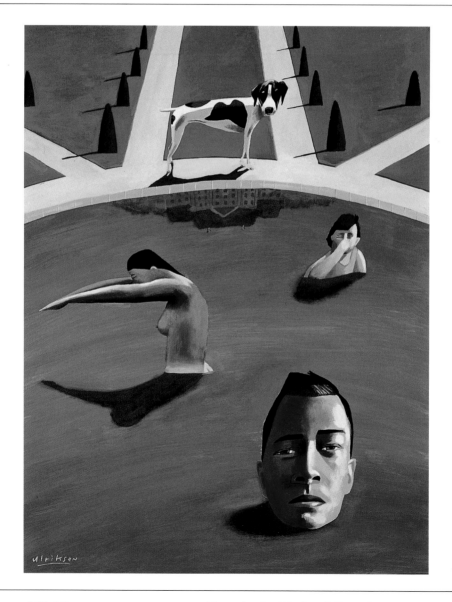

Home for the Weekend. Gouache on paper. 14" x 11"

My background as a designer influences my compositions. I'm sure my love of vibrant color comes from being a member of the TV generation, and movies are my principal source of inspiration. When I begin a new painting I tend to think of myself as a director, selecting the characters, props, point of view, and light source. I then try to simplify. Simplicity is powerful yet difficult to achieve."

San Francisco, CA
415-387-0170 www.markulriksen.com

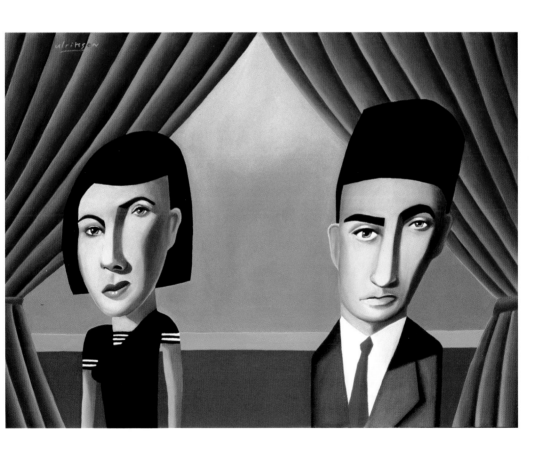

The Couple. Oil on canvas. 30" x 40"

Ulriksen

Laura Voight

Laura Voight received a BFA from Rosemont College in Rosemont, Pennsylvania and worked as an assistant photographer for the Philadelphia Museum of Art, where she began experimenting with image transfers of Polaroid film. "In December 1999 I wanted to explore photography's unique ability to capture a moment in time. *The Century Series* commemorates historic objects or moments during the 1900s through nostalgic photo still-lives and original stamps. Postmarking the rare USPS stamps series *Celebrate the Centuries*

 Hand Mixer. Polaroid image transfer. 10" x 8"

officiates the date of completion for historical reference. On the last day of the millennium I traveled between post offices in San Francisco and Marin County to obtain a 'government official' date and record of time on fifty original images with significant meaning to the 1900s.

Since then the artistic manipulation of Polaroid film and postmarking has become the signature of my work."

4405-A 20th St., San Francisco, CA 94114
415-383-7075 www.voightsvisions.com

Chevy. Polaroid image transfer. 8" x 10"

Voight

Leslie Anne Webb

Leslie Anne Webb is a self-trained artist with a singular focus. "At the age of three I painted the perfect rendition of 'the horse' as I saw him: spiritual, majestic and vividly colorful. Horses had captured my heart with their beauty, their grace, and the language of their soul. Today, my artwork involves real-life inspirations—horses that have been rescued and placed in loving homes and sanctuaries. Their personalities are to each their own. My paintings portray each individual, unique spirit through use of color, expression and also through language, for each

The Trio. Oil on canvas. 48" x 60"

horse has his own words. Horses are amazingly sensitive beings with whom I've shared my purest emotions. They are my teachers. They have been the calm in my life, the savior, the constant, the example of forgiveness. With their consent, I've obtained the means to transcend and transform myself. Being blessed with a connection to these horses allows me to educate through art."

Grass Valley, CA
530-274-7418 www.lawebb.com

Elwood #2. Oil on canvas. 96" x 48"

Webb

Idell Weiss

Idell Weiss studied art at Harvard University-Radcliffe College and at San Francisco City College. "I formerly worked as a physical therapist at the Northern California School for Cerebral Palsied Children, and was drawn to the painting, weaving and collage utilized by the occupational therapists, which led to my full-time devotion to painting…. Viewers expect painters to have a specific style and direction, an anticipated association that is made with an artist's work. When painting I seek the exact opposite, always experimenting

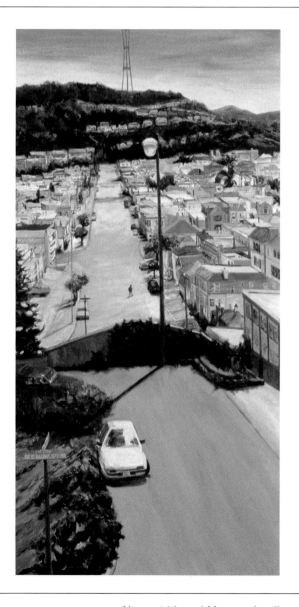

Above 14th and Moraga. Acrylic on canvas. 48" x 24"

in subject matter, media and style. Even my abstract paintings seem to take on an organic quality. I am drawn to the kaleidoscopic nature of city views and also to the natural landscape, especially rugged vistas prevailing in high altitudes. Because of its tactile and viscous quality, oil paint is my favorite medium, followed by acrylic, collage, mixed media and watercolor."

143 Mendosa Ave., San Francisco, CA 94116
415-564-2595 idellweiss@msn.com

Opus 34. Mixed media on canvas. 60" x 48"

Audrey Welch

Audrey Welch was born in Tempe, Arizona and received a BA in graphic design from the Colorado Institute of Art. "Over the past fifteen years, design has moved to the background while painting moved to the forefront. I was a figurative painter for years, but recently became interested in pattern and color. The images shown here are from the *Ice Cream* series. I begin by allowing a mass of flavors to build up, applying many layers of paint, and then slowly reveal the individual flavors by sanding each section of canvas. I make

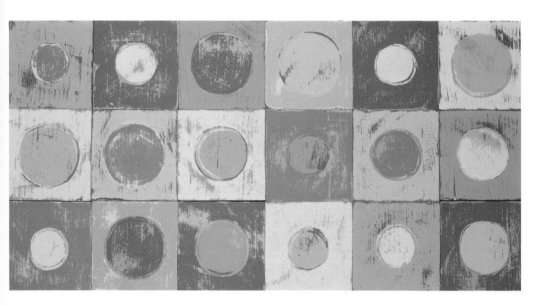

Chocolate Mango Heaven. Acrylic and latex on wood panel. 12" x 24"

discoveries in color and texture as I work through the layers, making the process fresh for me every time. I consider each square a painting in itself, but when circles are placed together they create a dynamic pattern and a rich visual texture. Hung together, the paintings bring back the memory of standing on my toes peering into the case at 31 Flavors, anticipating the pure joy of eating an ice cream cone."

San Francisco, CA
415-929-7910 audrey@audreywelch.com

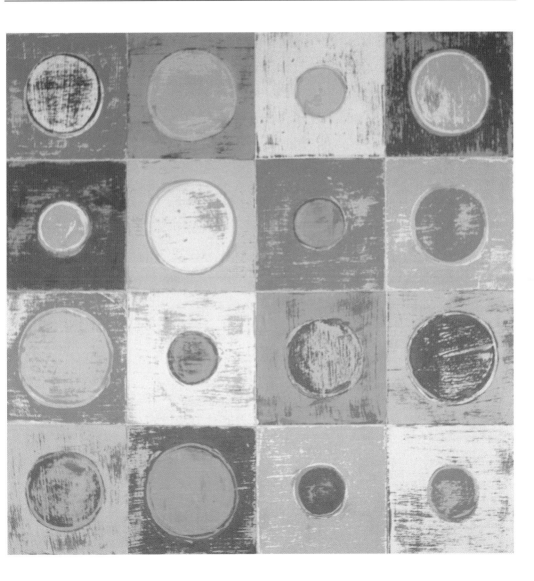

Green Tea Vanilla Swirl. Acrylic and latex on wood panel. 24" x 24" **Welch**

Nancy Willis

Nancy Willis received a BFA from the University of Cincinnati and is completing an MFA at the San Francisco Art Institute. "The *Bed* series begins with an everyday object as a springboard into the waters of subjectivity. The bed serves as a metaphor for such discourses as isolation and community, memory and presence, nurturing and abuse, longing and fulfillment. The beds are location or architecturally oriented. The color and atmosphere that surrounds the imagery supports or denies it. It is the viewer's

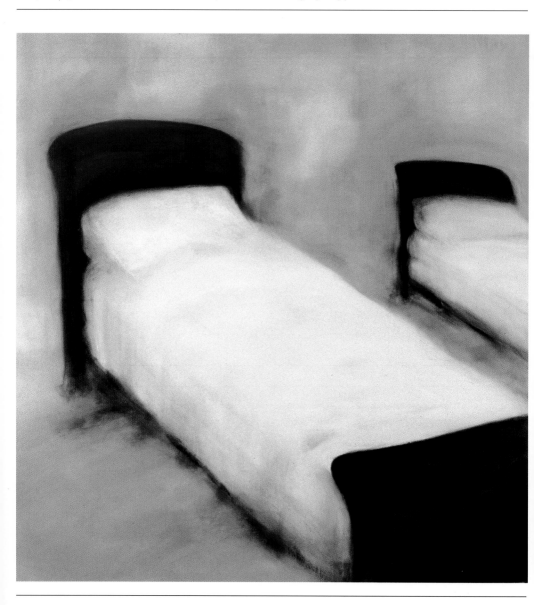

Susanna and Martin. Oil on canvas. 72" x 72"

participation and history with the imagery that defines it. The bed can be a potent suggestion of sexuality in reference to our relationship with the world. I am interested in the power of influence on perception and the sexual undercurrent of decision. In a world that has become increasingly narrative, I suggest the fragmentary aspects of storytelling. We only ever know part of the story."

P.O. Box 53, St. Helena, CA 94574
707-963-9410 nancy@nwillis.com

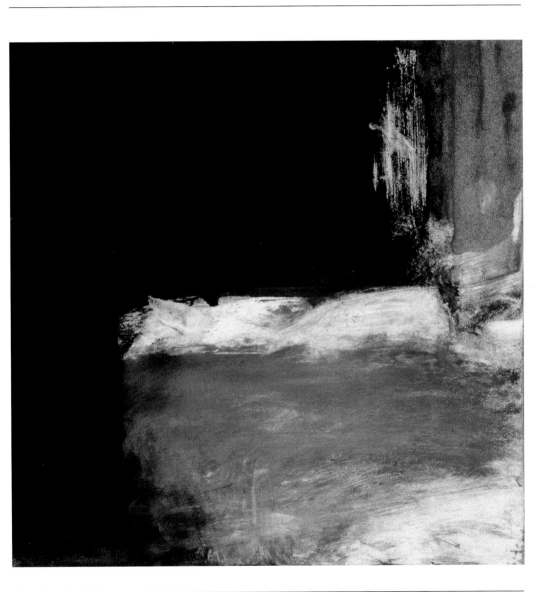

Literary. Monotype. 5" x 5" **Willis**

Juliet Wood

Juliet Wood studied at the California College of Arts and Crafts in Oakland and the Pacific Basin School of Textile Design in Berkeley. "My art consists of multi-media and multi-dimensional 'constructs' using a variety of traditional materials and found objects: papers, fibers, plaster, pellon, wax, threads, oil and acrylic pigments, dyes, charcoal, *caron d'ache* and photography. I print, paint, construct and often stitch on the surface of a piece. The images, scale and shape emerge in the construction, as a visual tension is

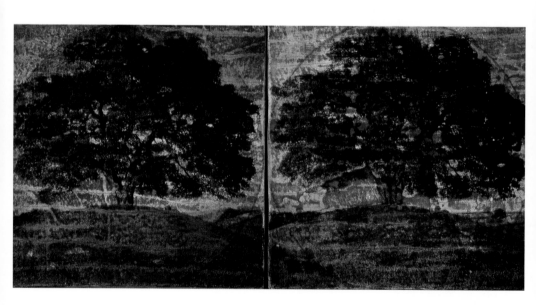

The Marriage. Printed, painted fresco on board. 8" x 17"

produced from incongruous materials. In the process I meet the intuitive, the meditative, the archetypal. The process is soulful. I work often in a spiral or circle form, creating a logos or story, a way of dwelling on the earth. Satisfying work and shape ultimately create logos, a redress of an imbalance in linear perspective. Perhaps all my work is one large work about transformation."

P.O. Box 1135, Ross, CA 94957
415-454-9817 awood@suttersf.com

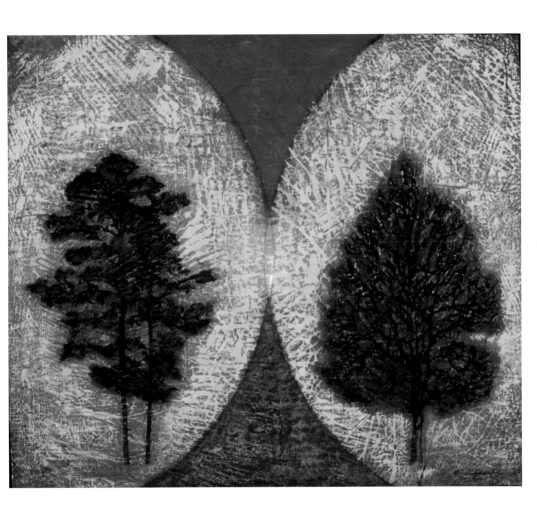

La Forza de la Vida. Printed, painted fresco on board. 48" x 55.5" **Wood**

Jan Wurm

Jan Wurm received a BA in pictorial arts from the University of California at Los Angeles and an MA in painting from the Royal College of Art in London. "My work explores the vagaries of romance, marriage, betrayal and loss, and the fundamental power structure that determines personal expectations. How people view themselves and the world is reflected in iconic distillations of California life. Leisure, work and family provide settings in which the values of society can be decoded. Simple encounters provide images in which people, through body

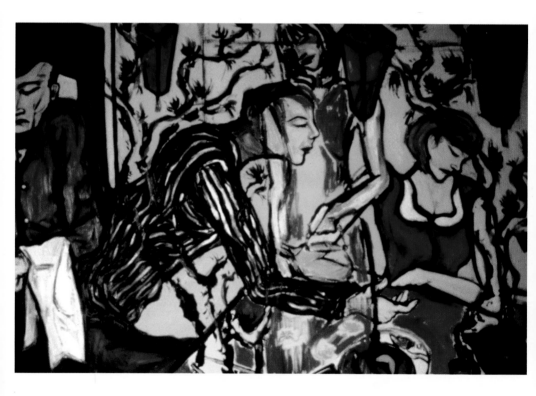

Fortune. Oil on canvas. 60" x 72"

language, gesture and fashion, reveal more intimate aspects of their self-conceptions and expectations. Both public and private manners mirror the self-images of people. How people view their lives is determined by values passed on not only by the family, but also by society.

These paintings attempt to go beyond the gesture of an individual's presence and confront the underlying social condition."

1308 Fourth St., Berkeley, CA 94708
510-526-0926 wurm@uclink.berkeley.edu

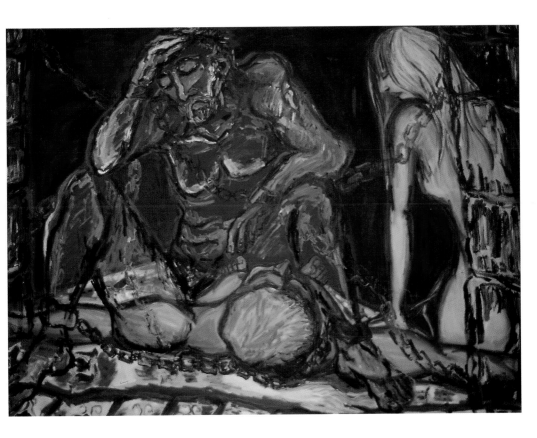

The Captive. Oil on canvas. 48" x 72"

Wurm

Carolyn Zaroff

A former writer, Carolyn Zaroff began painting in the mountains of Colorado and settled in Northern California in 1995. "My feelings about nature tumble out in bold color. My eye seeks the unexpected and I am drawn to contrast between simple forms and complex layers.

I look for structure under the surface. At the same time I want to capture shadow and light, the voluptuous color of a hillside, the sensual pleasure of an arrangement of flowers or the abstract beauty of the city. When I step back and look at my work, I realize that I have been

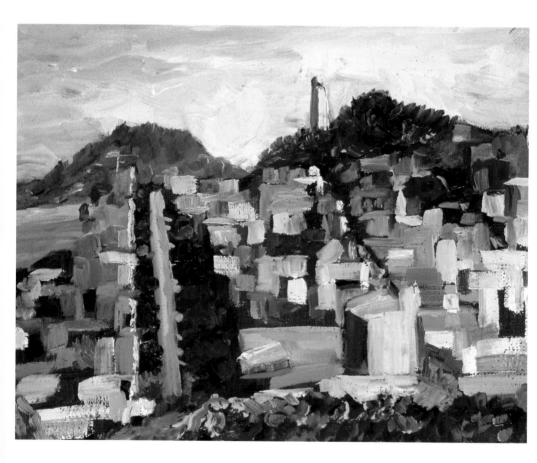

Coit Tower. Oil on canvas. 9" x 12"

influenced by my life-long love of the art of Monet, Cezanne and Matisse. I have seen Provence through their eyes but every day I am grateful for my own Northern California landscape. Here I find the cerulean skies, golden hills and amazing light to fuel my own passion for painting. Here I can look upon the limitless wonders of nature as my painting universe."

433 Bridgeway
Sausalito, CA 94965 www.art.net/czaroff

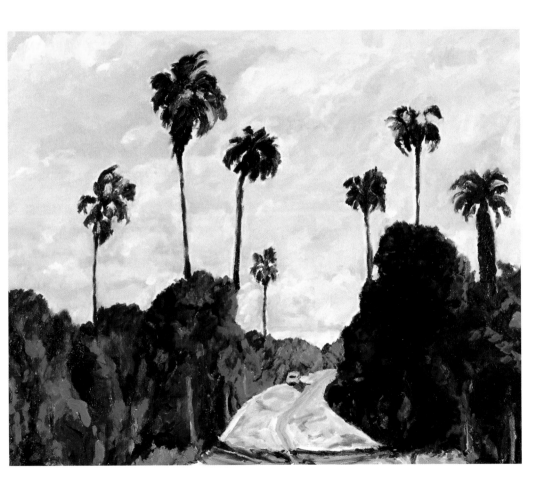

Road to Locke. Oil on canvas. 20" x 24"

Zaroff

AA	The Ansel Adams Gallery Yosemite 800-568-7398	**CN**	Art Concepts Walnut Creek 925-930-0157
AC	ACCI Berkeley 510-843-2527	**CP**	Calpaintings.com Tiburon 415-435-4200
AD	Artworks Downtown San Rafael 415-451-8119	**CT**	Cathcart Contemporary San Francisco 415-221-6093
AG	Artisan's Gallery Mill Valley 415-388-2044	**CU**	Cuttress Gallery Pomona 909-868-2970
AI	Ampersand International San Francisco 415-285-0170	**CX**	ConneXions Sausalito 415-332-1486
AL	Alinder Gallery Gualala 707-884-4884	**DC**	Dolby Chadwick San Francisco 415-956-3560
AS	Andrea Schwartz Gallery San Francisco 415-495-2090	**ER**	Eriksen Gallery Half Moon Bay 650-726-1598
AT	Artrails - Sonoma County O.S. (October) 707-579-2787	**FR**	Friday the 13th West San Francisco 415-863-2285
AU	Aguirre Gallery San Mateo 650-373-4900	**GE**	Graeagle Art Gallery Graeagle 530-836-1319
AW	ArtScape West San Francisco 415-648-1990	**GG**	The Garden Gallery Half Moon Bay 650-712-1949
CA	City Art Gallery San Francisco 415-970-9900	**GO**	Gallery One Sonoma 707-938-9190
CC	Christopher-Clark Fine Art San Francisco 415-397-7781	**HA**	Hang Gallery San Francisco 415-434-4264
CD	Chroma Art Design San Francisco 415-552-966	**HG**	Highlight Gallery Mendocino 707-937-3132
CH	California Heritage Berkeley 510-841-3111	**HP**	Hunters Point Shipyard San Francisco 415-822-9675
CL	Catharine Clark Gallery San Francisco 415-399-1439	**JL**	Judith Litvich Fine Arts San Francisco 415-863-3329

JR	James J. Rieser Gallery Carmel　　831-620-0530	**SD**	Solomon Dubnick Gallery Sacramento　916-920-4547
KG	Kings Gallery San Francisco　415-885-6018	**SFM**	SFMOMA Artists Gallery San Francisco　415-441-4777
LC	Loanna Clark Gallery Petaluma　　707-762-2133	**SG**	Stone Griffin Gallery Campbell　　408-374-2944
LL	Le Celle Gallery San Francisco　415-456-7873	**SJ**	San Jose Museum of Art San Jose　　408-294-2787
MA	Marin Open Studios (May)　　　415-499-8350	**SM**	Sonoma Museum of Visual Art Santa Rosa　707-527-0297
ME	Meridian Gallery San Francisco　415-398-7229	**SO**	San Francisco Open Studios (October)　　415-861-9838
MM	Michael Martin Gallery San Francisco　415-217-0070	**SS**	Stanford Spaces Palo Alto　　650-725-3622
MV	Meyerovich Gallery San Francisco　415-421-7171	**SV**	Silicon Valley Open Studios (April-May)　650-562-1949
NM	NextMonet.com San Francisco　888-914-5050	**SW**	Switzer Gallery Tiburon　　　415-789-5289
OM	Oakland Museum Collectors G. Oakland　　510-834-2296	**TC**	Tercera Gallery Los Gatos　　408-354-9484
OZ	Gallery OneZero San Francisco　415-989-9157	**TT**	Toomey Tourell San Francisco　415-989-6444
PA	Pro Arts - East Bay O.S. (June)　　　510-763-4361	**VB**	Virginia Breier Gallery San Francisco　415-929-7173
QM	The Quicksilver Mine Company Sebastopol　707-829-2416	**VG**	Voshan Gallery Palo Alto　　650-321-8108
RD	Red Door Gallery Oakland　　510-261-4517	**WG**	Williams Gallery West Oakhurst　　559-683-5551
SB	Santa Barbara Gallery Santa Barbara　805-884-4713	**ZYT**	ZYT Gallery Los Altos　　650-948-4363